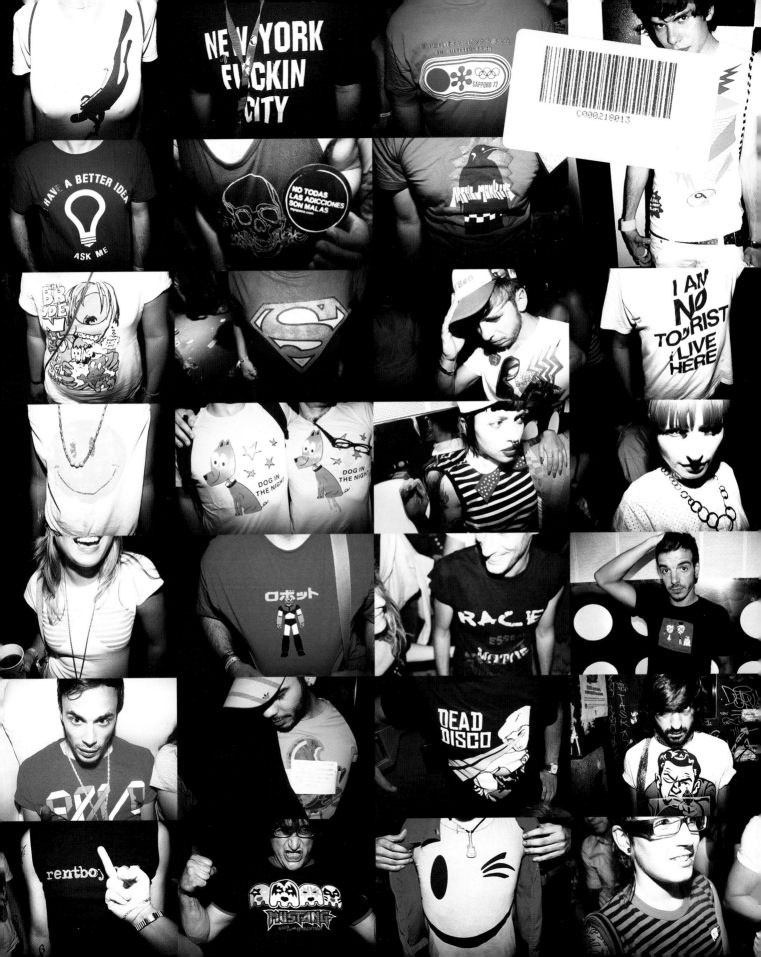

STREET T

Copyright © 2008 by COLLINS DESIGN and Monsa Publications

First Edition

First published in 2008 by:
Collins Design
An Imprint of HarperCollins*Publishers*
10 East 53rd Street
New York, NY 10022
Tel: (212) 207-7000
Fax: (212) 207-7654
collinsdesign@harpercollins.com
www.harpercollins.com

Distributed throughout the world by:
HarperCollins*Publishers*
10 East 53rd Street
New York, NY 10022
Fax: (212) 207-7654

Text, design and layout:
Louis Bou

Library of Congress Cataloging-in-Publication Data

Bou, Louis.
Street T / Louis Bou.
p. cm.
ISBN 978-0-06-144152-3 (pbk.)
1. T-shirts–Design. 2. Commercial art. I. Title. II. Title: Street tee.

NK4890.S45B68 2008
746.9'2–dc22

2007032832

Printed in Spain by:
Filabo

First Printing, 2008

Right page: Arwork by Kulte.

street

COLLINS | DESIGN

An Imprint of HarperCollins*Publishers*

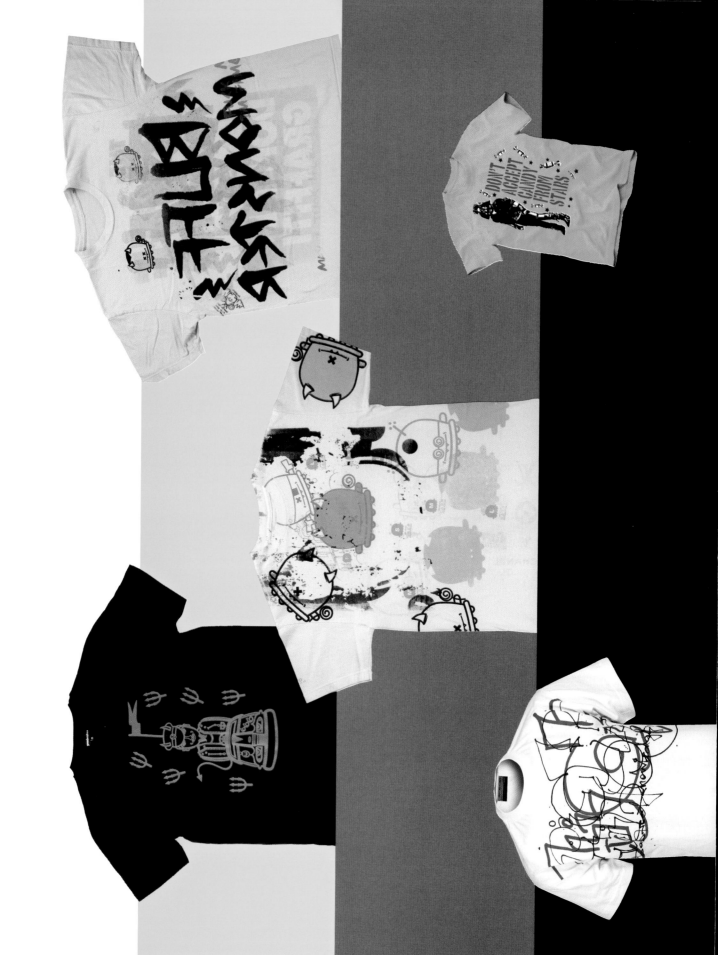

street T

living in a T world 9
01_ elena gallen 10
02_ ju$t another rich kid 12
03_ buff monster 16
04_ new york couture 22
05_ styletax 28
06_ silberfischer 30
07_ gonzalo cutrina 32
08_ world of found 38
09_ nubius 42
10_ t-book 44
11_ kulte 48
12_ joe rivetto 52
13_ davidelfin 54
14_ jon burgerman 58
15_ vier5 62
16_ me&yu 64
17_ threadless 68
18_ martí guixé 74
19_ gori de palma 76
20_ la mujer barbuda 82
21_ emess 84
22_ misericordia 88
23_ max-o-matic 94

24_ momimomi 98
25_ divinas palabras 102
26_ el xupet negre 108
27_ passarella death squad 110
28_ fienden 114
29_ magmo the destroyer 120
30_ 8mileshigh 126
31_ dolores promesas 130
32_ delphine delas 134
33_ flying fortress 136
34_ yogurt 142
35_ yackfou 146
36_ star electric eighty eight 150
37_ she's a superfreak 154
38_ barrio santo 158
39_ lady dilema 162
40_ aerosol 164
41_ t-post 168
42_ king stampede 172
43_ evil design 174
44_ pollock 176
45_ putos modernos 180
tees for peace 182

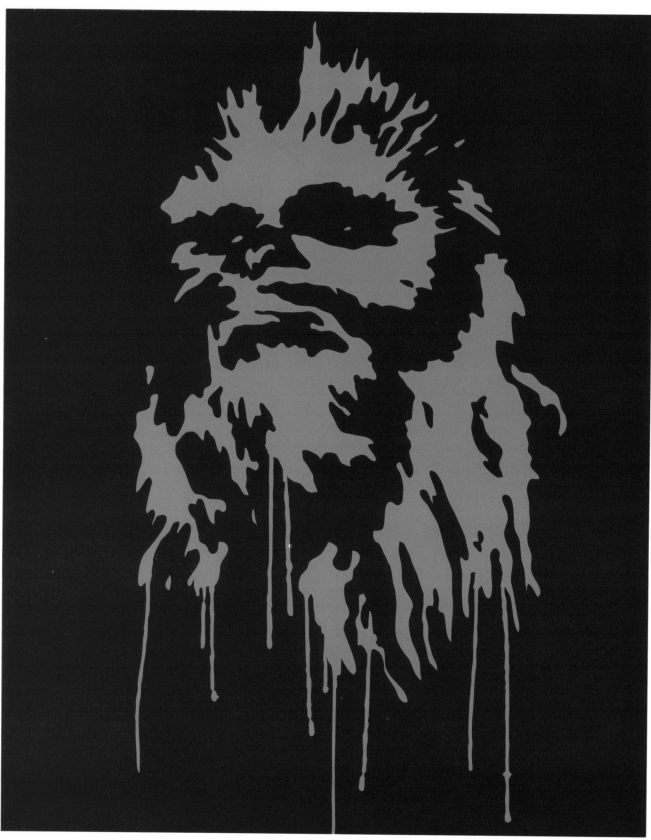

Artwork by Flying Fortress.

living in a T world!

Street T is not just a book about T-shirts—it is a window onto the worlds of graphic design, art, and fashion. For more than 20 years now, T-shirts have been escaping from the bottom of the underwear drawer to become ultra-popular, everyday outerwear. Leaving behind a humble past, the T-shirt has metamorphosized through countless fashions and trends, even rising to form a crucial part of renowned international couture collections. It was back in the 1990s when, for the first time, designers such as Vivienne Westwood, Jean Paul Gaultier, and John Galliano sent T-shirts strutting down the catwalk and then sold them for exorbitant prices.

Today, the T-shirt is a fundamental basic worn by millions all over the world, especially by young people. Together with jeans and sneakers, the T-shirt makes a perfect outfit for nearly any occasion: comfortable, easy to wash, and attractive. Although all T-shirts share the same basic essence, there are thousands of designs, patterns, colors, and fabrics making each one unique and allowing each T-shirt wearer to stand out as an individual. The T-shirt is used as a symbol of protest, an advertisement, a political campaign sign—and, also, as a way for many artists and designers to express themselves and promote their work.

At the turn of the millennium, the "graffiti" movement went through a resurgence, reinventing itself to become the socially recognized form of "street art." A large number of artists—the vast majority of which came from the ranks of graphic design—used the street as a medium to transmit their art directly to the public on a wide scale and, most importantly, free of charge. The boom of street art resounded through the world, and new talents, creators, and aesthetics sprang forth in a totally new kind of artistic renaissance. Artists who have achieved international fame now make their own lines of products and merchandise, using not only T-shirts, but also toys, badges, hats, and sneakers as mediums with which to spread and promote their work. The graffiti artist El Xupet Negre says:

"A T-shirt is the perfect way to hype yourself and spread your message. People see you as serious when they see something on a T-shirt, rather than on a wall. It seems more important. What's more, the T-shirt can travel on the street and around the world.... It's a way for a logo to go anywhere in the world, without the artist ever having to set foot there."

Street art activists go by the motto "Do it yourself," often creating their T-shirts with homemade stencils and simple cans of spray-paint. Through these rudimentary processes, they can attain effects, qualities, and textures virtually impossible to get with more complicated methods of heat presses and silkscreening. Their T-shirts, despite sharing the same template, are each unique, which makes them valuable as collector's items. Thanks to technological advances, it's fairly easy to make a personalized, artistic T-shirt in your own home: With only an ink-jet printer and some transfer paper, you can have your own special T-shirt ready to wear in a matter of minutes. The graffiti artists captured in *Street T* show us a new way of spreading a message and marketing a product—and, most important, a new way of making art.

Beyond the orbit of the graffiti artist there is another world, that of the graphic designers and illustrators who use T-shirt designs as a fun escape from their stressful design careers. They may devote much of their time to their work in design studios, agencies, and publishing houses, but on occasion, they also design and manufacture their own T-shirts, often in a completely amateur way—just for the fun of it. The Catalan artist Pollock, for example, secretly hand makes a collection of T-shirts every year to sell or give away to friends, with the simple intention of having a good time:

"One day, when I was 15 and at home in a bad mood, I said to myself: I wanna do T-shirts! And so, with a paintbrush and a jar of paint I did three T-shirts; I kept one for myself, and sold the others to my brother. Ten years later, I said to myself again: I wanna do T-shirts! Although I took it more seriously this time, my intention was still the same—to have a good time."

Other designers go much further toward using the T-shirt in a conceptual context. Take Sweden's *T-Post*, the first magazine created "to be worn": a T-shirt received in the mail, by subscription, every six months, with an illustration on the front and a short article printed on the back.

"Back in 2004, we started coming up with new ways to engage people important topics, and T-shirts seemed ideal for doing so. T-shirts are conversation pieces, and when you put an actual news story on one, you get people thinking—forming opinions, discussing various topics with their friends. Nobody asks you about the article you read in the bathroom. But if you're wearing an issue of *T-post*, people tend to ask what it's about."

The world of fashion is also covered by this book, as many fashion designers use the T-shirt to promote their logo or brand, and, on many occasions, make the T-shirt a fixture in their more sporty streetwear collections. The New York artist Cassie K, founder of the brand New York Couture, uses vintage T-shirts to create unique and original garments, even daring to reinvent the classic I Love NY T-shirt into a sexy mini dress. She says:

"The first T-shirt I designed was a flutter-sleeve top. I took an old vintage size extra-large band tee from the '80s and cut off the sides and sleeves. Then I hand-tailored the top to make it fit nice and snug on a slim body. I added a flutter-sleeve to make the top very flirty. I still offer this style."

With the explosion of graphic design that accompanied the Internet revolution at the turn of the century, the T-shirt attained its status as a fashion phenomenon. Companies such as Threadless have had a hand in this: a community of designers, illustrators, and graphic artists who submit their designs to the website from any point on the globe; the designs with the most votes of approval are marketed and produced through the same website. As the website says: "T-shirts are the perfect medium for illustration. They're accessible, and everyone loves a tee!"

Street T is an introduction to the passionate world of T-shirt design—an integral part of the current developments of urban culture.

Louis Bou

THE DOUBLE HEADED BAMBI

THE TATTOOED OCTOPUSSY

THE TRIPLE BREASTED SIREN

THE BEARDED LADY

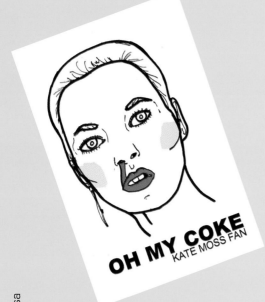

OH MY COKE
KATE MOSS FAN

01_Elena Gallen

www.elenagallen.com
www.myspace.com/laninadelabicirosa
www.fotolog.com/bicirosa
www.elenagallen.blogspot.com
Barcelona, Spain

ELENA GALLEN is a young, completely self-taught, multidisciplinary artist currently living in Barcelona, who combines graphic design with web design, photography, illustration and painting. Together with the shoe brand Victoria she has also dabbled in the world of publicity (www.calzadosvictoria.com). She likes the cinema, diamonds, old toys, photography, postmodernism, monsters, music, fashion, skateboarding, the '80s and '90s, Chanel perfume, surrealism, the art of transgression, unicorns and, vampires.

Why T-shirts?
Because it's an easy way to reach a potential audience without frightening them. Sometimes "art" in any kind of form, including illustration, can be taken as a big word I thought of using T-shirt design as a platform to reach general public with my creations and help them take art less seriously. Plus it's a pleasure to have your work not only recognized but actually worn by people. There's a step between liking something and making it part of oneself; I think T-shirts are able to eliminate that step.

What was the first T-shirt you designed?
I designed some tees last year but the first one I brought to life was one I hand painted with pantone markers of an old Super 8mm camera. I called the tee *J'adore cinéma*.

What are you wearing right now?
I'm wearing a vintage T-shirt of Victoria Beckham in her Spice Girls days, which I found snooping in some boxes in the storage room of my parents' house last year. It was given to me as a present by a kid in my school like 8 years ago. And slim-fit black jeans and a pair of Vans old school shoes.

What famous person would you like to design a T-shirt?
Wow! I have so many idols it'd be hard to pick. I'd choose Lady Di for being an influential celebrity connected to the music, art and movie worlds. A very contemporary and controversial figure that fits with the profile of my customer.

A message you would like to spread with a T-shirt...
Don't resign yourself. Question, reinterpret, twist and turn the world until you can feel it as your own. That's the main message I would like to spread with my tees. Especially with my first T-shirts, the Freakshow series, I wanted to focus on reinterpretation of well-known worldwide symbols, as I consider reinterpretation the vertex of postmodernism.

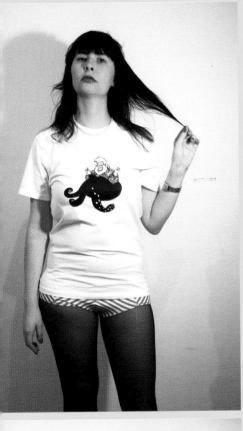

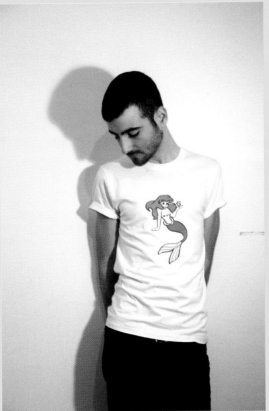

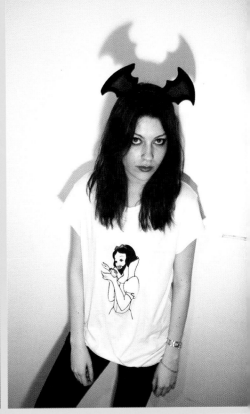

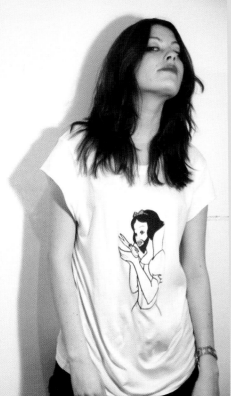

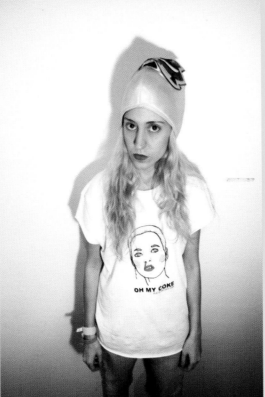

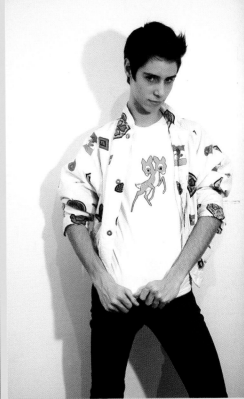

All photographs by Elena Gallen.

ELENAGALLEN.COM

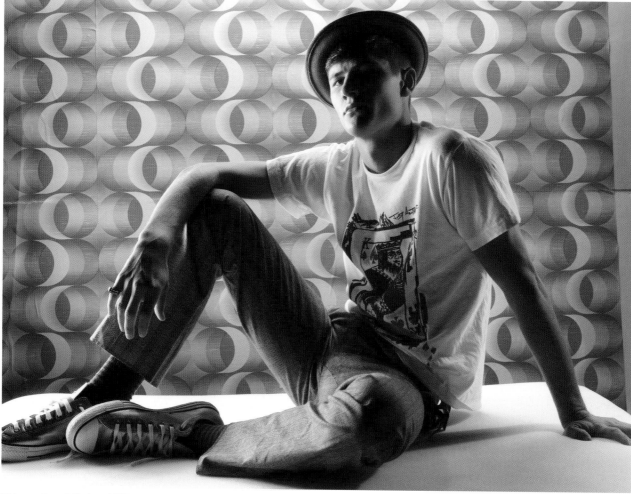

All images from fall/winter 2007 collection "But Here I Dreamt I Was An Architect."

All photographs by zachgold.com.

02_ Ju$t Another Rich Kid
www.justanotherrichkid.com
New York City, USA

New York based artist and designer Ken Courtney is the founder of the independent fashion label JU$T ANOTHER RICH KID. The collection is composed of tailored, custom-fit men's crew-neck and deep V-neck T-shirts, short-sleeved polo shirts, and hooded sweatshirts. Every season a new collection is designed, using an electric mix of one-of-a-kind artist-drawn graphics, each with a hint of rebelliousness and a taste for all things pop culture.

Courtney debuted in 2002 with an installation entitled *The New American Dream*, addressing the commodity of celebrity. He then presented a performance piece entitled *Paparazzi* in September 2004 at the now infamous, short-lived exhibition Terminal 5 in New York. In the spring of 2005, he invited Tobias Wong to collaborate with him on the highly successful design collection Indulgences (for the man who has absolutely everything!), which has been sold around the world and displayed in the galleries at Colette and Loveless. This series then lead to a collaboration on an Absolut vodka ad, featuring a gold plated Absolut bottle, "Absolut Indulgence."

Why T-shirts?
I was painting prior to starting Ju$t Another Rich Kid, but that was a very different process. Lots of time at home alone, and nobody ever saw what I did. I needed more interaction with my work and people. Painting also sucks up all your money. It's so expensive.

What was the first T-shirt you designed?
The now infamous I Fucked Paris Hilton tee.

What are you wearing right now?
Nothing. (Kidding...) Ju$t Another Rich Kid SS07 pink Suicidal Tendencies tee, a navy New Era New York Yankees baseball cap, dark blue Levi's Eco jeans, and white Air Jordan Retro 3's.

What famous person would you like to design a T-shirt?
Patti Smith.

A message you would like to spread with a T-shirt...
Don't believe the hype.

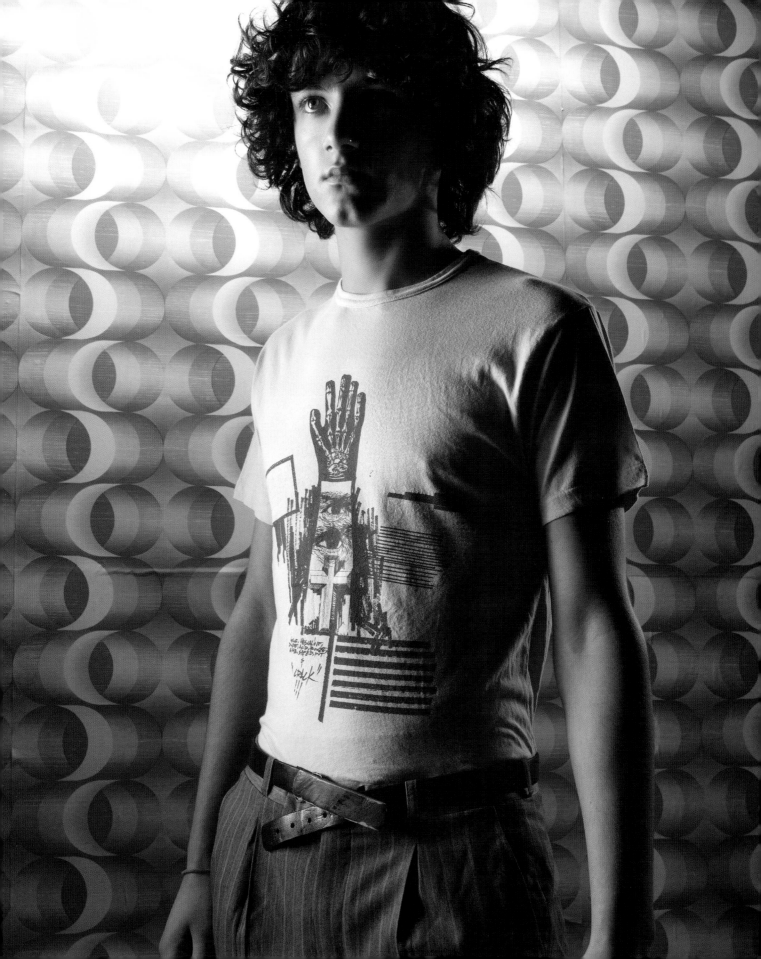

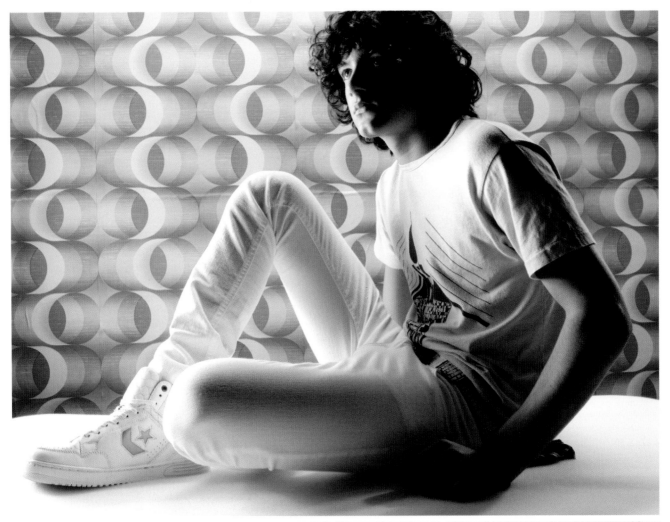

 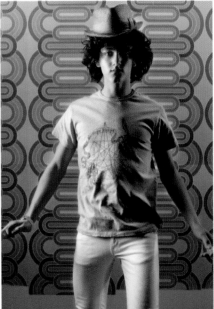

Images on this page and next page, top, from fall/winter 2007 collection "But Here I Dreamt I Was an Architect".
Next page, bottom, from spring/summer 2007 collection "Sex.Money.Violence."

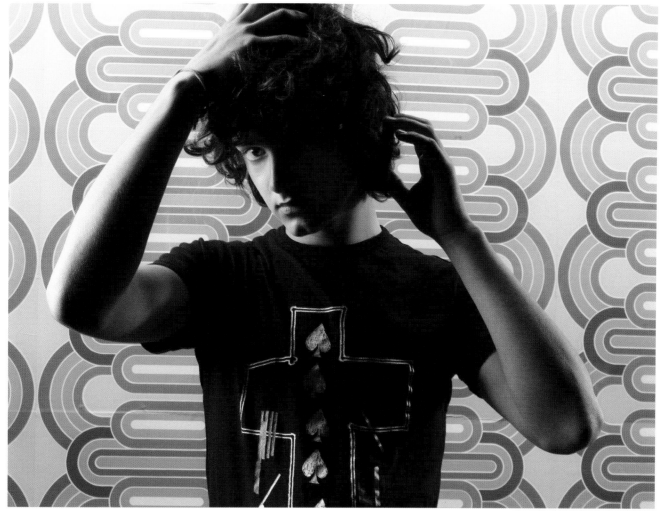

JU$TANOTHERRICHKID™

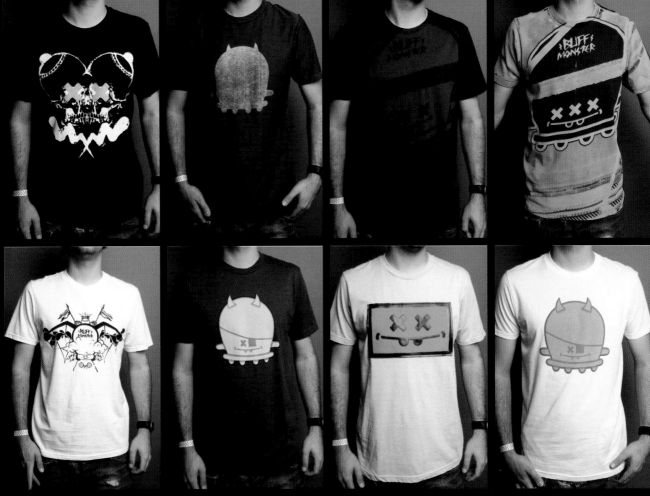

Images on this page by Rony's Photobooth.
Next page image by Buff Monster.

03_ Buff Monster

www.buffmonster.com
Hollywood, USA

BUFF MONSTER comes from Hollywood and often cites graffiti, heavy metal, porn, and ice cream as major influences on his work. He is primarily known for putting up thousands of hand silk-screened posters all across LA and as far away as Barcelona and Tokyo. Usually using wood and found metal, he paints intricate scenes of oozing breasts, squirting vaginas, and delicious fluffy clouds. He has worked on projects with Nike, Vans, The Standard Hotel, Hurley, Vivid, Hustler, and others. He had three ambitious solo exhibitions in the first six months of 2007. He has also created a line of signature vinyl toys and plush figures, a clothing line, and limited silk-screen editions. Buff Monster works tirelessly day and night to expand the empire.

Why T-shirts?
They're easy and cheap to print and experiment on. Everyone has a lot of them, and everyone always gets more.

What was the first T-shirt you designed?
It was just a basic one-color Buff Monster character on a shirt. It was rad. I had just taken a silks-creen class and burned the screen and printed it in my buddy's garage. It came out perfectly. We were shocked.

What are you wearing right now?
A sample from the line I put together a year ago.

What famous person would you like to design a T-shirt?
I don't care about any ol' famous people. But I do love Takashi Murakami and want to see more shirts of his.

A message you would like to spread with a T-shirt...
I think T-shirts are about graphics, not messages.

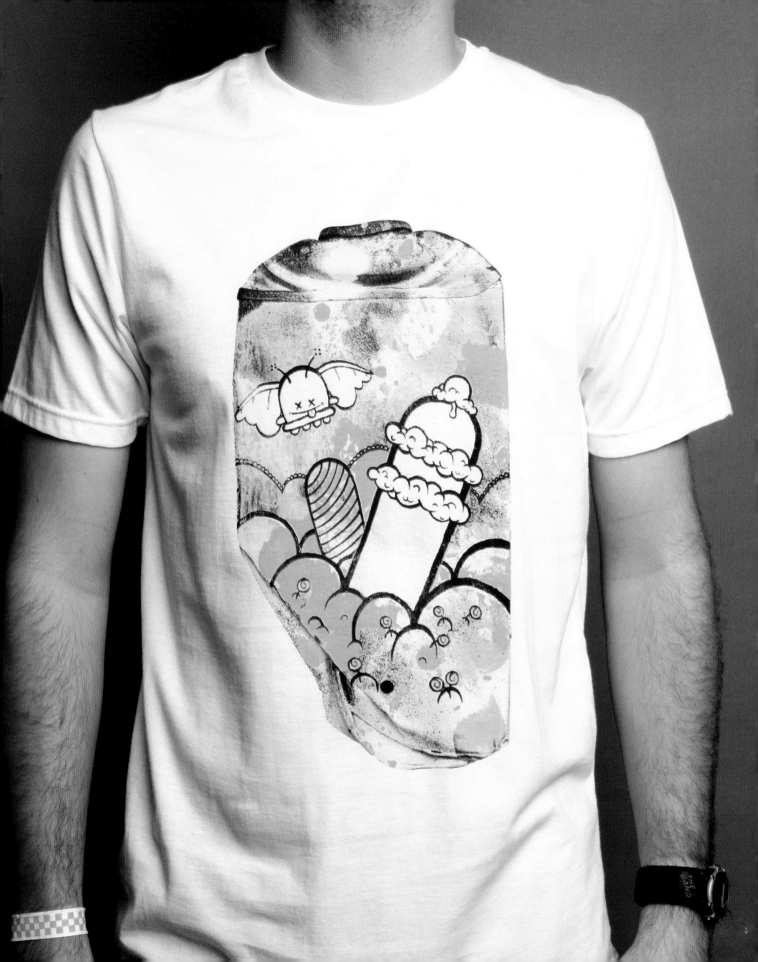

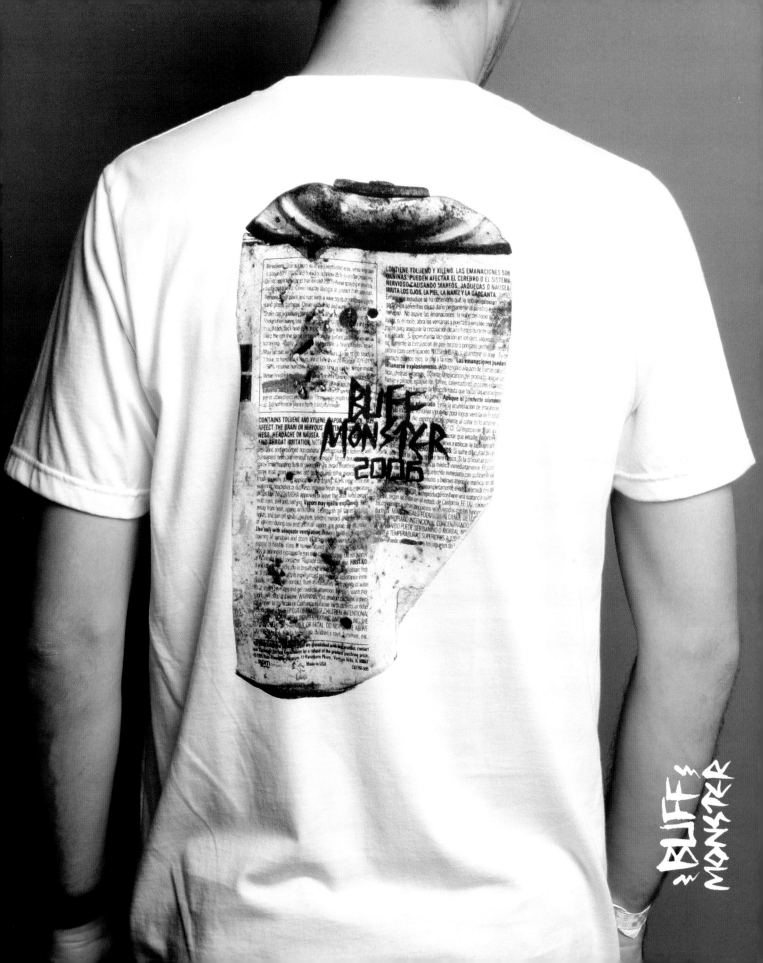

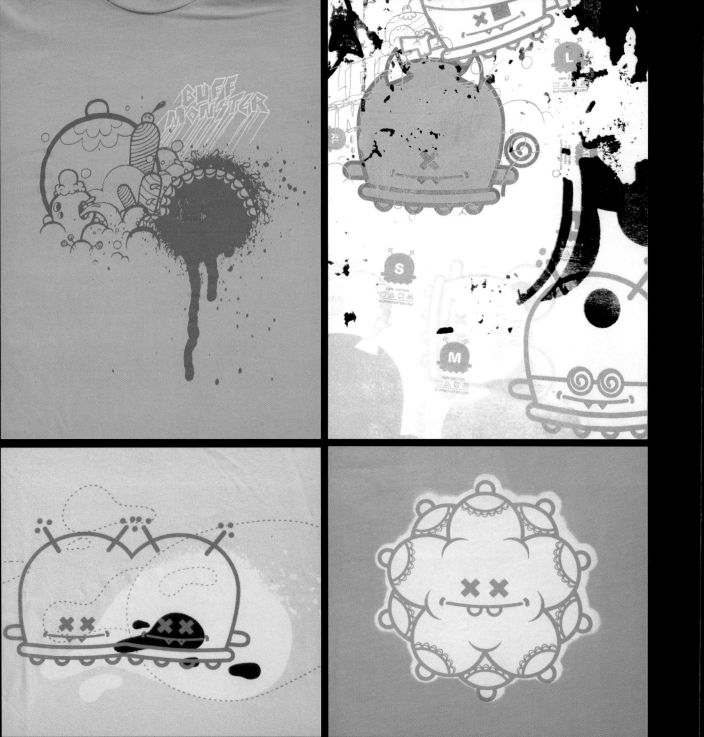

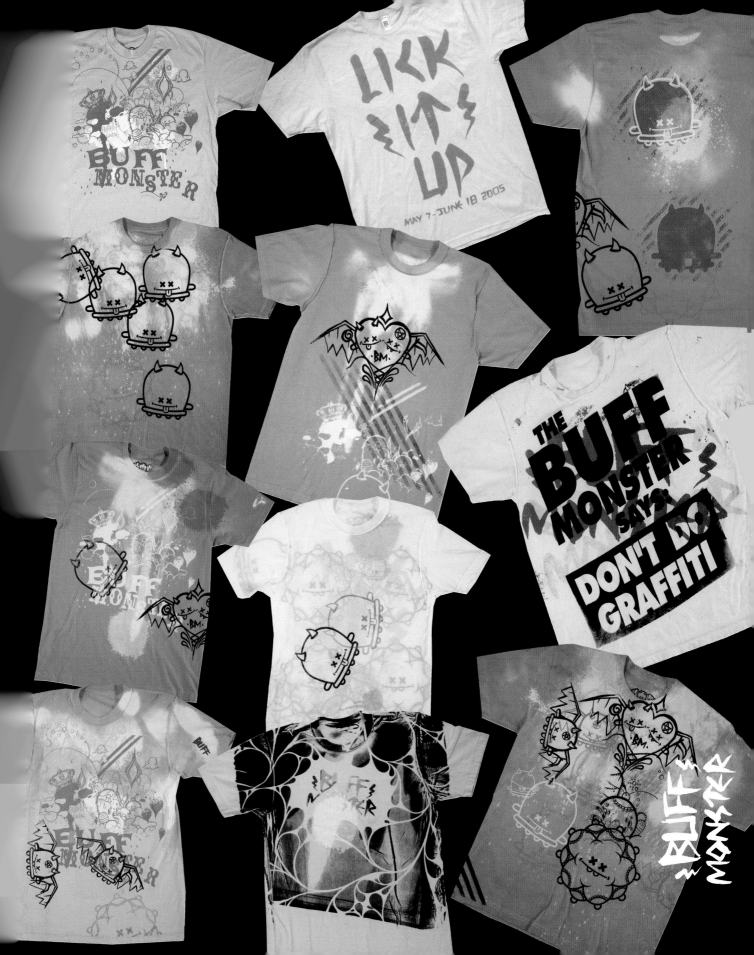

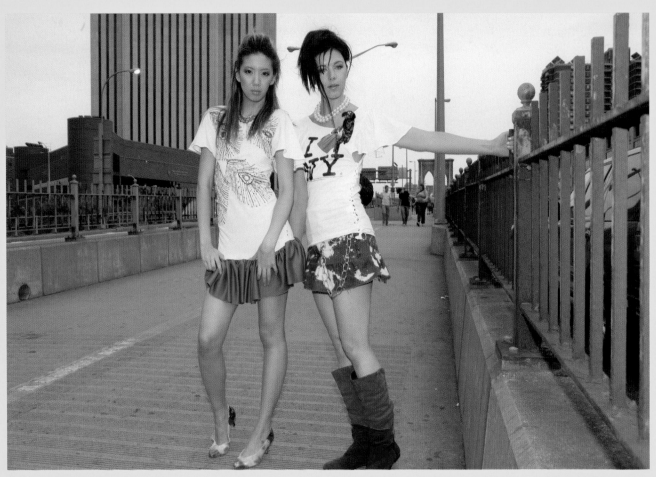

Photograph by Mike Cetta.

04_New York Couture

www.newyorkcouture.net
www.myspace.com/nycouturerules
New York, USA

NEW YORK COUTURE is run by an eclectic 24-year-old named Cassie. Fashion has been Cassie's life since she was just a little girl. When she was 4, Cassie's 2-year-old sister had a very high fever. She got her sister out of bed, put her in a dress, and brought her down to show their parents. Cassie's mother took one look at the two little girls and said, "Cassie your sister is very sick. Why did you dress her up?" Cassie's reply was, "If you look good, you'll feel good." To this day, Cassie still believes that clothes can transform a person.

New York Couture believes that clothing is a way to express yourself. Everyone is unique and that is why New York Couture only makes one-of-a-kind pieces; to represent your own style and originality. All of the fabulous mini dresses designed by Cassie have been created from vintage T-shirts from past decades.

Why T-shirts?
Why not T-shirts? Everyone wears them. They can be simple, crazy, fun, flirty, sexy...anything you are feeling and wanting to express.

What was the first T-shirt you designed?
The first T-shirt I designed was a flutter-sleeve top. I took an old vintage size extra-large band tee from the 80s and cut off the sides and sleeves. Then I hand-tailored the top to make it fit nice and snug on a slim body. I added a flutter-sleeve to make the top very flirty. I still offer this style.

What are you wearing right now?
It's getting late here in New York, so I'm just bumming around in something comfy...nothing worth mentioning.

What famous person would you like to design a T-shirt?
That depends...are they asking me to design it for them or am I just making it with that famous person as inspiration. Either way I would be honored if someone like John Galliano or Patricia Field asked me to design them a tee. Both are a huge influence on my life and my clothing line, so if they wanted me to design anything for them I would jump at the honor!

A message you would like to spread with a T-shirt...
That you should have fun with what you wear!

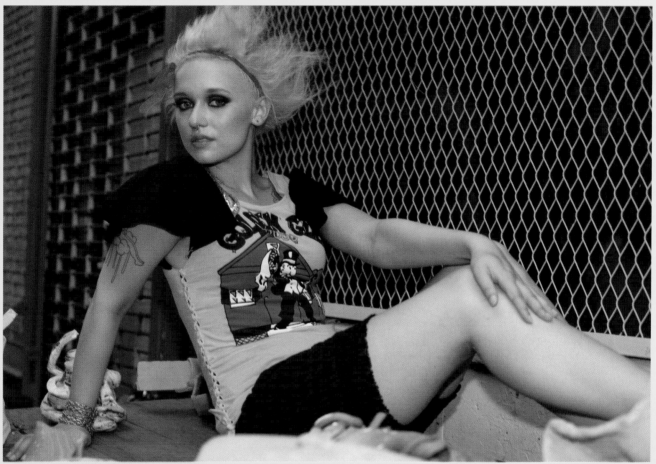

 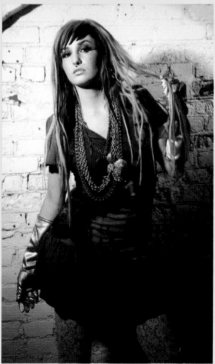 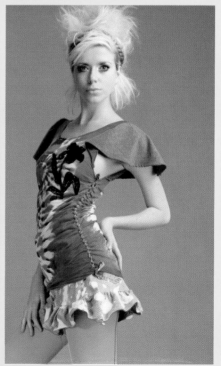

Top photo by Mike Cetta. Bottom photos, from left to right by Janira Martinez, Steve Prue, and Alex Covo.

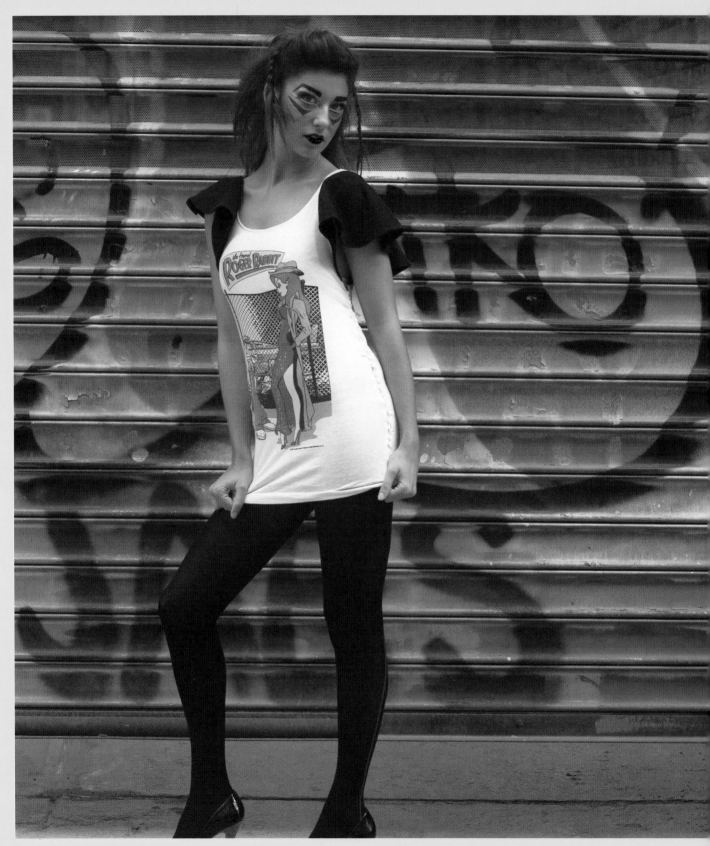

Photo by Mike Cetta.

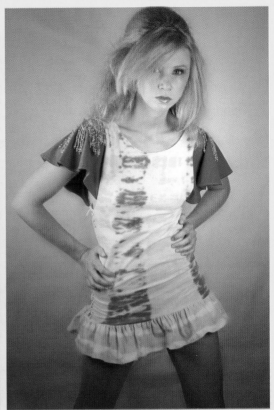

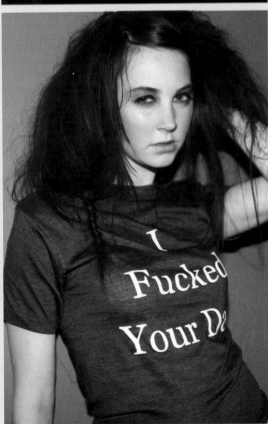

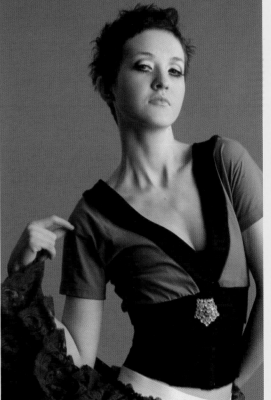

Top photos from left to right by John Perez and Mike Cetta.
Bottom photos from left to right by Victor Santana and Alex Covo.

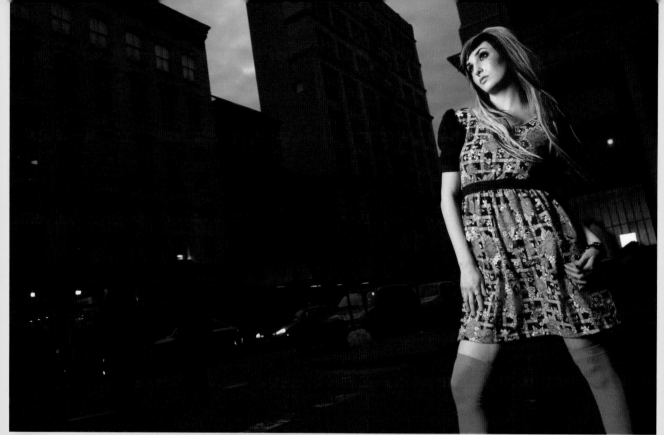
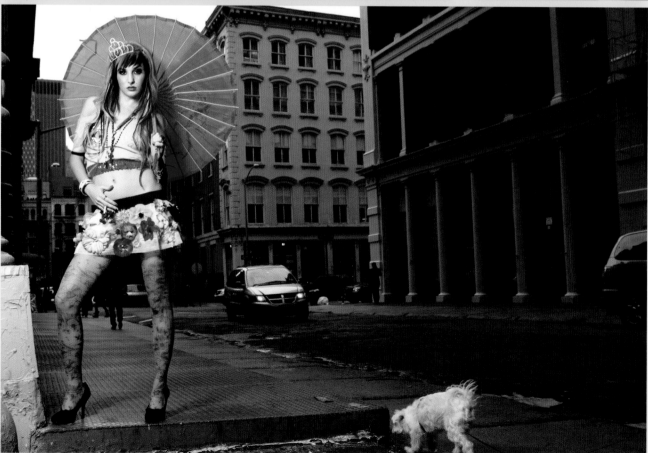
All photos on these pages by Steve Prue.

Clockwise designs by Torso-Chenzo, Tommy A, and Loulou. Next page, top right, design by Dilski.

05_Styletax

www.styletax.com
styletax.blogspot.com
Netherlands

STYLETAX.COM is a way for up-and-coming design talent to show the world their skills! Create a T-shirt design and submit it. If you win, you get your design printed on a shirt and sold in the online shop!

Styletax.com is a fairly new player on the T-shirt market. They started in December 2005 and have since then (to their own surprise) experienced a huge growth in membership, people who actively contribute to the website by submitting designs and reviewing the work of others. One of their unique features is that they offer low-cost worldwide shipping. They also certify that the designs on their T-shirts are high-quality screen prints, and that the shirts themselves are top quality!

How do they select the designs? Much is done by community voting. When enough designs have been entered into the competition and enough votes have been cast, the competition ends. A final selection determines a winner whose design will be printed on a T-shirt and who, of course, will receive large quantities of fame and glory as well as a bunch of T-shirts and one euro for each of their T-shirts sold. Then, people can submit new designs and the cycle starts again.

Why T-shirts?
Because we're T-shirt junkies! We love to wear fantastic, gorgeous, and funny shirts, and we think they are a universal and unique way to show off your designs to the world.

What was the first T-shirt you designed?
It was a black shirt for a rock concert crew, with on the front the logo of the organization and on the back the word crew and some sort of smurf with a shabby hat on.

What are you wearing right now?
A T-shirt of course! Antwan by ready2rumbl from our shop to be exact.

What famous person would you like to design a T-shirt?
Keith Giffen, an amazing comic book artist.

A message you would like to spread with a T-shirt...
Keep on rocking in a free world!

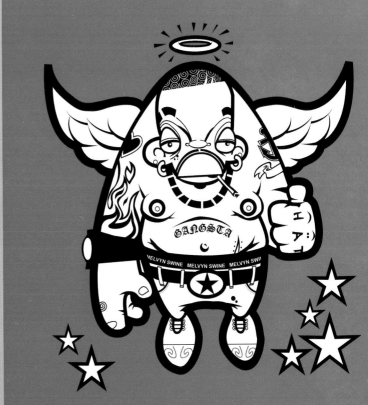

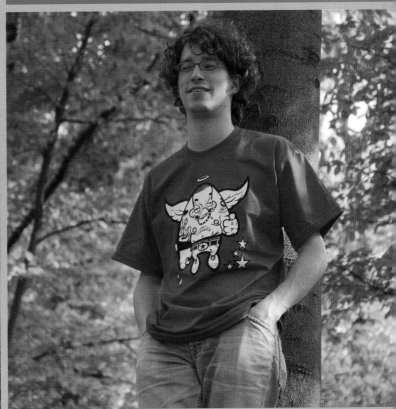

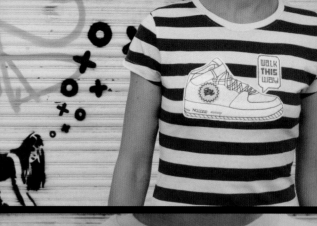

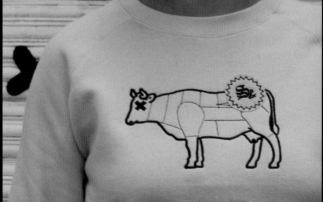

The SILBERFISCHER label was established in 2004 by Elke and André Riethmüller when they acquired a computerized stitching machine. To reanimate the dull image of drawn thread work they started to apply traditional techniques like cross-stitching to unconventional motifs, such as ghettoblasters and skulls. Their experiments resulted in fashionable stitching design for urban people. The label fishes for inspiration from everyday life in Berlin. Hence, unusual items like dusters or waxed Asian tablecloths find their way into their collection. The stitched buttons, with the cute name "buttonies," are unique and some even glow in the dark. The shirts originate from continental clothing company and are not produced in sweatshops, exemplifying high quality. Design and stitching from Berlin:
Let's rock the *kreuzstich!*

Why T-shirts?
I don't know. It just happened to be shirts. But now it is much more: caps, buttons, bags, and so on. I think I liked the idea of people wearing my stuff. Before that I designed 2-D stuff like websites, business card, and so on because I'm a communication designer. So I don't feel like designing fashion but designing graphics on shirts. I also like to experiment with appliqués and stitching techniques when I design a new shirt.

What was the first T-shirt you designed?
That was a printed T-Shirt in school when I was about 8 years old for a summer party. The first design I made for Silberfischer was the butcher's cow because I thought it would be a good icon for our consuming society.

What are you wearing right now?
Pink and black striped sweater with one of our cross stitched bomb buttonies on it and normal jeans.

What famous person would you like to design a T-shirt?
I wish I had the time to design stuff for my two children. I'm not interested in designing stuff for famous people. I'm always happy to see just normal people on the streets wearing my designs. That's what makes me proud.

A message you would like to spread with a T-shirt...
Keep your eyes and mind wide open.

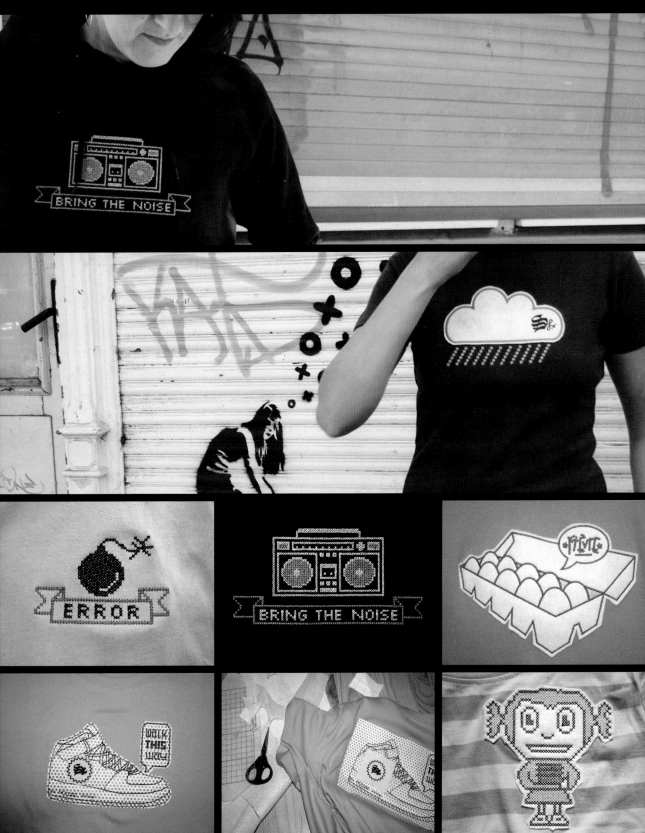

On these pages: eggs design by 39fieber, manga-girl design by Nokopi; all other designs by Elke Riethmüller.

GONZALO CUTRINA is a young freelance illustrator from Barcelona who has been working on an international level since 1999. His projects encompass the worlds of press and publishing, including prestigious fashion magazines the likes of *Vogue* and *Glamour*.

The publicity world is also something for which he has a passion and the reason why he has been involved in numerous publicity campaigns for the Japanese agency Dream and More Tokyo. His works are featured regularly in both private and exhibitions. The summer of 2006 saw the launch of his T-shirt range, of which there are to be two collections each year, each based on a different theme.

Why T-shirts?
I have always been a T-shirt buyer myself and considered them the ideal mainstay for my work.

What was the first T-shirt you designed?
A print designed for a promotional T-shirt and a shopping bag for a chain of stores in Japan.

What are you wearing right now?
A pair of yellow jeans and a ragged white T-shirt (my favorite).

What famous person would you like to design a T-shirt?
Nobody specific, anybody that wears my t-shirts may become famous someday.

A message you would like to spread with a T-shirt...
Sense of humor.

07_Gonzalo Cutrina
www.gonzalocutrina.com
Barcelona, Spain

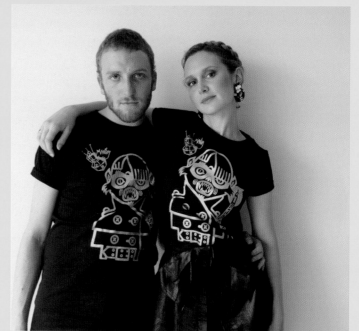

Photo @ Ramiro e

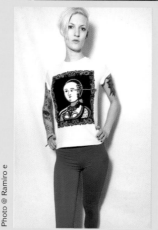

This page: some T-shirts from different collections; right page: Cheeeesse T-shirt.

Dorigato

Hiroshi

Gaston Dj

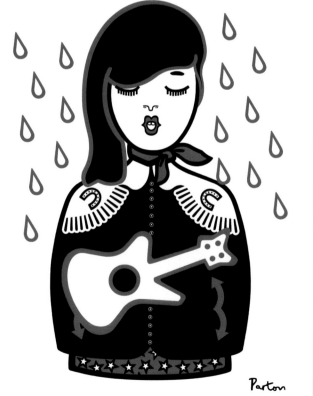

Parton

Designs on these pages from the Rua collection, spring-summer 2006.

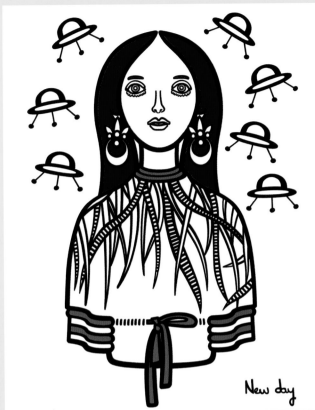

New day

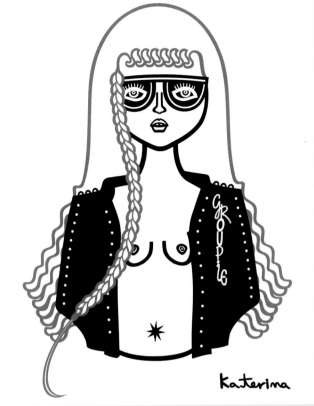

Katerina

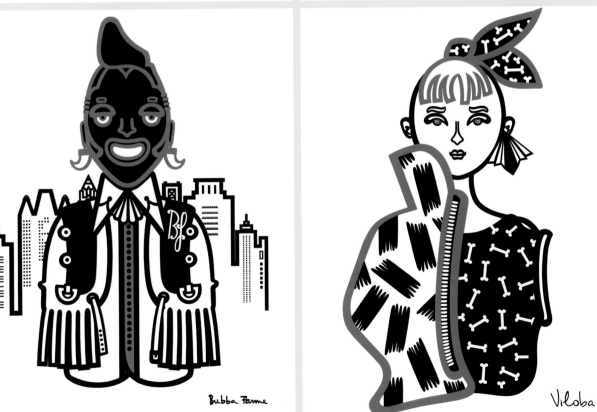

Bubba Fame

Viloba

www.gonzalocutrina.com

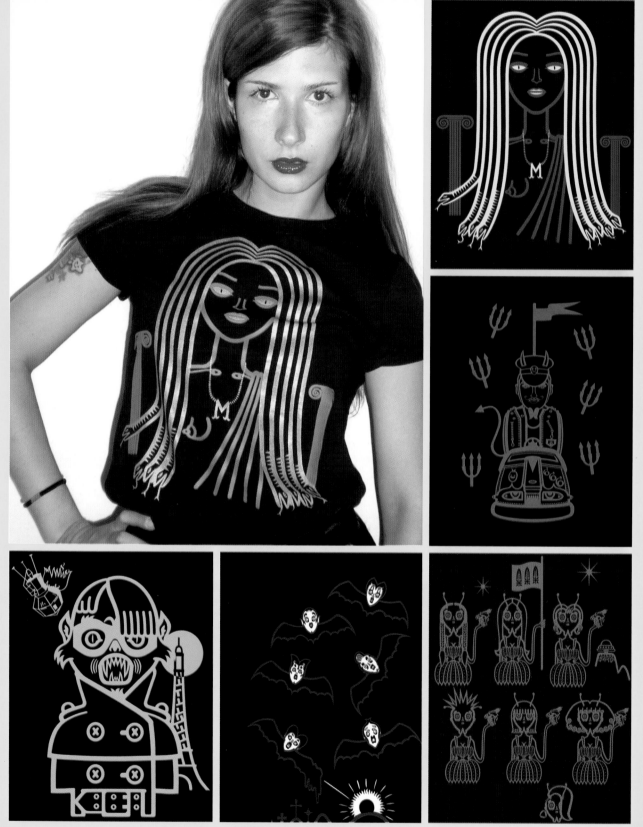

Designs on this page from the Terror collection, fall–winter 2006.

Designs on this page from the We Are Observing You collection, spring–summer 2007, and from Terror, fall–winter 2006.

www.gonzalocutrina.com

In the year 2000, in Kobe, Japan, two friends found a photograph of a girl and a rabbit at a temple market. Her image inspired conversations and ideas about creativity, chance, everyday life, the world and its endless possibilities. WORLD OF FOUND was born to honor the anonymous girl and her rabbit, and simple meetings that happen by chance, not design.

WOF explores creative connections through a core philosophy: By Chance not Design. WOF is based on an attitude of creative equality community, and paying tribute to the world a little Japanese girl opened for us. Join them in the World of Found no matter where in the world you are.

Why T-shirts?

Well a T-shirt is a T-shirt and not a T-shirt at the same time, the same way that a canvas is a painting, something existing in a space somewhere, the intentions of the artist sometimes known and sometimes not. The response from people who view the art varies too. The art also exists in the room or studio when no one is there. For us it's the same: a tee is an idea, a response to something, a canvas you wear, and it reads differently depending on the circumstance, who is wearing it where. We made I Am Not JT Leroy, or the Kate Moss tee way before the stories broke. So people are like "What's that...?" Others already had an idea. Now they become collector pieces. Or Starman. What is a "Starman"? Well it was a song by Bowie many years ago. But it's also something glamorous and distant. Sometimes we all have the I-want-to-be-a-Starman feeling. We say "Andy, give me my 15 Minutes now!" Sure, Warhol said his famous for 15 quote, but now the everyday person sees it as his or her right to have it. Why they want it from Andy we dunno. We can also talk of Baudrillard and Deleuze, and Foucault, and others, but what's the point?

What was the first T-shirt you designed?

It was of a dog with a circle of stars around it. Like the pet or guard dog of WOF. We looked at it recently and we still liked it so much. There was also another tee that combined French, Italian, and Spanish: *Le Mondo Imperfecto*. Funny phrase, don't you think?

What are you wearing right now?

We always work naked or with our super hero costumes on. Sometimes we wear each other's bodies! Today you can play a lottery and guess for yourself.

What famous person would you like to design a T-shirt?

Maybe Shakyamuni Buddha is walking in New York, Barcelona, Rome or Istanbul. I think the word *aware* is written across his chest. Many people pay attention: others don't. Yes, that's sweet.

What message would you like to spread with a T-shirt?

The message we would like to fly the flag for is There Is No Message or You Are The Message, something that can mean a lot to someone or nothing at all. Of course, we have other messages discreetly placed in the form of mantras, signs, and hieroglyphs. We have been around many lifetimes!

Oh yeah! There is another great message we like: "The finger pointing at the moon is not the moon," and of course "Sweet Nothing At All."

All photographs by World of Found.

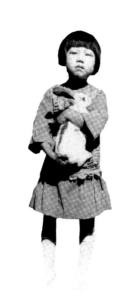

08_World of found
www.worldoffound.com
Barcelona - Milano - Glasgow - Tokyo

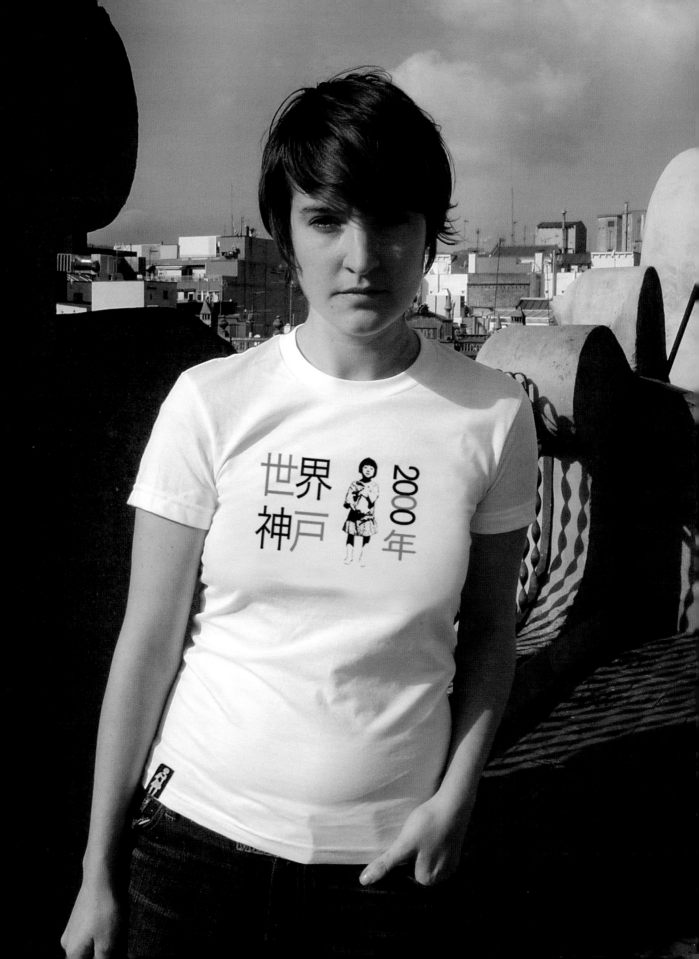

Artwork by World of Found.

Artwork by World of Found.

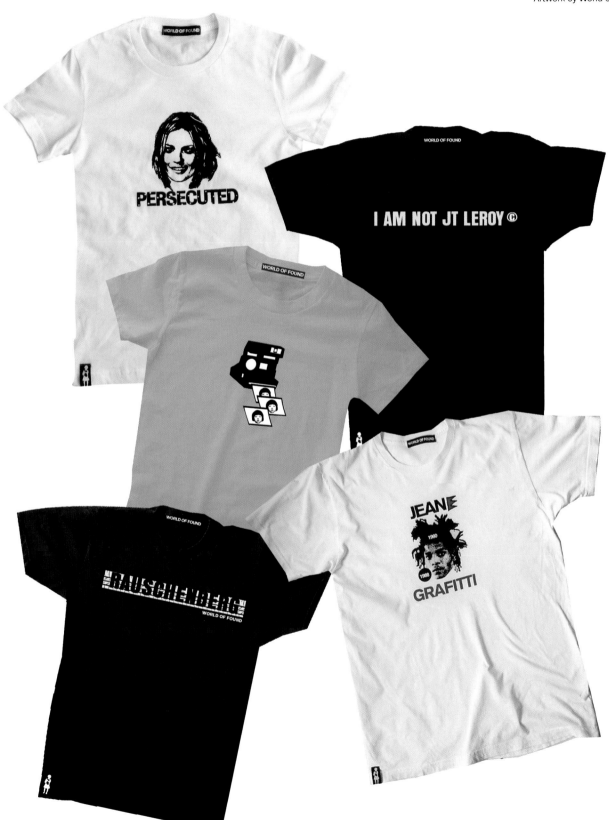

WORLD OF FOUND

NUBIUS is a young design company creating embroide-red T-shirts that has rapidly reached cult status in Barcelona. The designs are geared toward a young 18-60), cosmopolitan, trendy and sensitive public, weary of "hyper-commercialised" brands. Their star garment is the T-shirt but they also do embroidered shirts, skirts, pullovers and sweatshirts, and other items. Nubius has been created by sculptor Nico Nubiola, who, having the expressive potential of embroidery as a technique and the T-shirt as a medium, decided to make history and revive the art of Catalan embroidery. Nubius T-shirts come with body and soul, rhythm and melody, tragedy and comedy, reality and fiction, nature and progress, contemporary and traditional, sea and mountain, drum and bass, Mortadelo & Filemón. At Nubius the message is treated with the same respect as any "art and literary" film.

Why T-shirts?
The T-shirt displays a slogan, a motto ór a message, and this is something new in the history of apparel.

What was the first T-shirt you designed?
At 15 I created a screen printing of an aircraft landing and a woman saying "take off." My brother and i attempted to sell the T-shirts on the beach just like those who go round selling drinks.

What are you wearing right now?
I'm wearing a T-shirt from a friend's shop in Portland: Missing Link.

What famous person would you like to design a T-shirt?
Alvaro Vitali.

A message you would like to spread with a T-shirt...
My message isn't exactly overt and might be classed as banal criticism.

www.nubius.es
Barcelona, Spain

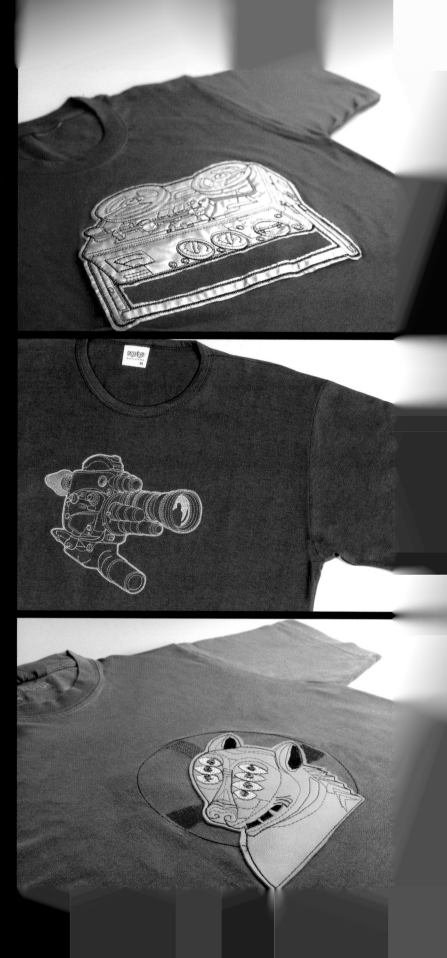

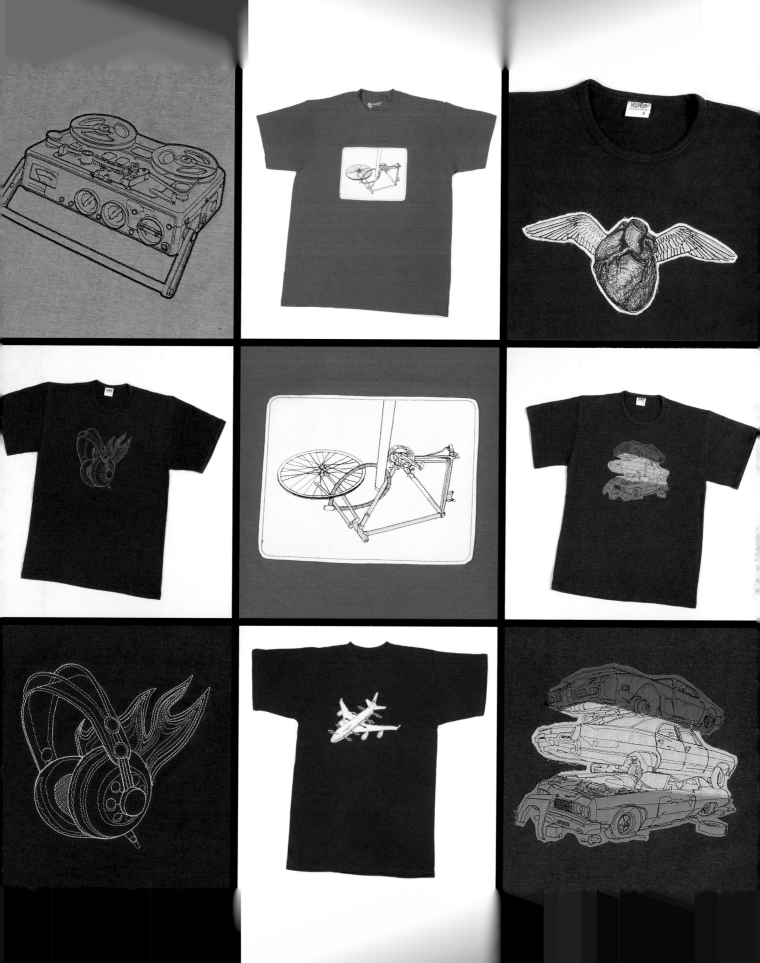

MILLIMETREKILOKITRE is a joint venture of two lonely designers in London who met in the computer lab at college. MilliMetreKilokitre documents moments that cannot be calculated but condition our existence. The duo initially made seven T-shirts and accompanying artworks, and suddenly found their way to do installations and shows at Levi's concept stores, NIM Paris, and CINCH London. Soon after, the label *T-Book* was born, and they expanded the concept into an apparel collection.

T-Book wears emotions, expressions, statements and visions. It is a T-shirt publication that expresses, the quirkiness of human conditions and feelings. As a hybrid medium of fashion and print, *T-Book* merges what's on a page and what's on a t-shirt. While the pages of a book are bound together by a bind, their T-shirts are bound by graphic elements that often whisper romantic narratives.

Why T-shirts?
When we started it was just an idea out of boredom. I wanted to make a book and my partner-in-crime wanted to make t-shirts. So we thought of making one in both mediums. I guess it all made sense in our heads. T-shirt, a blank canvas, is the most basic wearable form. The next question is whether you want to wear clothes or wear statements. In our case, we find statements through putting messages on clothes.

What was the first T-shirt you designed?
Crush 001, a poem to begin our book. Crush was the perfect theme to begin our book making/love making. After the poem, most designs were born to make up the issue. We printed that with a tomato red, on a pink tee, and then enzyme washed the tee.

What are you wearing right now?
I'm wearing a stripey woolie jumper my mum bought me. A checkered cropped jacket I got made, three-quarter-legged trousers, and black and white brogues.

What famous person would you like to design a T-shirt?
The Queen.

A message you would like to spread with a T-shirt...
All you need is love.

T-shirt I Spy with My Little Eye from the first issue, CRUSH.

10_T-Book
www.t-book.co.uk
London, UK

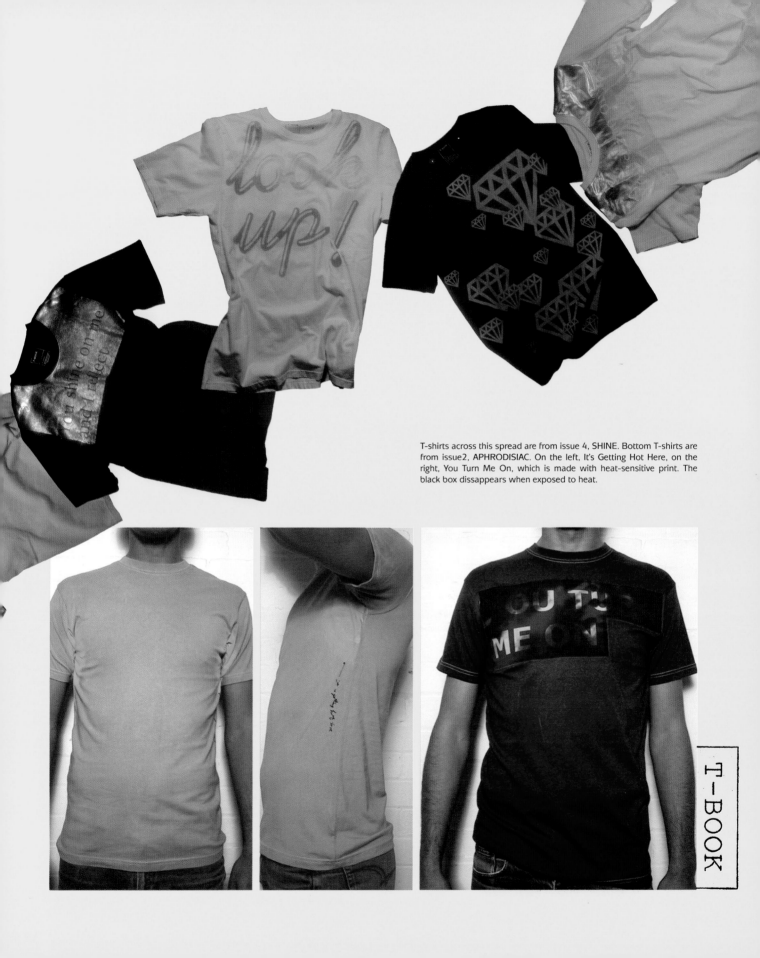

T-shirts across this spread are from issue 4, SHINE. Bottom T-shirts are from issue2, APHRODISIAC. On the left, It's Getting Hot Here, on the right, You Turn Me On, which is made with heat-sensitive print. The black box dissappears when exposed to heat.

T-BOOK

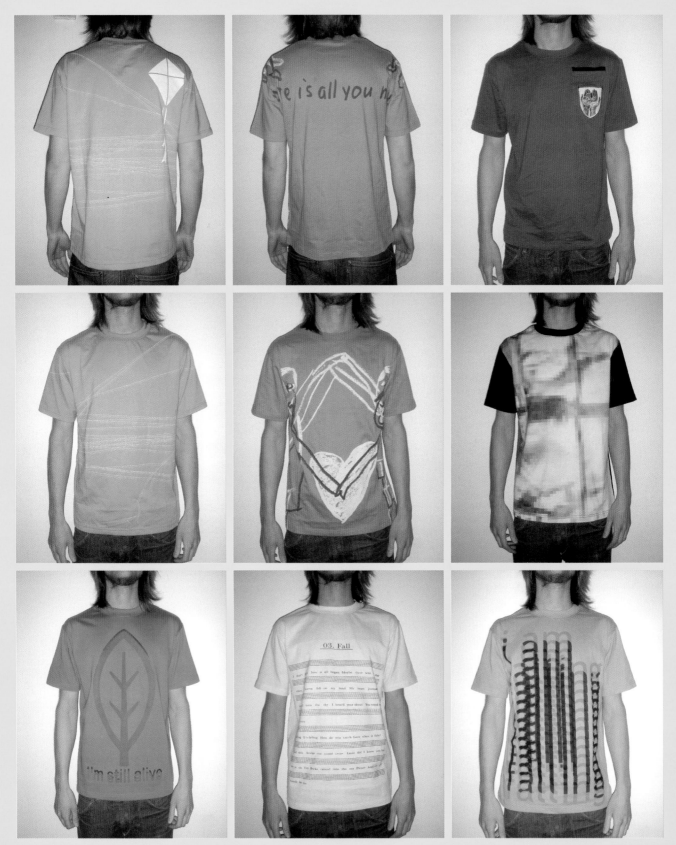

T-shirts on this page from issue 3, FALL.

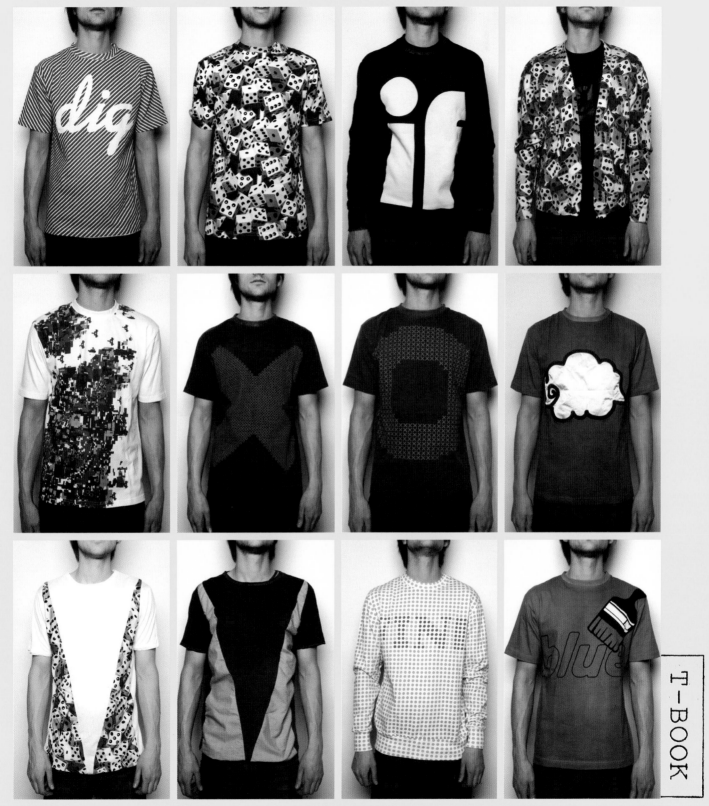

T-BOOK

T-shirts on this page from issue 6, IF.

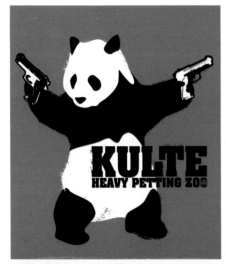
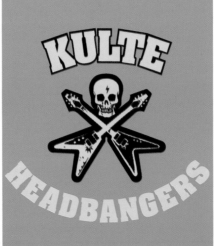
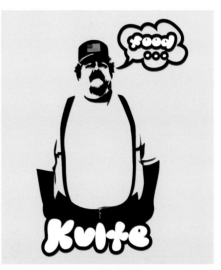

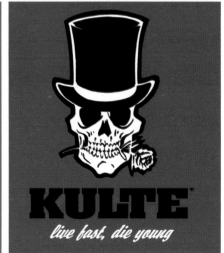

11_Kulte

www.kulte.fr
France

In 1995, a vintage clothing store called KULTE opened in Paris. The shop was the brainchild of three friends, and it became a laboratory for studying customers' needs and wishes. One year later, during a trip in Thailand, one of the Beastie Boys gave his dragon shirt to one of them. Sensing the commercial potential of the product, the friends decided to return to Thailand in 1998 and find the shirt's manufacturer. The stock they imported was sold rapidly. Building on its success, the friends began designing and selling shirts, T-shirts and sweatshirts adorned with kung fu symbols, fictional cult heroes like Rocky Balboa, and the Z-boys, and graphics from '70s and '80s TV shows such as *Degrassi*, *Starsky and Hutch*, *The A-Team*, and *Knight Rider*. The year 2005 was when the big bang happened. The founder of Kulte, Serge Bordonaro, met Michel Gamet. Serge was tired of the whole fashion industry, and Michel had just ended 10 successful years with the brand VOLCOM. Straight away, they both understood that the destiny of Kulte would belong to the mix of their two cultures: fashion and board sports.

Why T-shirts?
When it comes to men's fashion, the T-shirt is essential. If you reduce men's fashion to the essentials, T-shirt will remain as a top. You can wear a t-shirt under all circumstances, to do sport or for a wedding. Rare are the men who never wear a T-shirt.

What was the first T-shirt you designed?
A bloke riding a motorbike with sunglasses, moustache, big muscles and a girl on the back. The tee was saying: "Patrick is a connoisseur, he's wearing a Kulte T-shirt, the T-shirt that attracts the woman".

What are you wearing right now?
I'm wearing a shirt actually. Ha ha ha...

What famous person would you like to design a T-shirt?
The King: Elvis Presley, there would be so much to do.

A message you would like to spread with a T-shirt...
Make love, not war.

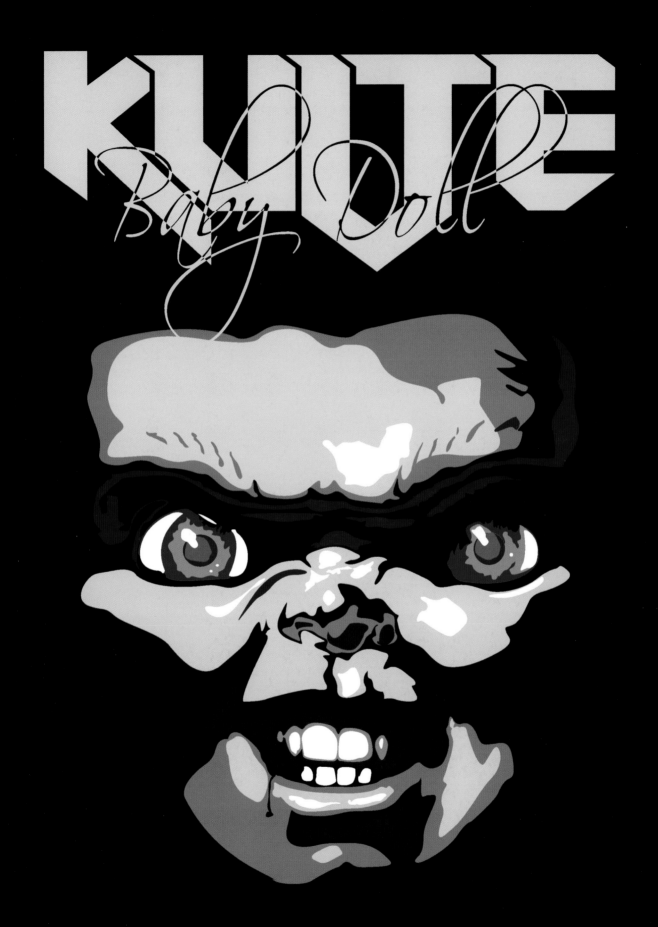

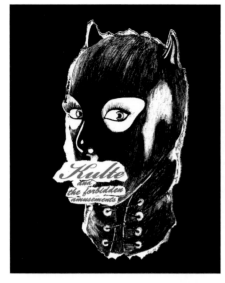

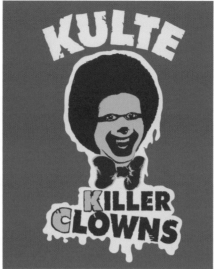

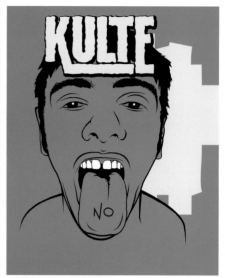

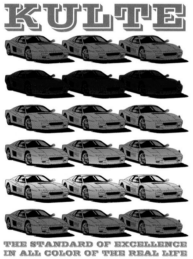

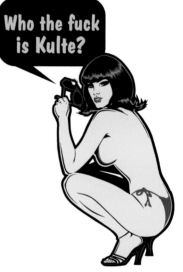

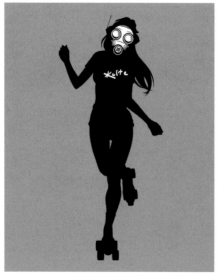

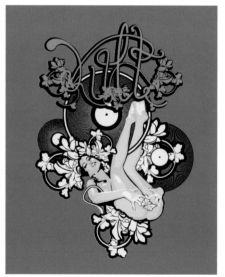

All artwork by Kulte.

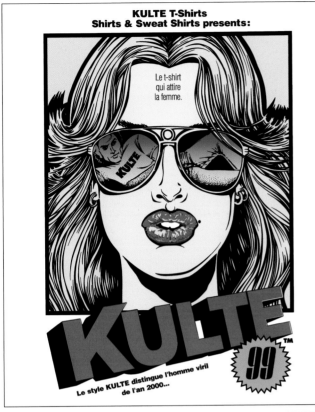

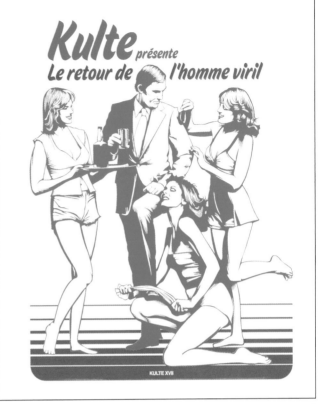

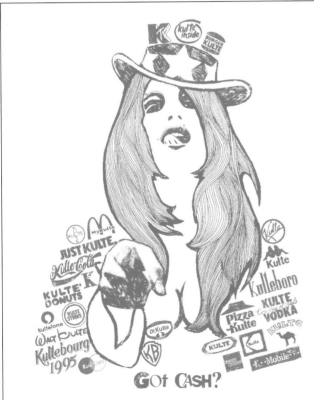

All artwork by Kulte.

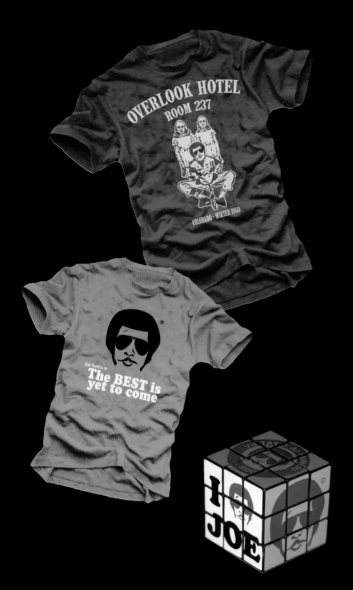

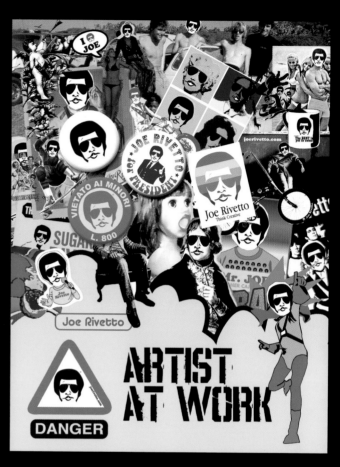

12_ Joe Rivetto

www.joerivetto.com
www.myspace.com/joerivettoparty
Italy

JOE RIVETTO launched his namesake brand back in 2003, his dream being to establish his own creativity factory. He initiated an all-encompassing project in which irony was to be the main thread of communication. The T-shirt was to become the principal mechanism by which to spread the word via the Joe Rivetto slogan: The Best Is Yet To Come. More than 400 T-shirts were manufactured in the first four years alone. They all had different designs and sported terribly ironic messages on the worlds of fashion, sports, art, politics, and society. The brand can be seen at all the world's major fashion tradeshows such as Pitti Immagine Uomo (Florence, Italy) or Bread & Butter (Barcelona). Joe Rivetto's idea factory doesn't stop at T-shirts, also having created an art gallery dedicated to the purest of pure art.

Why T-shirts?
The T-shirt is a powerful communication medium able to transmit a wide range of emotions: rage, hate, love, provocation, and so on.

What was the first T-shirt you designed?
"The best is yet to come" T-shirt.

What are you wearing right now?
I wear anything that makes me feel good.

What famous person would you like to design a T-shirt?
Leonardo da Vinci, but I believe it would be a little difficult. Joking apart I would be very happy to be able to design for Bansky, a true genius in stencil art and in making statements.

What message would you like to spread with a T-shirt?
The best is yet to come! Peace!

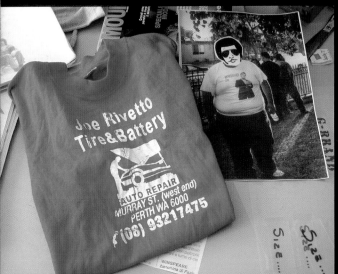

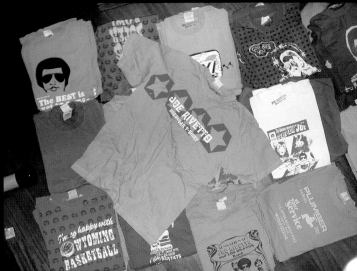

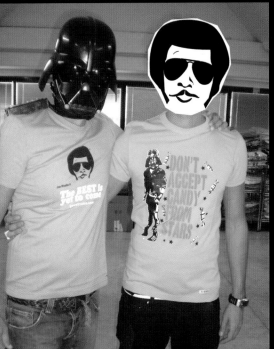

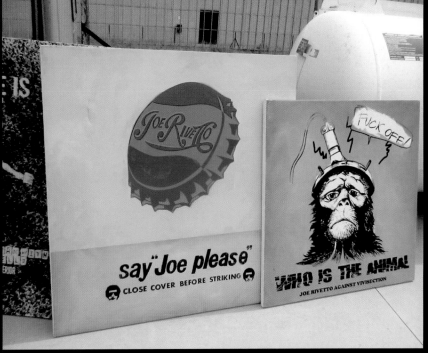

All images courtesy of Joe Rivetto.

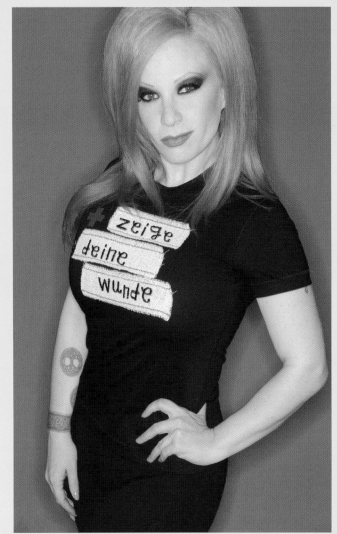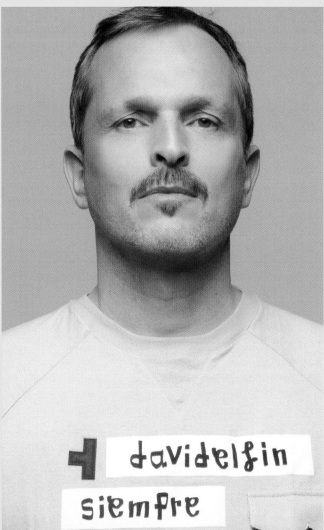

All photographs by Gorka Postigo.

13_ Davidelfin

www.davidelfin.com
www.myspace.com/davidelfin
Madrid, Spain

DAVID DELFÍN is one of the leading designers on the Spanish fashion scene. In September 2001, together with some friends, he launched the nationally successful Davidelfin brand, whose fashion shows have gone from controversial to award winning. Davidelfin is rather more than a clothing manufacturer, perceiving fashion as a means of artistic expression. A second Davidelfin line called DA has now been launched, with five new lines: Left Hand, Midnight, Lifting, Deconstruction, and Déménagement, these icons being the hallmark of the Davidelfin prêt-a-porter collection. T-shirts, sweatshirts, jackets, and accessories adorned with felt crosses, military aesthetics, embroidery and bandages, designed for men and women with enquiring minds.

Why T-shirts?
Because this is our daily apparel.

What was the first T-shirt you designed?
Originally a recycled military T-shirt over which three white stripes were painted in acrylic paint. The words *zeige deine wunde* were written on the stripes in black marker. Then, a red felt cross was sewn as the final touch. The T-shirt was designed to respectfully pay homage to the life, philosophy and the work (isn't it the same thing?) of Joseph Beuys.

What are you wearing right now?
White socks.

What famous person would you like to design a T-shirt?
Louise Bourgeois.

A message you would like to spread with a T-shirt...
"The virtuous man is content to dream of what the wicked man does with his life." Plato.

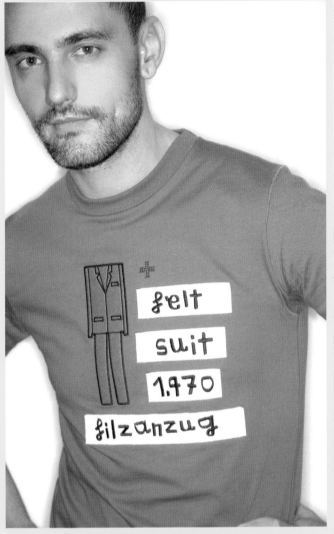

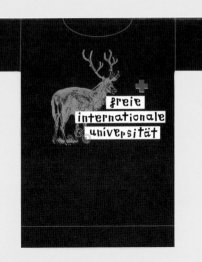

davidelfin

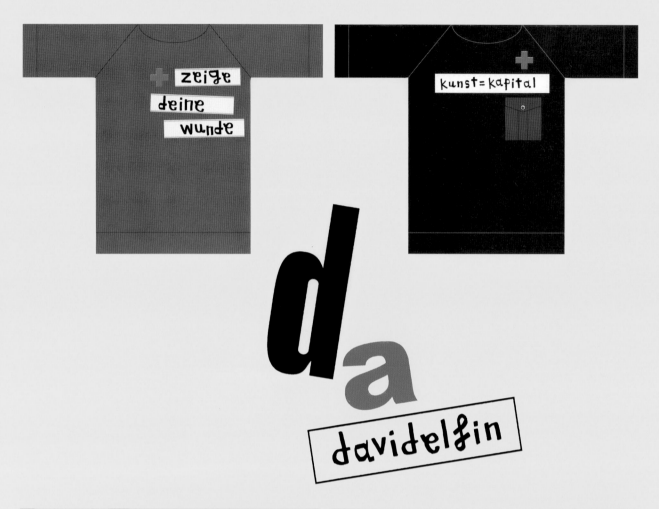

All artwork by Davidelfin.

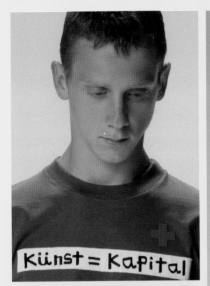

Künst = Kapital

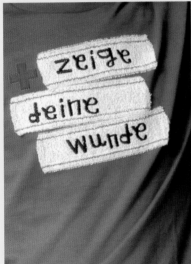

zeige deine wunde

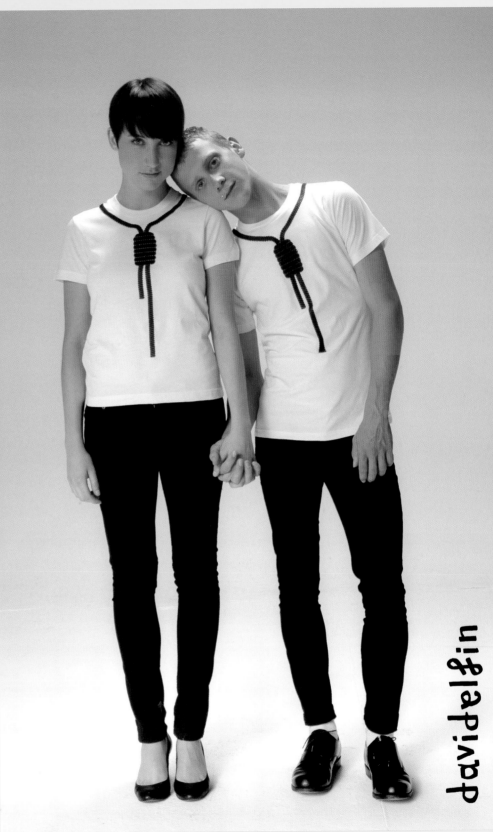

davidapap

All photographs by Gorka Postigo.

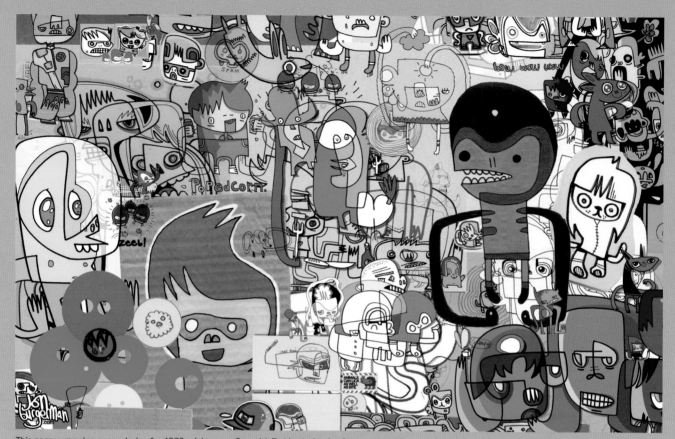

This page: wrapping paper design for 1973; right page: Smactick T-shirt design for Concrete Hermit.

14_ Jon Burgerman

www.jonburgerman.com
Nottingham, UK

JON BURGERMAN draws, paints, clicks and sleeps. There is a very British sense of self-deprecation, humor and anxiety in his work. Burgerman's artwork has been widely exhibited in great cities such as New York, Los Angeles, London, Hong Kong, Paris, Melbourne, and Derby. Over the years his characters and art has adorned bags, books, belts, snowboards, skateboards, surfboards, ice-cream trucks, lunch boxes, stickers, posters, collectable toys, computer games, exhibitions, mobile phones, clothing, cushions, mugs, wrapping paper, record covers, and frisbees.

Burgerman received a D&AD Silver award nomination for his work for Levi's and has worked on big projects for many high profile organizations. Some of these include: The Science Museum (UK), The BBC (UK), SONY (worldwide), KidRobot (worldwide), *The Sydney Morning Herald* newspaper (Australia), MTV (Worldwide), Pepsi (USA), Coca-Cola (worldwide), 55DSL (UK), Gortex (Europe), Crown Creative Inc. (Japan), NookArt (Australia), Snickers (UK), Miss Sixty (Italy), Rip Curl (worldwide), and Symbian (worldwide). He also designed a special air sickness bag for Virgin Atlantic flights.

Burgerman currently lives in Nottingham, in the East Midlands of the UK, which is famous for lace production and Robin Hood. When he is not creating artworks he likes to stay in bed and dream of large, tasty cakes.

Why T-shirts?
T-shirts are a very immediate form. They allow for easy and open communication of graphic forms.

What was the first T-shirt you designed?
One called Devil Pet. It was a yellow outlined drawing on a red tee.

What are you wearing right now?
A mutlicolored cardigan.

What famous person would you like to design a T-shirt?
Someone I'd like to design a tee? Hmm, I don't know, every famous person I can think of is boring.

A message you would like to spread with a T-shirt...
Salads are the new steaks.

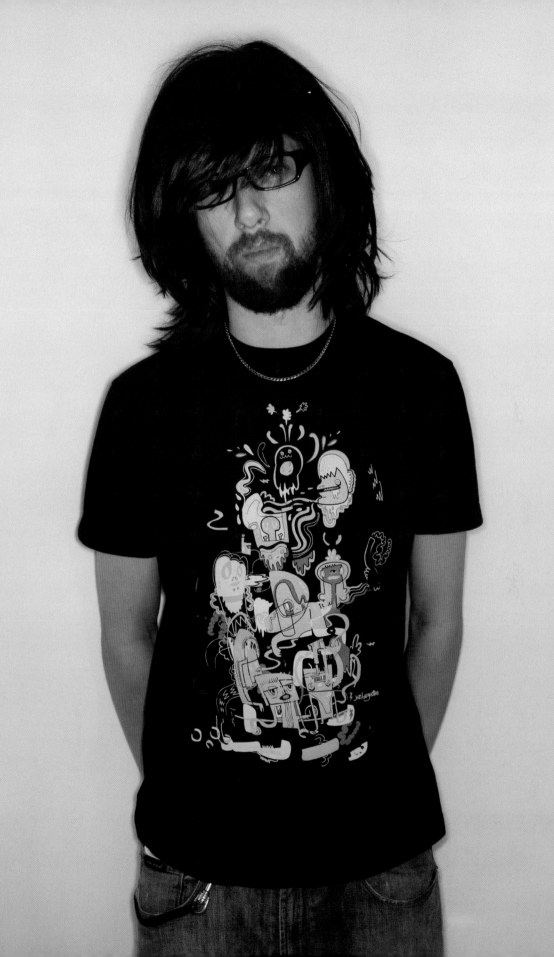

This page: Isodope T-shirt design for Concrete Hermit. Next page: top left, poster for Candy Sweet Talk event, Dublin; bottom left, Delete T-shirt design for I Dress Myself; middle right, Dual Canvases, private painting commission; bottom right, Smactick T-shirt design for Concrete Hermit.

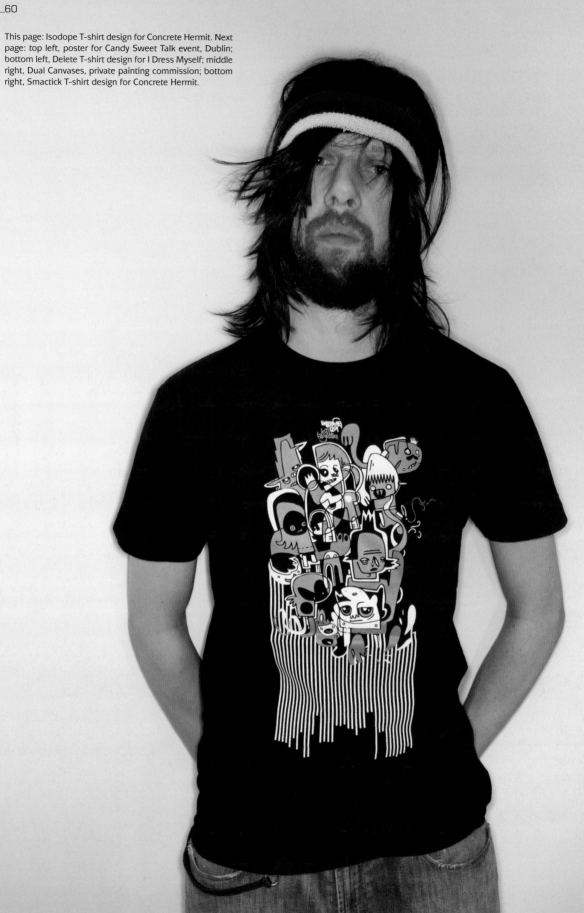

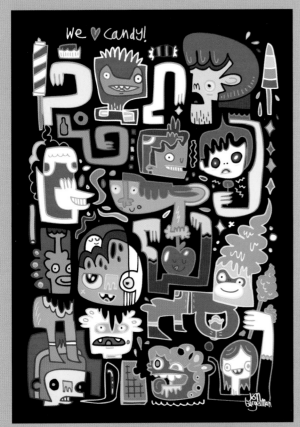

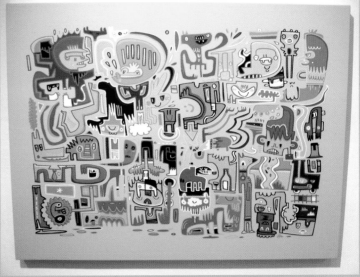

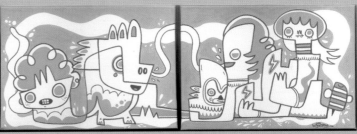

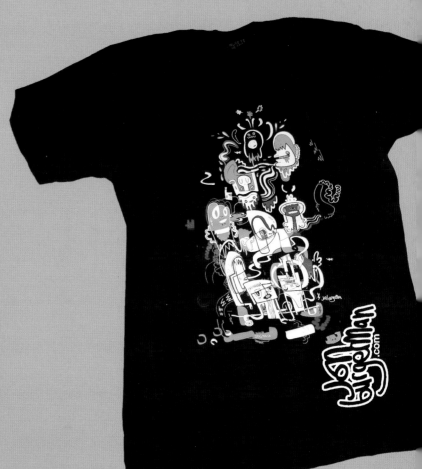

All images courtesy of Jon Burgerman.

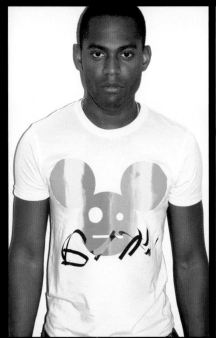
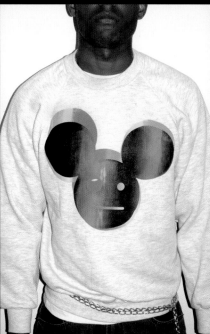
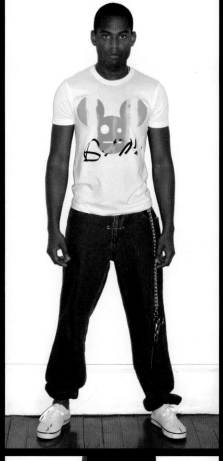

The work of Vier5 is based on a classical notion of design as the possibility of drafting and creating new, forward-looking images in the field of visual communication. A further focus of their work is designing and applying new, up-to-date fonts.

The work of Vier5 aims to prevent any visual empty phrases and to replace them with individual, creative statements, which were developed especially for the medium used and the client.

Why T-shirts?
Why not?

What was the first T-shirt you designed?
It is better not to describe it! It was for a high school graduation party. You know this kind of T-shirt? You don't need a description for this. When you see it, you know why.

What are you wearing right now?
We never wear T-shirts. We just wear shirts. Mostly white or with stripes. Very classic. We think others look much better in T-shirts than we do. But we look perfect in shirts.

What famous person would you like to design a T-shirt?
We think democratic, for us, famous people don't exist.

A message you would like to spread with a T-shirt...
There is not a message on the T-shirt. The message is in the body behind. But the T-shirt can help you in every situation.

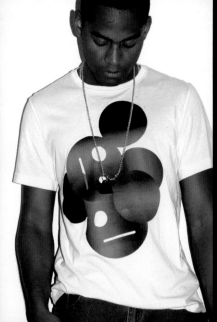

15_ Vier5

www.vier5.de
Paris, France

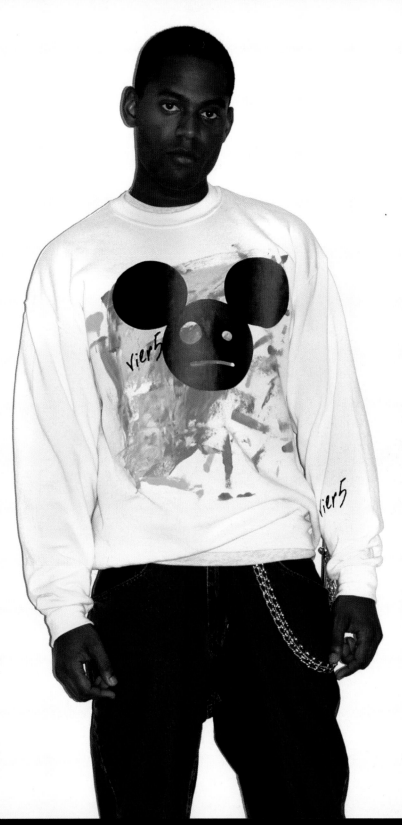

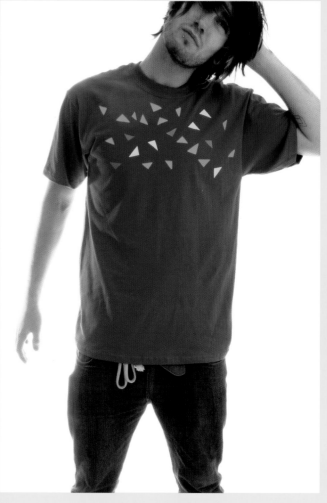

All photographs by NHRB.co.uk.

16_ Me&Yu

www.meandyu.com
www.myspace.com/lovemeandyu
Manchester, UK

ME&YU is the collaboration of Angela Hulme and Gordon Cullerne. The two offer original and one-off designs straight from their workshop at their home in Blackpool. They specialize in hand-made and hand-printed menswear and womenswear designs available through them directly at Manchester Fashion Market, Liverpool Heritage Market, the Me&Yu online boutique, and at their small store at Afflecks Palace, Manchester.

Clothing from Me&Yu is also available at a small number of boutiques in the Northwest. Gordon and Angela between them have a background in fashion, graphics, art, and photography. Both menswear and womenswear from Me&Yu combine bold colors and strong graphic elements in a range of casual, streetwear influenced clothing.

Why T-shirts?
Everybody wears T-shirts. It's a very accessible way to display art, and if I'm honest I am constantly disappointed with the the amount of crap designs out there, so we've taken it upon ourselves to increase the amount of good stuff.

What was the first T-shirt you designed?
When I first discovered T-shirt transfer paper (about 8 years ago) I made myself a tee that read "Would you die for rock'n'roll?" in a vag rounded font.

What are you wearing right now?
One of our new acid vinyl thunderbolt sweatshirts (it's winter in the UK, too cold for T-shirts).

What famous person would you like to design a T-shirt?
Noel Fielding / Vince Noir (The Mighty Boosh).

A message you would like to spread with a T-shirt...
Me&Yu forever.

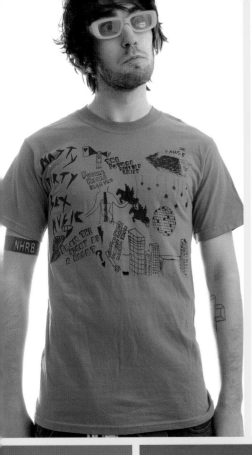
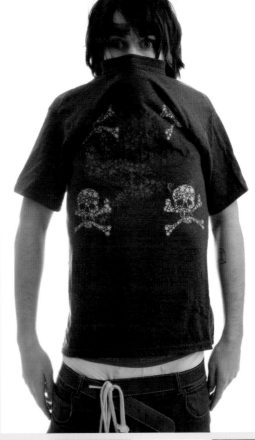

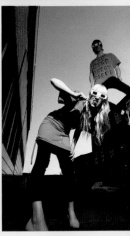

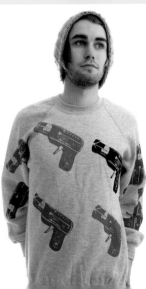

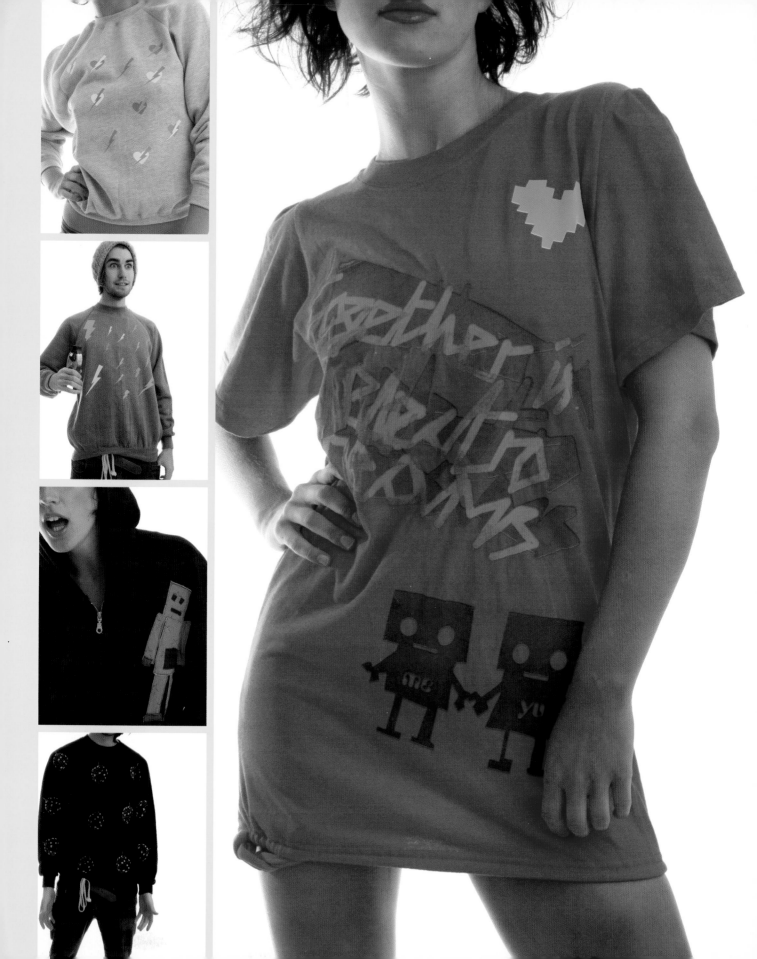

Only a limited number of each design are made, and no two are ever exactly the same. Each garment has special finishing touches like hand embroidery, vintage trims, appliqué, printed pictures, and messages.

me&yu

All photographs courtesy of Threadless.

17_Threadless

www.threadless.com
Chicago, USA

THREADLESS is an ongoing T-shirt design competition. Four to six designs are chosen every week from more than 600 submissions to be printed and sold from the site. The winning designers also receiving $2,000 in cash and prizes. The project was started in January of 2000 by two Chicago area designers, Jake Nickell and Jacob DeHart. Since, then over 450 winning designs have been chosen for print from more than 60,000 submissions. The Threadless community is thriving with over 300,000 users signed up to score designs. Average, 3,000 new designers sign up every week.

Why T-shirts?
T-shirts are the perfect medium for illustration. They're accessible and everyone loves a tee!

What was the first T-shirt you designed?
Well, technically I've only designed one tee for Threadless. All of our tees are designed by people in our community and then submitted to our site. The T-shirt I did pales in comparison to the level of work produced by Threadless contributors.

What are you wearing right now?
Right now I'm wearing a Google T-shirt that our friends at Google sent over. I'm so ashamed! I should probably be wearing a Threadless tee for this interview!

What famous person would you like to design a T-shirt?
I'd love for Frank Gehry to design a tee for us. In my opinion, he's one of the most important artists alive today, and I'd love to see what he could do with a tee.

A message you would like to spread with a T-shirt...
We don't really have a message per se, but we would really like to push the point that a T-shirt can be for anyone, for any time, for any occasion and used in such a multitude of ways — showcasing art, sharing an opinion, or simply just as a fashion statement.

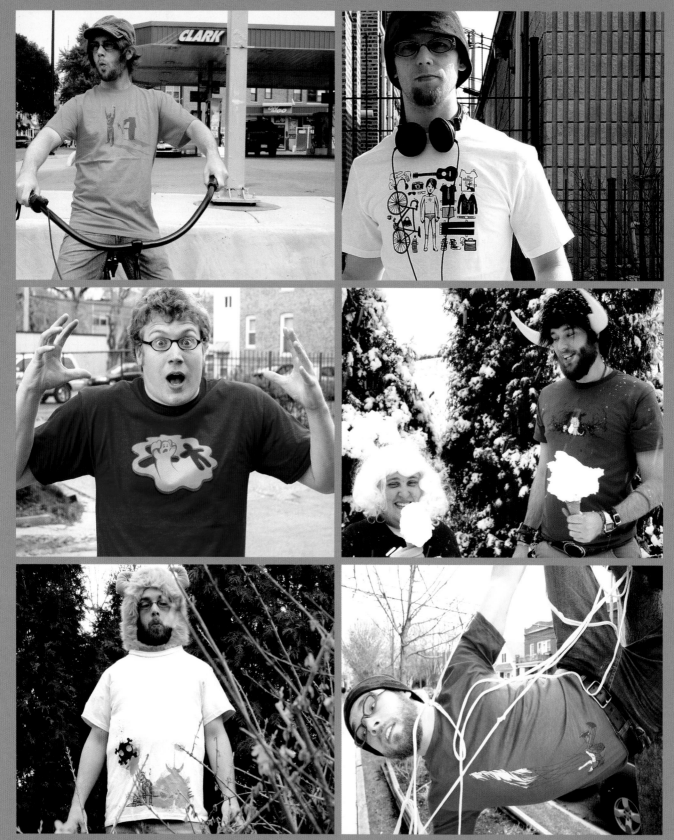

All photographs courtesy of Threadless.

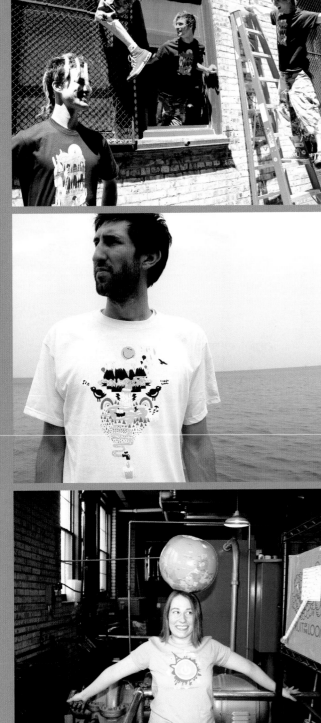

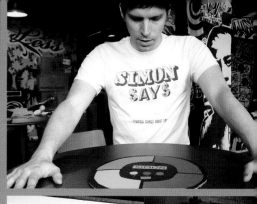
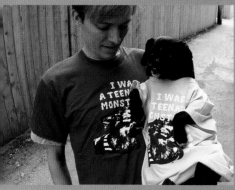

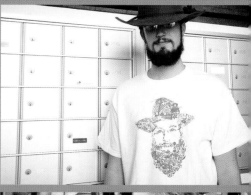
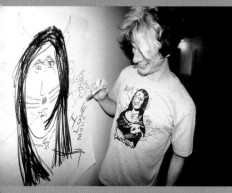

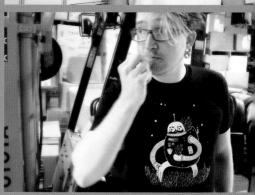
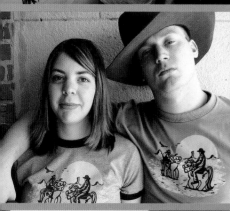
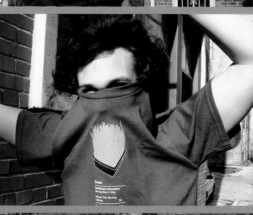
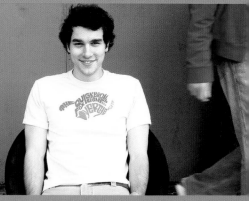

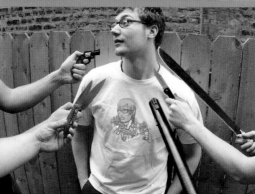
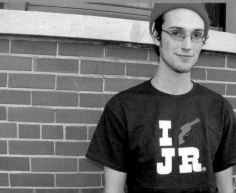

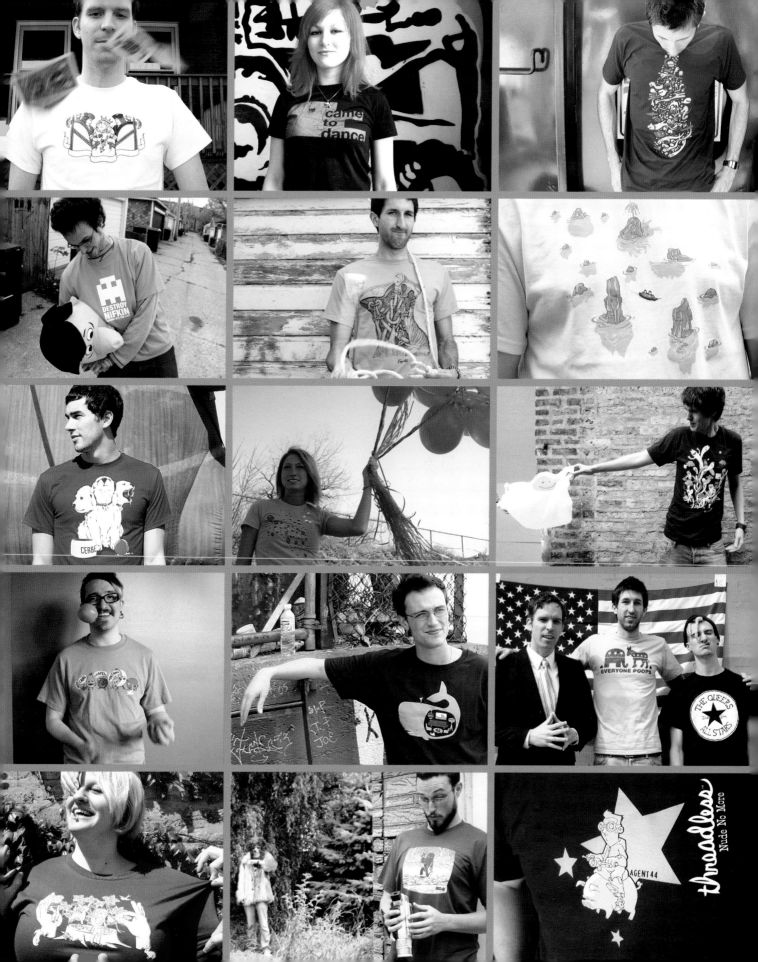

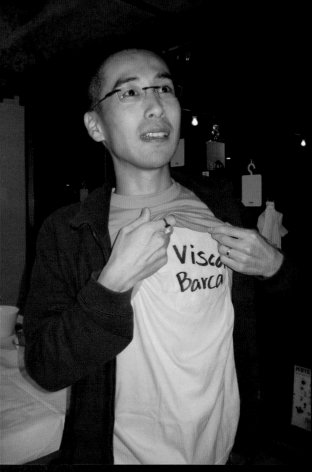

This page: Trico T-shirt collection produced by Trico and designed by Martí Guixé. If the goal of a T-shirt is to express your opinion, the best is to write it on —thinking it, saying it, or screaming it.

All photographs by ImageKontainer.

18_ Martí Guixé

www.guixe.com
www.buyguixe.com
www.collectguixe.com
www.ex-designer.com
www.food-designing.com
Barcelona and Berlin

MARTÍ GUIXÉ began in Barcelona and Milan as an interior and industrial designer. In 1994, periodically working as a design advisor in Seoul and living in Berlin, he formulated a new way to understand the culture of products. Guixé started to exhibit his work in 1997, work that focuses on the search for new product systems, the introduction of design in food, and presentation through performance.

His unconventional gaze provides brilliant and simple ideas of a curious seriousness. He is based in Barcelona and Berlin and works as an executive designer for companies such Authentics, B-Sign, Camper, Cha-cha, Desigual, Droog Design, Esencial mediterrá-neo, Imaginarium, Isee2, Nani Marquina, Very Lustre and Saporiti.

Why T-shirts?
T-shirts are a good platform! The value of the T-shirt is no longer in the object but in the message.

What was the first T-shirt you designed?
In 1999, i did several T-shirts promoting Barcelona as a place to drink and party. Instead of the word *Barcelona*, i used *Bar-zona*.

What are you wearing right now?
45 rpm black T-shirt.

What famous person would you like to design a T-shirt?
Karl Marx.

A message you would like to spread with a T-shirt...
That a T-shirt is like a canvas.

Martí Guixé

This page: Social Texture T-shirt collection produced by Cha-Cha
and designed by Martí Guixé.

The GORI DE PALMA brand was originally launched in 2004 at the Salon Gaudí (Barcelona Fashion Week) with the Confusion collection, based on recycled Levi's 501s. Shortly afterwards came the black trilogy, three collections linked by the color black: Die Rote Rechte Hand, Fade to Black and Fallen Women. Gori is inspired by rock and roll, punk, and subcultures, and movements such as bondage and sadomasochism. Aside from his own collections Gori has also worked with artist Manual Albarrán and music group Glamour to Kill and has also been involved with making various videoclips. His collections have been featured in numerous shows such as Pasarel.la Barcelona, Círculo de Belles Artes de Madrid, BAC, Eurobijoux, Mid-E Bilbao, Murcia Joven, La Santa Proyectos Culturales, Fame, El Ego de Pasarela Cibeles, FAD, Changing Room, TG in London, Düsseldorf Textile Fair, NIPI Milan, and Bread & Butter in Barcelona and Berlin.

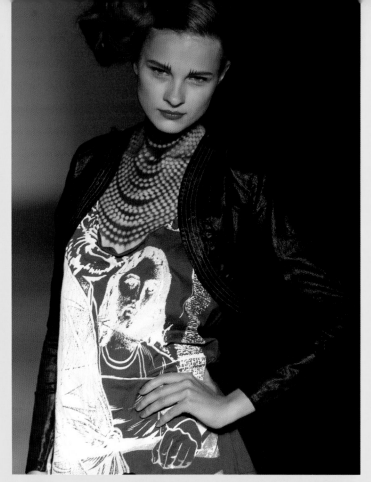

Why T-shirts?
Because a T-shirt is a plastic support of direct action, it is also the manifestation of ideas, social and personal worries, a sense of humour, reflection, and a noncomformist element to criticisim.

What was the first T-shirt you designed?
It was a hand serigraphied gun with a Christ on it, and the phrase "Reza lo que sepas" (Pray what you know).

What are you wearing right now?
A T-shirt from the last Gori de Palma collection, "Amante, Querida, Puta." It is a collaboration with American Apparel and Manuel Pazo. And some Chanel n° 5 perfume drops.

What famous person would you like to design a T-shirt?
Jean-Michel Basquiat.

A message you would like to spread with a T-shirt...
Two messages:
1. Concept, attitude, and style.
2. Bankruptcy.

19_Gori de Palma

www.goridepalma.com
www.myspace.com/goridepalma
Barcelona, Spain

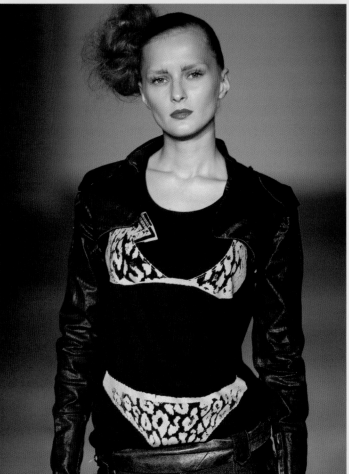

All photographs by Gustavo López Mañas except catwalk photographs by Ugo Camera, courtesy of Gori de Palma.

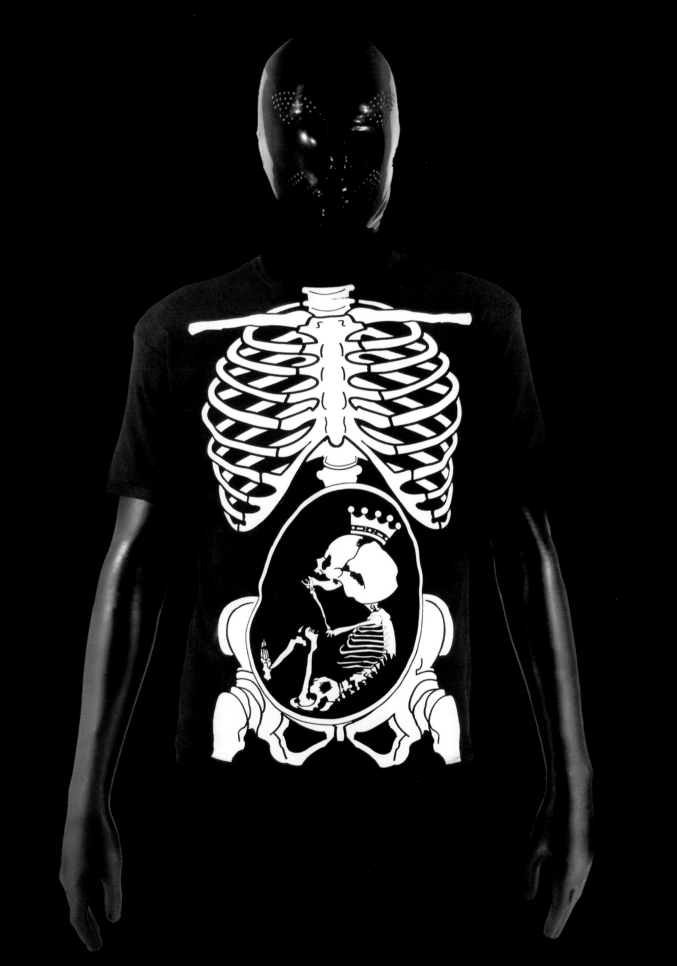

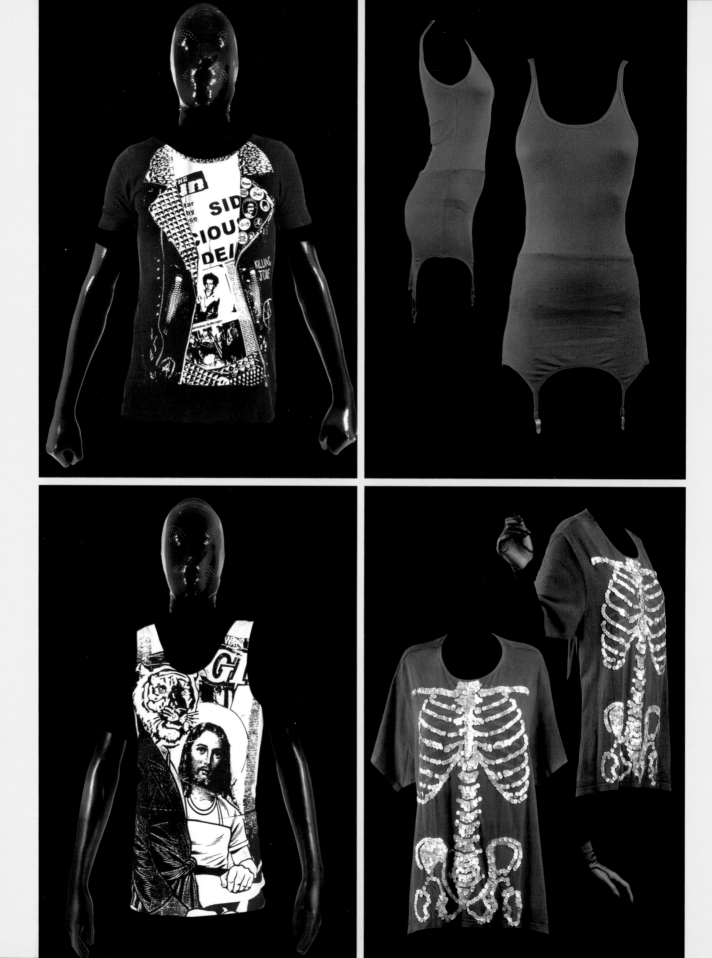

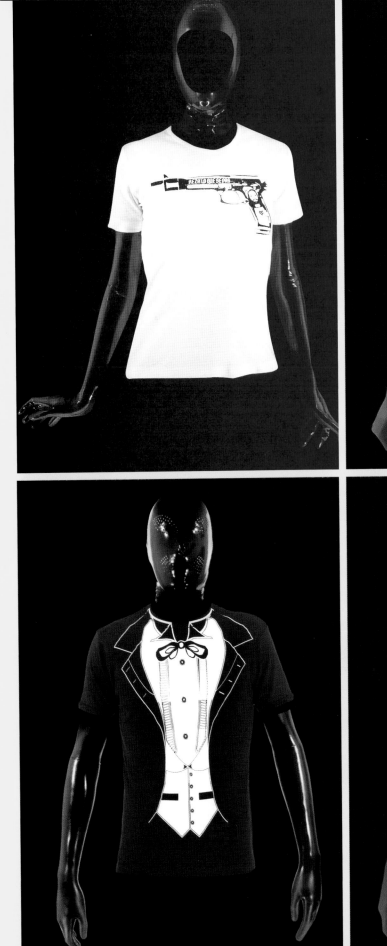
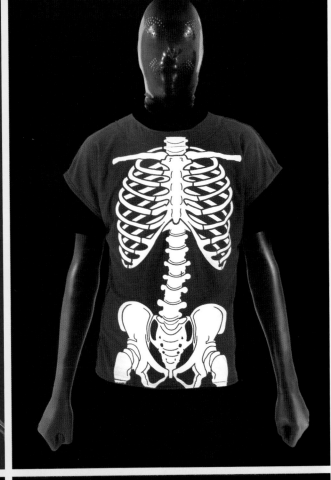
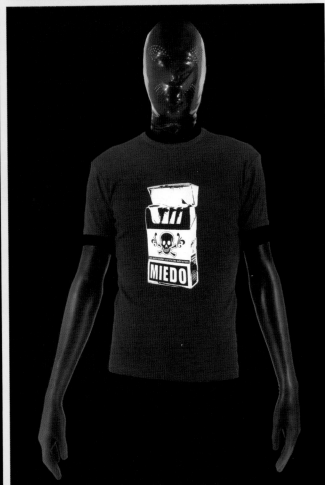

BASQUIAT,
BARNEY,
CATTELAN,
CHAPMAN,
DE PALMA,
HIRST,
KOONS,
LEMPICKA,
PAZO,
PETTIBON,
PIPILOTTI,
SHERMAN.

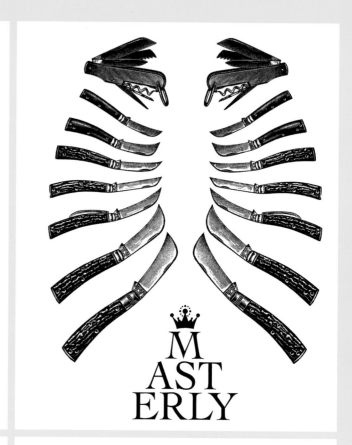

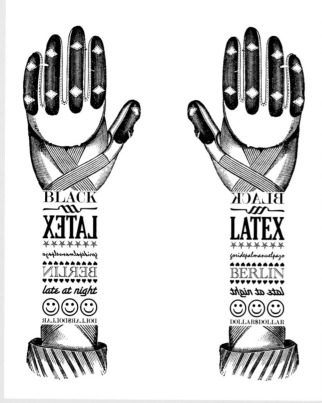

This page and next: T-shirt graphics for fall/winter 2007-2008
in collaboration with Manuel Pazo.

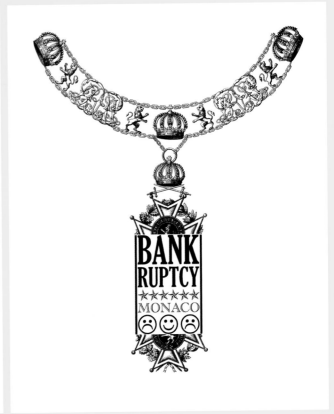

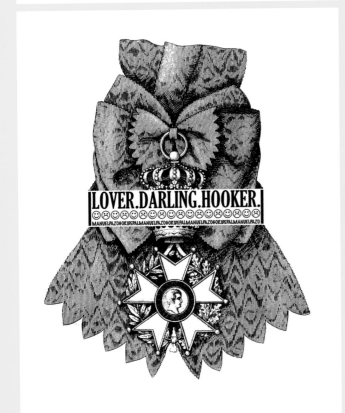

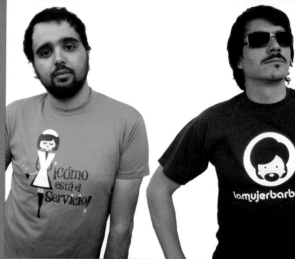

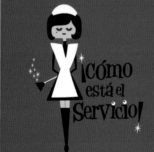
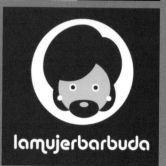

All images courtesy of La Mujer Barbuda.

20_La Mujer Barbuda

www.lamujerbarbuda.com
www.fotolog.com/mujerbarbuda
Sevilla, Spain

The brand LA MUJER BARBUDA ("the bearded woman") is actually David Rodríguez (Davis) and Armando Jiménez (Mandi). LMB came into being at the beginning of 2005 when the men decided to create an Internet portal as a means of advertizing their designs. Both had past experience in the field of graphic design and shared common anxieties and passions: pop culture, the circus, Freak shows, trash culture, and heroic movies. It was therefore a question of trying to work side by side without dying in the process. They began by designing T-shirts for pure entertainment. With the success of their first collection they soon expanded the catalog and began to publicize the web page on the Internet sites most likely to attract the public they were aiming for. Apart from direct sales on the internet, through their web page they also supply other clothing, music, and accessory outlets at music festivals throughout Spain. LMB pays special tribute to bearded women the world over, to the *Divine*, *yé yé* movies, and to what's still to come.

Why T-shirts?
Worn by the entire world, these are universal garments, inexpensive little works of art. Everybody wants to be seen wearing the most original T-shirt of the night!

What was the first T-shirt you designed?
A T-shirt from the Japanese Comando G collection ("The Battle of the Planets") hand painted as a youngster (Davis), and a T-shirt with deformed foetuses inspired by H.R.Giger (Mandi).

What are you wearing right now?
Nothing but our I Love Freaks T-shirt.

What famous person would you like to design a T-shirt?
John Waters! (Davis); Mink Stole! (Mandi).

A message you would like to spread with a T-shirt...
Bearded women of the world, don't ever shave!

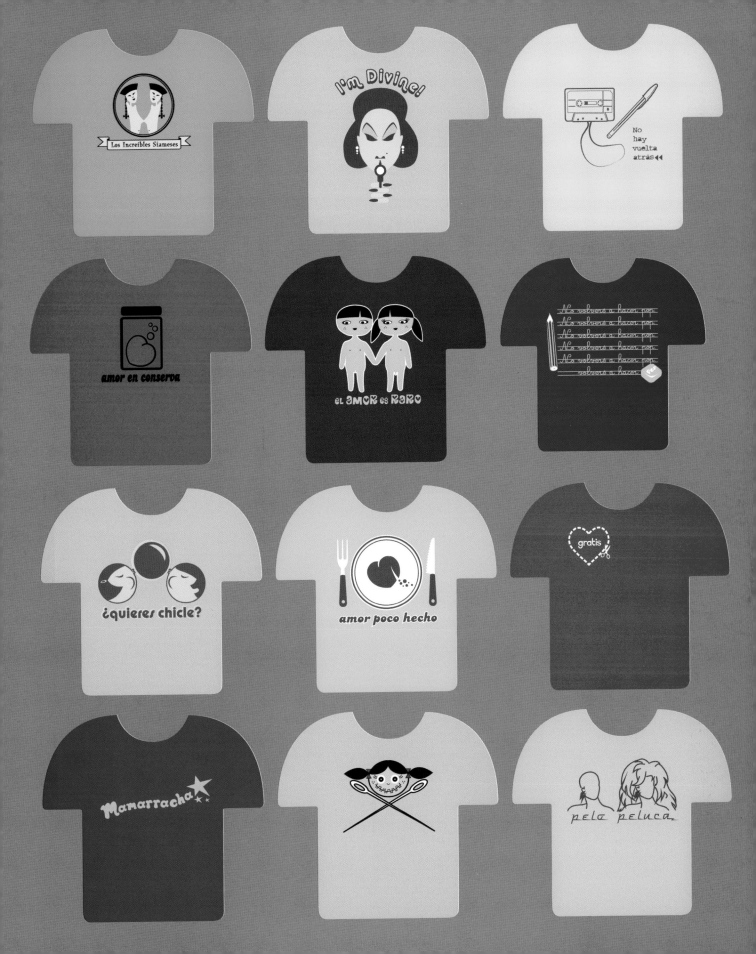

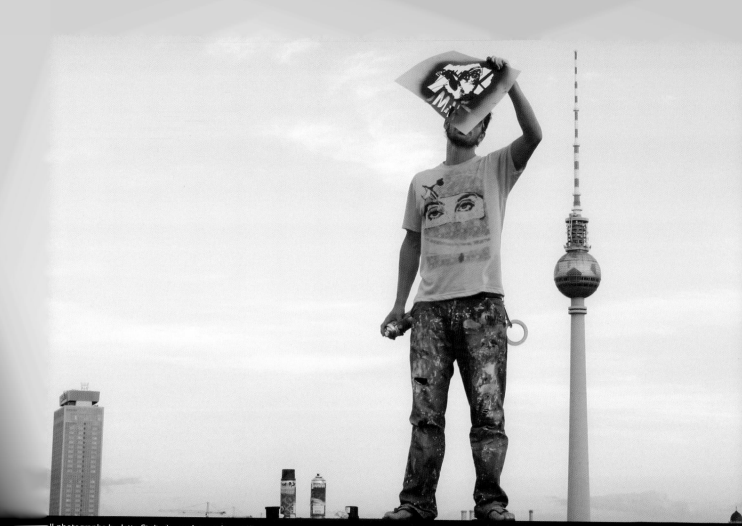

All photographs by Jette Stolte (www.jettestolte.com).

ww.emess-berlin.de
erlin, Germany

EMESS creates and realizes experimental and commercial projects in the area of graphic/object/installation/decoration/street art. Leaving a message within the city without having to worry about getting arrested is what they want. And why only allow a few to see your work by showing stuff in commercial galleries? People are walls in motion, and their clothes are canvases.

Emess applies designs on some of the industry's hottest clothes, creates a moving showroom in public. Emess likes street and tattoo styles, individual stencils, maritime longing, provocative combinations and motives at the right spot. They use vertically integrated T-shirts from L.A., sprayed by hand and stencil with absolutely washable vintage-optimized textile

Why T-shirts?
Basic and all-time fashion wear, ideal to post shit in public!

What was the first T-shirt you designed?
Exploited cover fake, the one with the skull.

What are you wearing right now?
Blue long sleeved H&M workshirt.

What famous person would you like to design a T-shirt?
Darth Vader.

A message you would like to spread with a T-shirt...

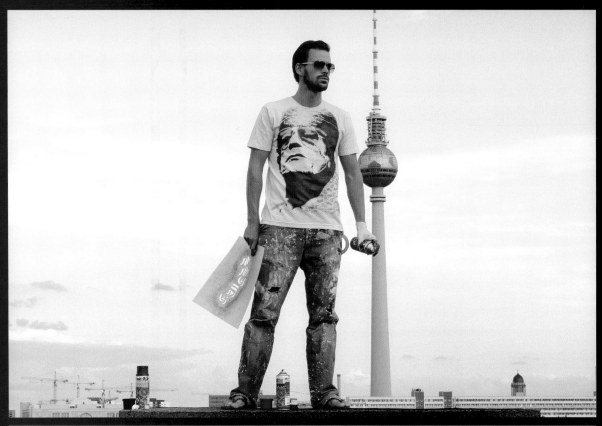

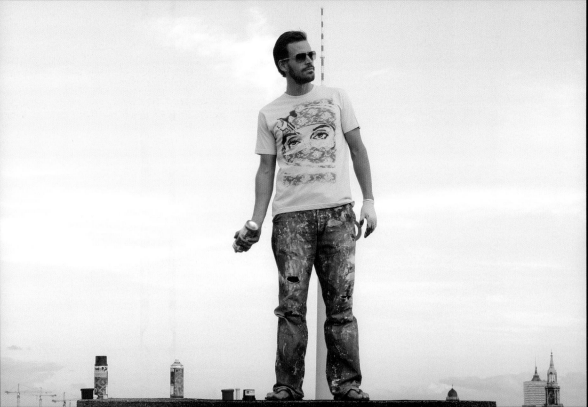

All T-shirt graphics on these pages hand sprayed by Emess.

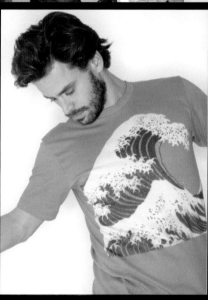

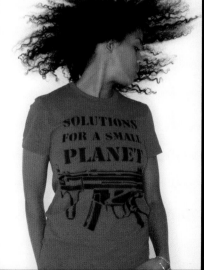

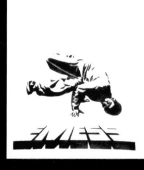

EMÈSS

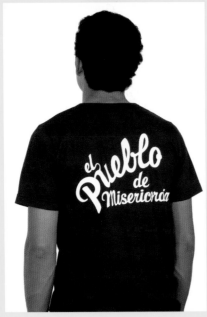 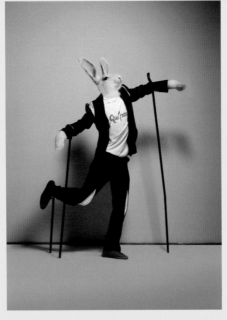

All images courtesy of Misericordia.

No Más Utopía

22_Misericordia
www.misionmisericordia.com
Lima, Peru

Aurelyen is the designer, illustrator, photographer, film director, webmaster, artistic manager, commercial director, and communication manager, the orchestra's conductor of MISERICORDIA. In Lima, he is helped by Carlos Montverde, his cruising commander, to manage the project in Peru. For the creation of Misericordia's clothes, he is helped by the Peruvian seamstresses. Aurelyen lives more than 6 months of the year in Peru and has his *carnet de extranjería* (Peruvian green card). The rest of the time, he travels over the world to share and promote Misericordia's project. There remains approximately 3 months per year in Paris, where he pre-sents the collection at Misericordia's Parisian showroom and visits his brother Léonard, the key man in charge of Misericordia in Paris.

Peru is the adopted country of Aurelyen, where he got to learn Spanish in Lima's streets. Everything started in 2002, when Aurelyen began using Peru to develop his artistic, social, and political ideas. His clothing reflects his immersion in Peruvian culture and suggests everyday life within chaos, the struggle for survival.

Why T-shirts?
We create T-shirts because in Peru, you can find here the most beautiful cotton in the world. T-shirts are the most universal items of clothing. They're perfect for expressing our message of solidarity and creation.

What was the first T-shirt you designed?
My first T-shirt design was with the Misericordia logo in the front and on the back the address of the workshop in Peru. On every Misericordia item, you can find the address of the workshop so you come to see us in Lima. We want to share our experience with the entire world: you're welcome.

What are you wearing right now?
I'm naked. It's summertime in Lima and every morning, I'm staying home responding to e-mail. I'm alone listening to music and solving problems. After I will take my shower, and go out for lunch and do some real work at the workshop. But please don't tell anybody.

What famous person would you like to design a T-shirt?
Pizarro, the most famous Peruvian soccer player for the famous boy or Shakira for the famous girl, because my team would be so proud, you can't imagine. Me, I would love to do a T-shirt for Jean Luc Godard (it would be so funny).

A message you would like to spread with a T-shirt...
No Más Utopia ("No More Utopia"). Just move the world right here, right now. Show me the real boy or girl behind the T-shirt !

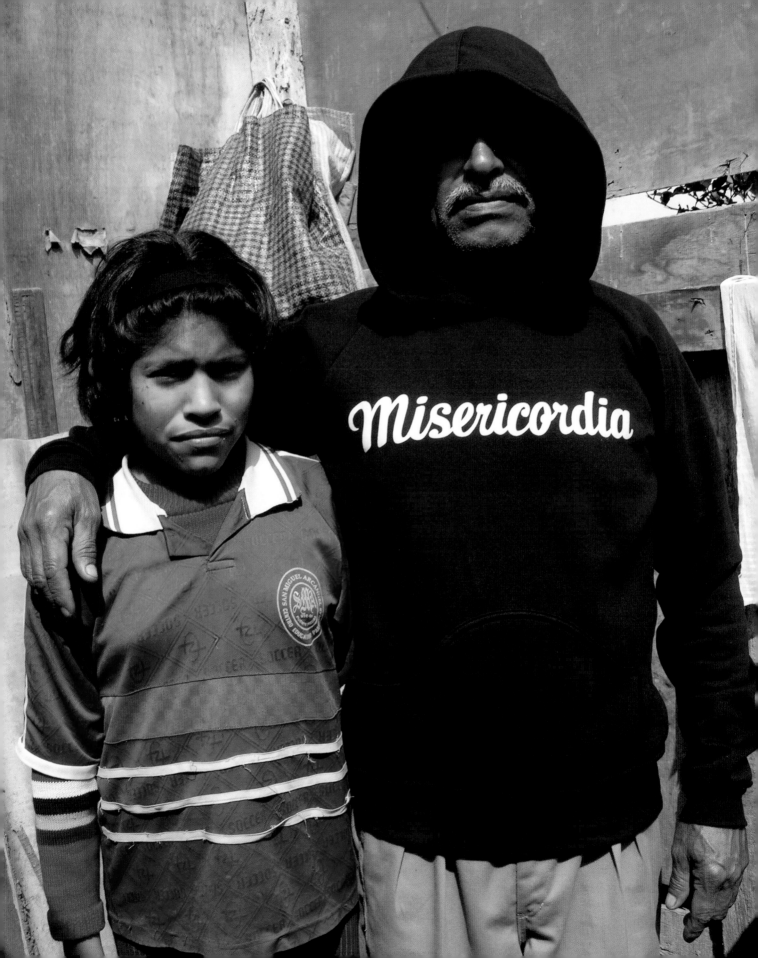

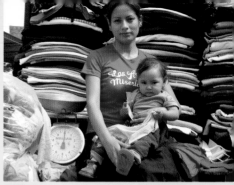
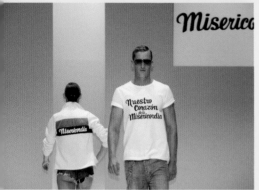

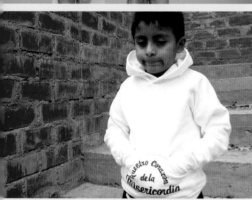
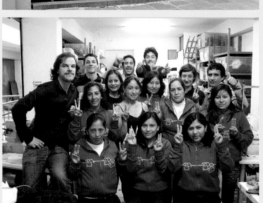
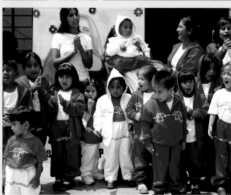
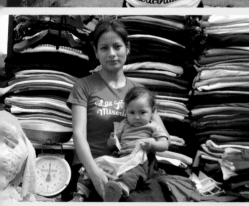
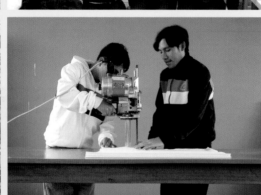
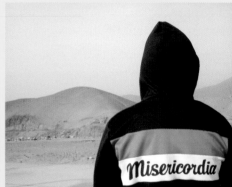

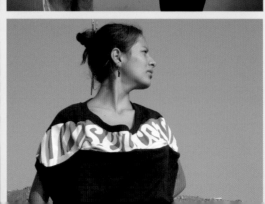
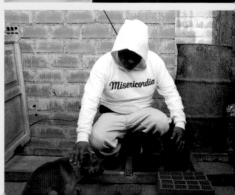

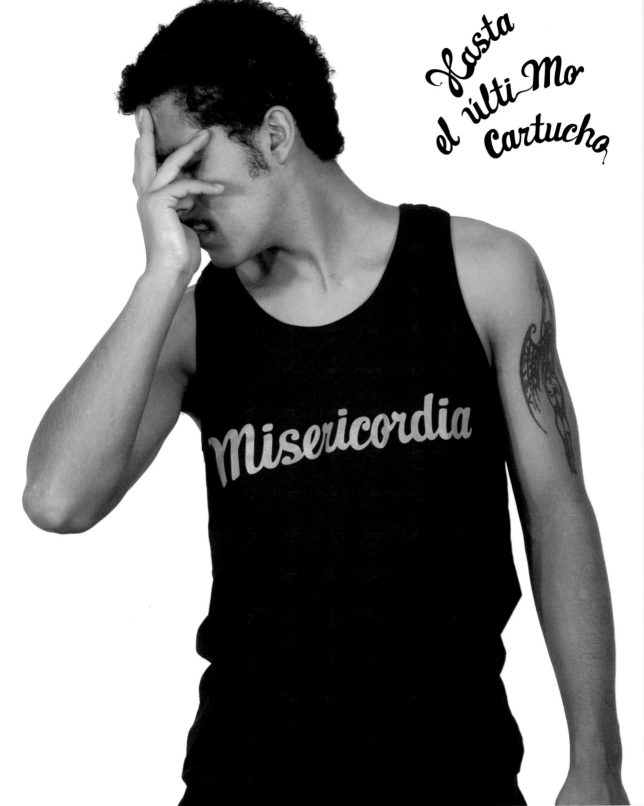

Hasta el último Cartucho

Misericordia

All designs on these pages by Misericordia.

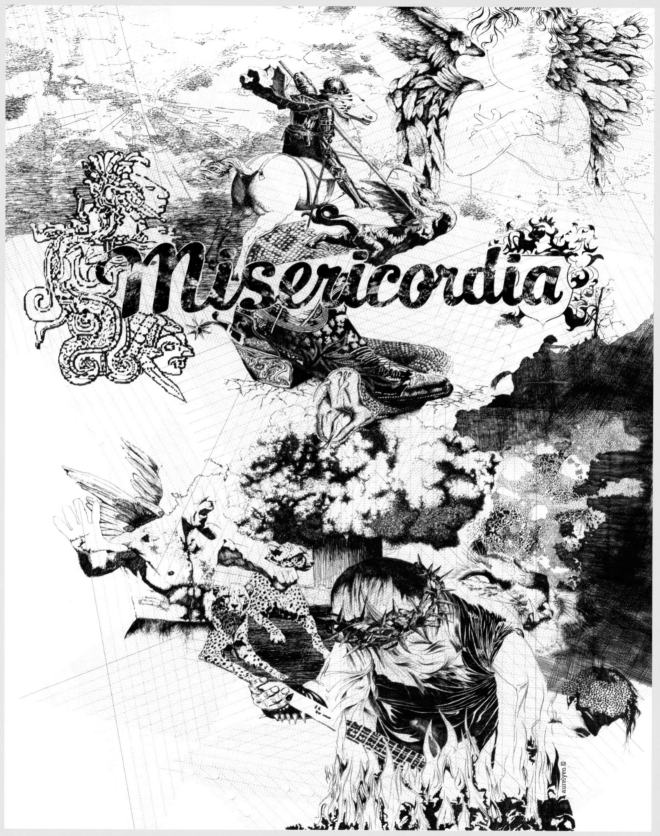

All designs on these pages by Misericordia.

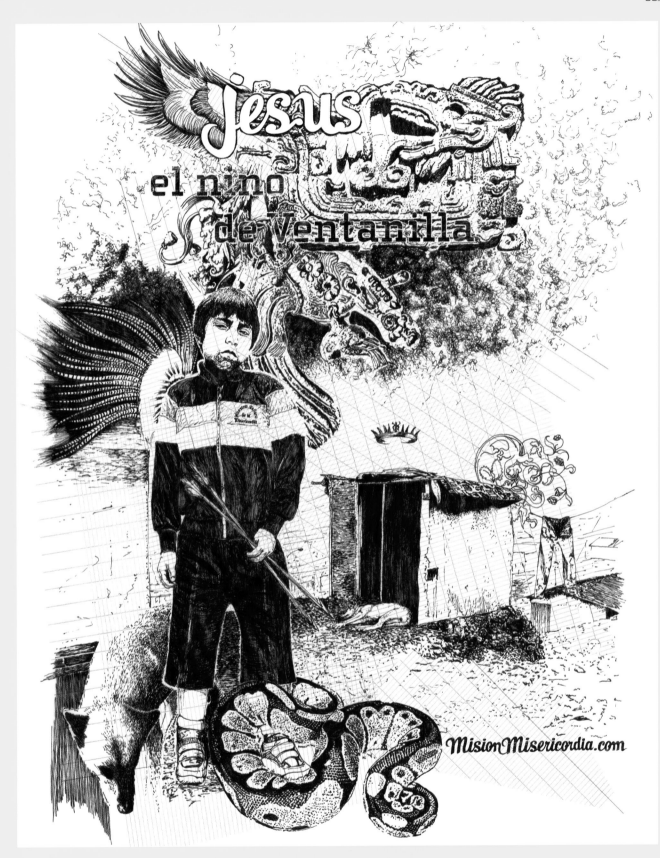

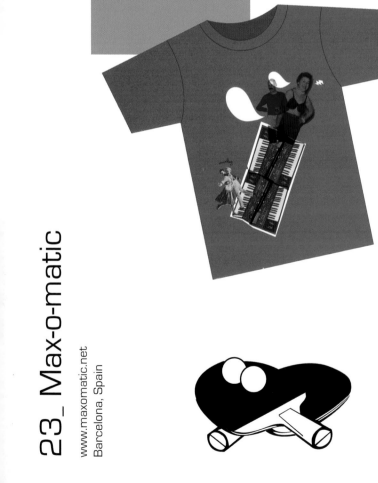

23_ Max-o-matic

www.maxomatic.net
Barcelona, Spain

MAX-O-MATIC is Máximo Tuja. This multidisciplinary artist based in Barcelona works in graphic design and professional illustration and is fascinated by drawing images from the past on his T-shirts, trying to create a parallel and imaginary world.

Why T-shirts?
I love them. They're a very cool way to say how you feel that particular day.

What was the first T-shirt you designed?
My Greatest Hits T-shirt. I designed it for my first appearance as selector/DJ in a small and filthy bar in Barcelona. The DJ session sucked, but the T-shirt was acclaimed by the (small) audience.

What are you wearing right now?
A T-shirt designed by Sauerkids. Everyone should own one and wear it at least once a week.

What famous person would you like to design a T-shirt?
I'd love to design a T-shirt for the German singer Heino. In fact, I'll do it soon.

A message you would like to spread with a T-shirt...
"Buy my T-shirts" would be a bold statement to spread.

All images courtesy of Max-o-matic.

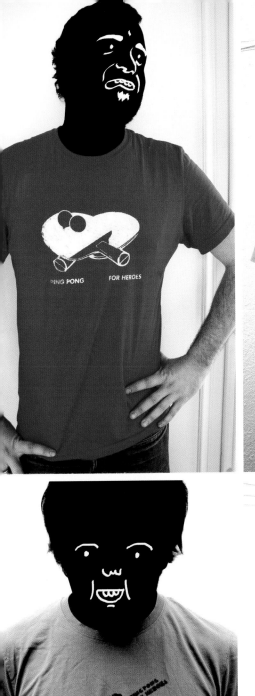
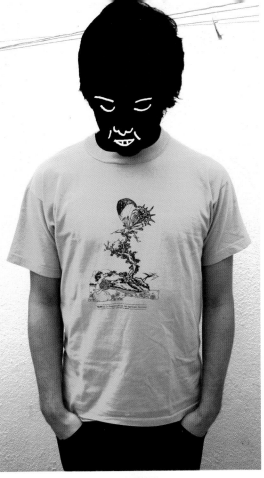
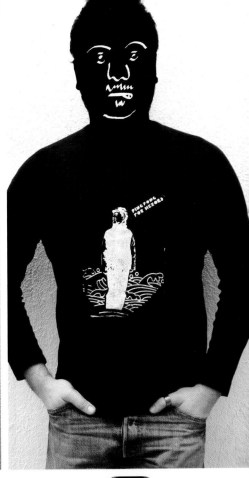
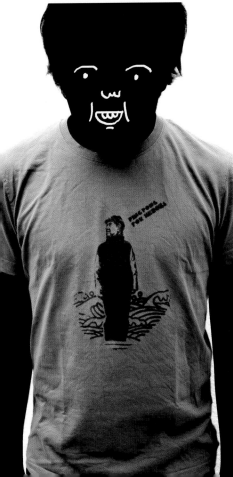

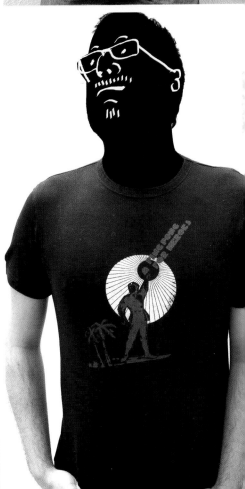

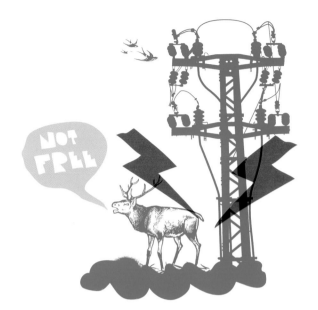
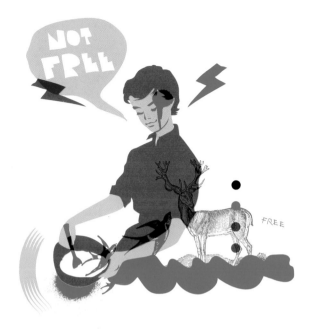

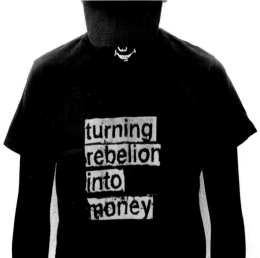
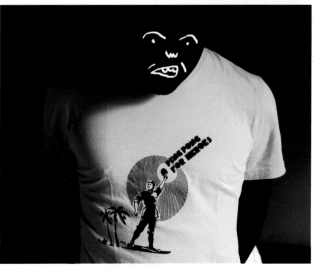

All images courtesy of Max-o-matic.

max-o-matic™

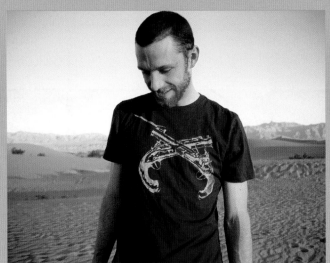 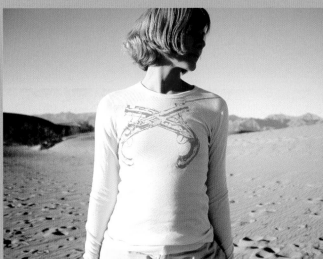

All photographs by Olin McKenzie.

24_Momimomi

www.momimomi.com
www.myspace.com/mymomi
New York City, USA

MOMIMOMI started as a hobby, really. Immensely frustrated with any real outlet for their creative energies, the founders of Momimomi decided to set out on what they saw as a simple venture: establishing a T-shirt company. In 2001, their East Village apartment became a venue for responding to the energy of the vibrant downtown New York culture that they called home. Out of a love for thin, soft, history-worn T-shirts, they chose the vintage tee as their first medium. Each season's line is created along an open, but thoughtful, conceptual framework. Momimomi rebukes the notion of an overt and strong brand-aesthetic in favor of an ever shifting style that celebrates the idea of an open narrative. Long live the viewer (and the wearer). Concentrating on designs of simplicity and comfort, the aim of Momomomi's work today is to conflate graphics and wearability, treating the T-shirt as a billboard for the body, not the other way around. While Momimomi no longer exclusively works with vintage pieces, the oneness of print and tee that these precedents possess remains a consistent goal. The label's aesthetic direction is and has been derivative of things it holds dear —layered histories, culturally rich locales, Mother Nature, persistent street art, and all shit sublime.

Why T-shirts?
In 2001, when Momimomi was first conceived, we loved wearing old, history-worn T-shirts (as opposed to the suits we had to wear in our day-to-day) and decided to use them as a medium for some graphics. It was all about accessibility.

What was the first T-shirt you designed?
The first Momimomi design was called Fey-Sue –she grew out of a sketch that Olin had in one his pads– and became a mascot of sorts for the first year or two. We have plans to do a best-of collection in the near future so she will probably make it back into circulation soon enough.

What are you wearing right now?
It's hard not to wear one of your own tees when you're surrounded by them every day. Right now I have on our A Light Snow design from the MOMI TEeA PARTY, a monthly subscription program we started this year (2007) where subscribers receive a limited edition tee to their doorstep each month.

What famous person would you like to design a T-shirt?
Jacques Cousteau.

A message you would like to spread with a T-shirt...
We're not so big on spreading "messages" or in branding for that matter– we would like our tees to be a source of expression for the wearer and a cause for curiosity in the viewer.

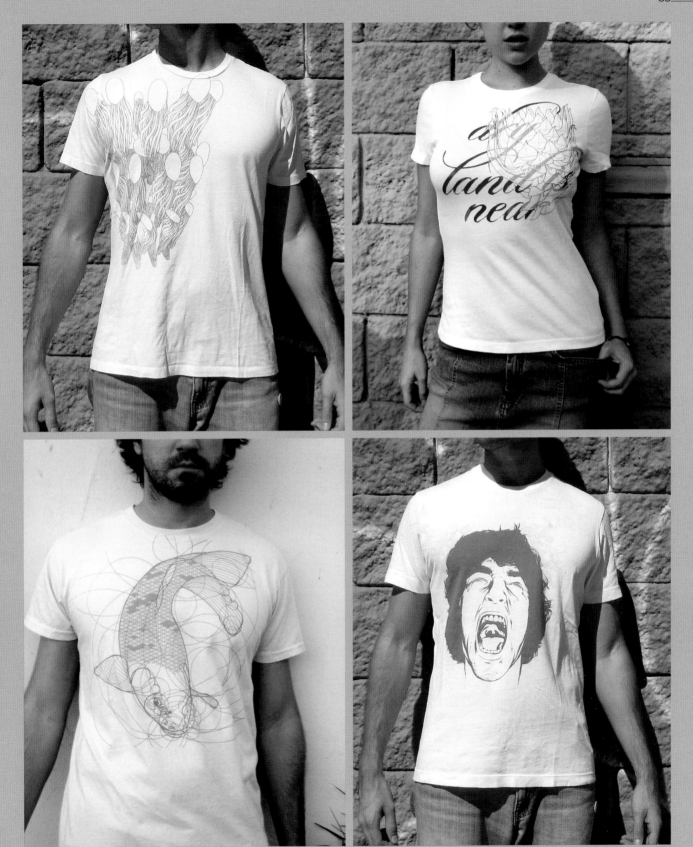

Left page: T-shirts from The Golden Age of Piracy collection. On this page: T-shirts from collections A Hollywood Ransom and The Golden Age of Piracy.

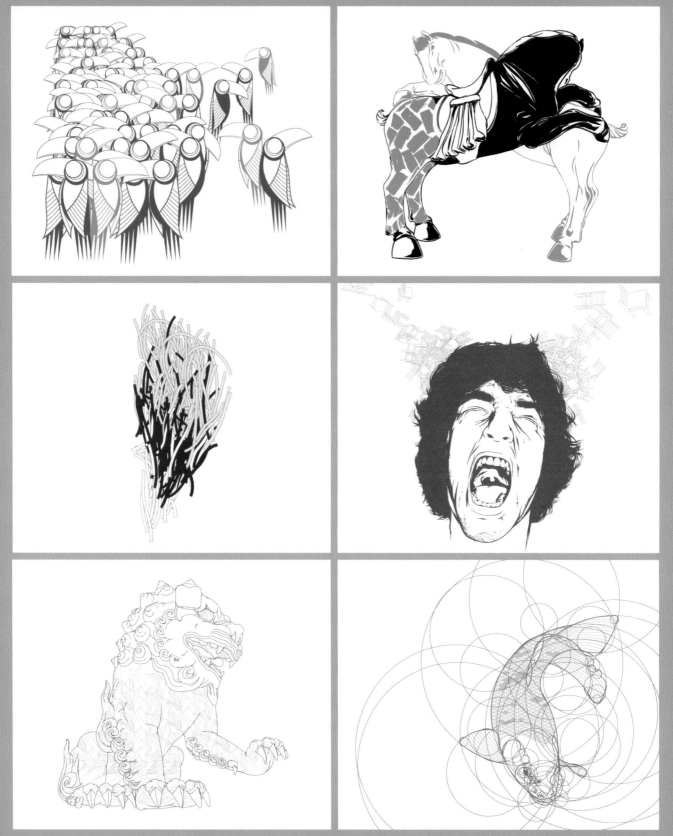

This page: T-shirts from collections A Hollywood Ransom, The Golden Age of Piracy, and Made in Peking.

This page: T-shirts from collections Natural Causes and Room Number.

DIVINAS PALABRAS ("Divine Words") is actually made up of a group of artists specializing in a variety of disciplines: the fashion designers team up with various writers, visual artists, and film directors to create their famous T-shirts. The objective is to vindicate the word as the primordial means of expression and transform humanity itself into a means of communication.

In a world where image is all important, Divinas Palabras has taken on the creative challenge of integrating meaning with form and seeking interaction with the individual, who is given a free choice in expression: You have the say. You are the medium. You are the message.

Why T-shirts?
The Divinas Palabras project was set up in 1999 with the intention of vindicating the power of the word. The first achievement was a collection of T-shirts (spring–summer 2001) that converted wearers into messages.

What was the first T-shirt you designed?
A T-shirt bearing elevator symbols is accompanied by the word "relationship", in effect comparing us to lifts with regards to our relationships. A small space where we create an intimacy, at times uncomfortable, and into which there is a constant coming and going of people.

What are you wearing right now?
A T-shirt with the message:
"Everything is wrong, therefore everything is possible."

What famous person would you like to design a T-shirt?
Walter Van Beirendonck.

What message would you like to spread with a T-shirt?
Make love, not war!

Photographs by Hugo Iglesias, Héctor Pérez, Eduard Brugué, and Ricard Giró.

25_Divinas Palabras
www.divinaspalabras.es
Barcelona, Spain

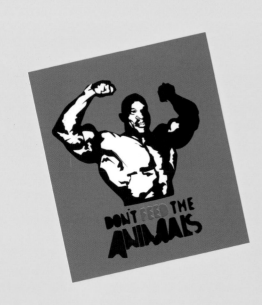

T-shirts from collections Luck Not Money, Mental Disorder and Hungry.

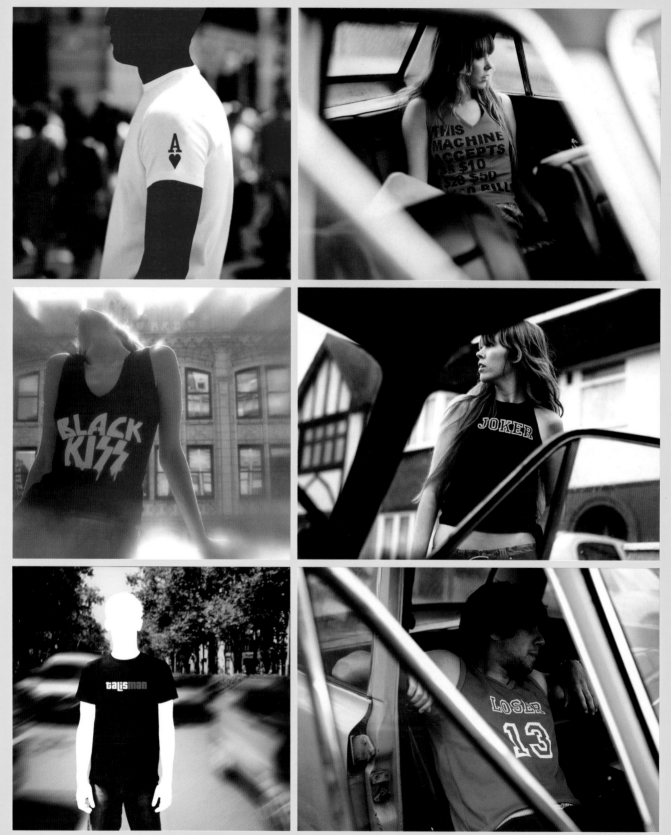

All designs on these pages by Divinas Palabras.

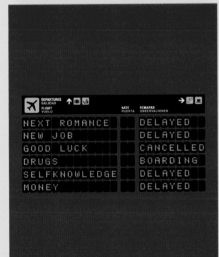

| DEPARTURES ✈ SALIDAS | | GATE PUERTA | REMARKS OBSERVACIONES |
FLIGHT VUELO			
NEXT ROMANCE			DELAYED
NEW JOB			DELAYED
GOOD LUCK			CANCELLED
DRUGS			BOARDING
SELFKNOWLEDGE			DELAYED
MONEY			DELAYED

Divinas Palabras Classics es el nuevo proy
plataforma de comunicación Divinas
cuperamos nuestros modelos favorito
teriores . En este caso te presentamos
ue mejor reflejan el espíritu de nuestra
e vio la luz en Barcelona en marzo de
ivinas Palabras Classics is the new p
ivinas Palabras communication platfo
ur favourite items from previ
designs that best

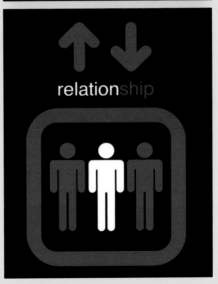

ALASKA para

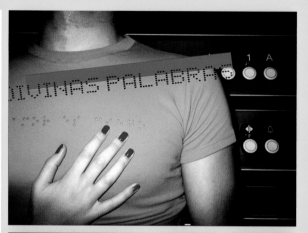

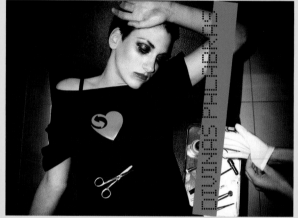

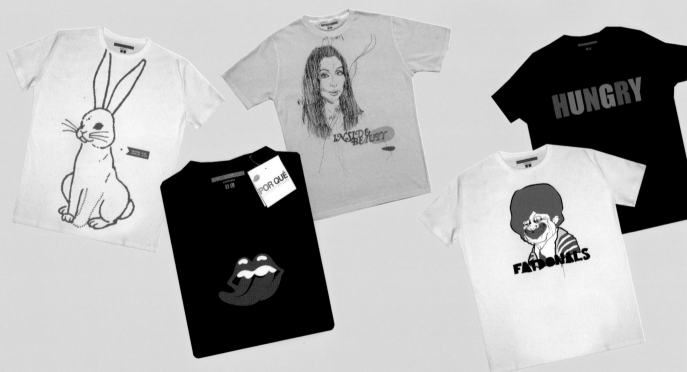

All designs on these pages by Divinas Palabras.

Consumición mínima obligatoria

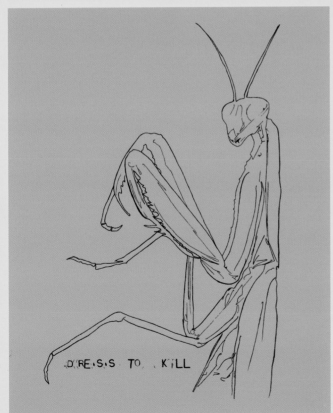

.D·R·E·S·S· TO· ·K·I·LL

DIVINAS PALABRAS

EL XUPET NEGRE began painting in 1989 in Barcelona and was one of the first artists to bombard Europe and the world with his logo. In 1991 he started to paint large walls and doorways in the city center together with other artists. Soon many spaces were freed to be painted with grand colorful works, and people began to see graffiti as a true art form. By painting a logo or icon (a drawing) instead of a signature (a tag), people would remember and recognize him much more easily, and thus bring graffiti to a much broader public. In the last few year El Xupet Negre has appeared in periodicals, on the radio, and television. He has worked as an artist for brand names and exhibited his art in galleries. The T-shirts are another way of spreading his work and his *xupet*!

Why T-shirts?
A T-shirt is for the young, a perfectly publicity board to hang your message. You seem more serious when people see it on the street, rather than a wall. A shirt can also travel through the streets and around the world. It's a way for your mark to be anywhere on the globe, without having ever set foot there.

What was the first T-shirt you designed?
The first T-shirt was the extra-large El Xupet Negre on the front without a message, as I wanted to give more importance to the logo, the name.

What are you wearing right now?
Etnies sneakers, Adidas basketball sweatpants, Montana Colors sweatshirts, and a wool cap handmade by Helena Palanca.

What famous person would you like to design a T-shirt?
...

What message would you like to spread with a T-shirt?
The message of the tees is the same as the walls −peace and respect, freedom for urban artists, and liberation from the oppressive system.

All photographs on these pages by Louis Bou.

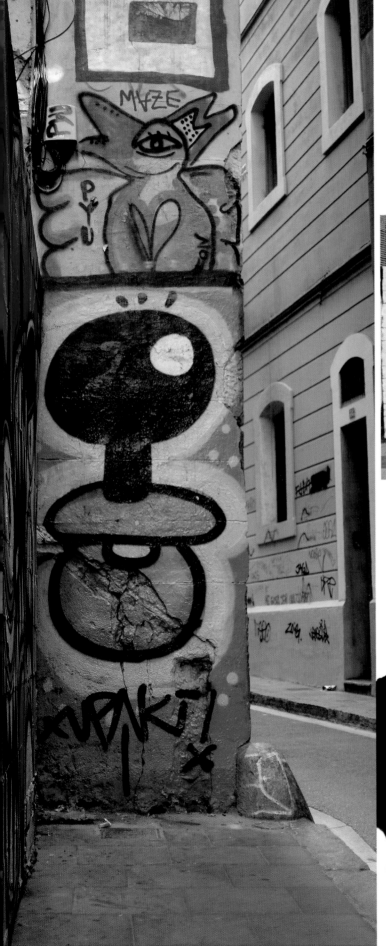

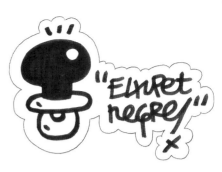

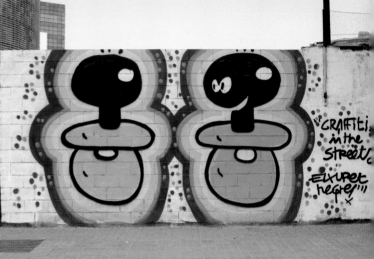

27_Passarella Death Squad

www.passarella.co.uk
London, UK

PASSARELLA DEATH SQUAD, London, was established in 2003 by Danny Broddle (Whitley Bay, England) and Emilie Albisser (Durmenach, France). Designed and manufactured in London using fabric imported from Japan and Italy, Passarella Death Squad T-shirts are now distributed, stocked, and written about throughout the world from London to Paris, New York to Tokyo. The shirts can be found at Liberty's (London), Purple (Milan), and Baycrew's (Tokyo). Passarella Death Squad also signed a record deal with the Republic of Desire Recordings. The first release came out in early 2007.

Why T-shirts?
We like them.

What was the first T-shirt you designed?
The *Je viens du Palais des Péchés* one.

What are you wearing right now?
Vivienne Westwood, Balenciaga, Burberry Prorsum, CP Company, and Adidas.

What famous person would you like to design a T-shirt?
Mary Woronov (Warhol superstar), Edie Sedgwick, Larry Clark (Tulsa period), David Bowie (Low/Heroes period) and Serge Gainsbourg.

A message you would like to spread with a T-shirt...
Ne vend jamais ton ame ("Never sell your soul").

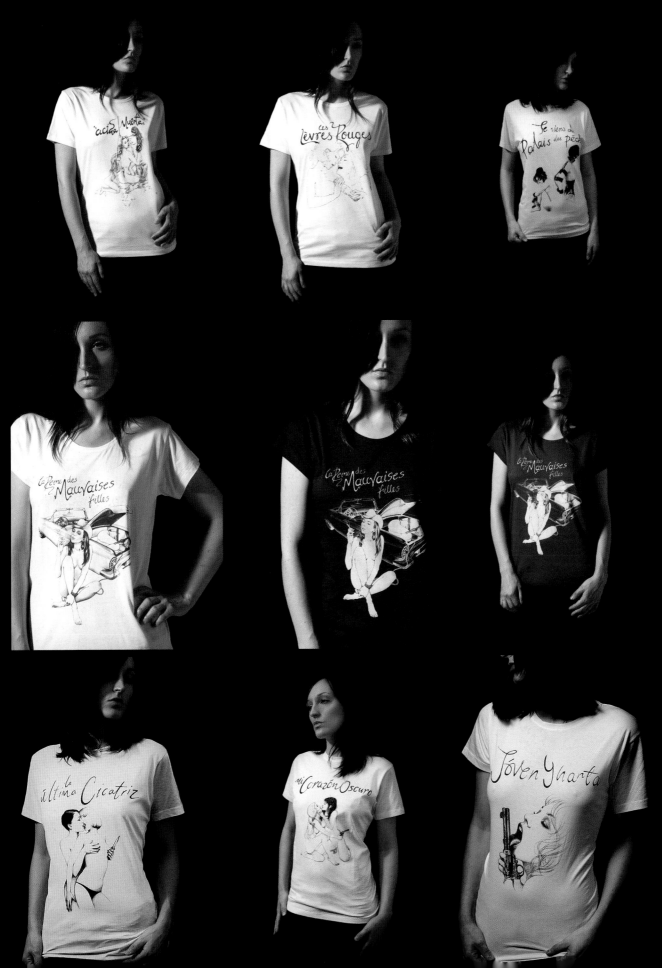

PASSARELLA DEATH SQUAD

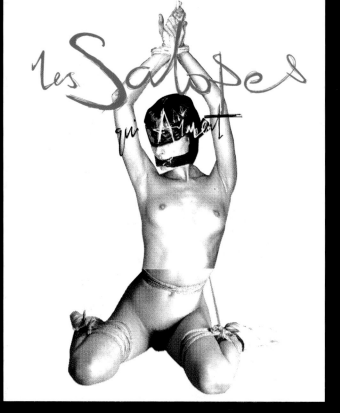

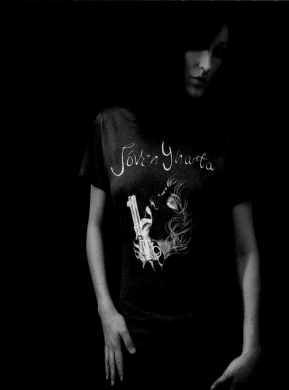

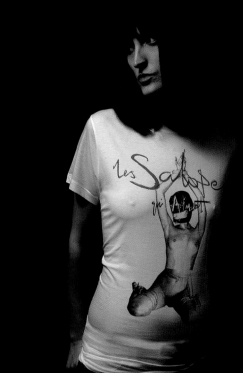

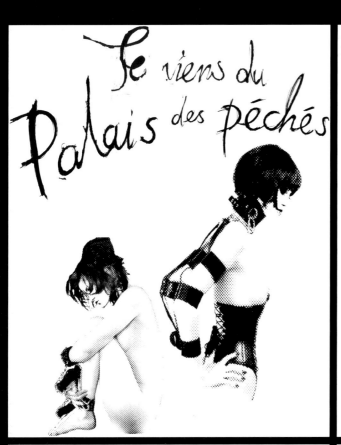

Je viens du Palais des péchés

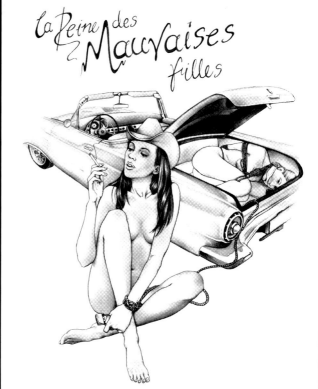

La Reine des Mauvaises filles

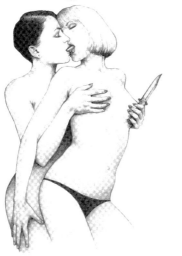

la última Cicatriz

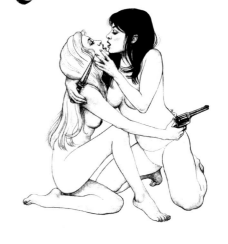

Mi Corazón Oscuro

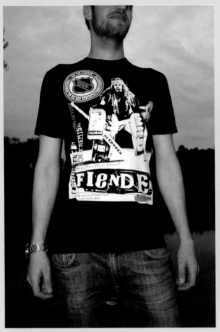 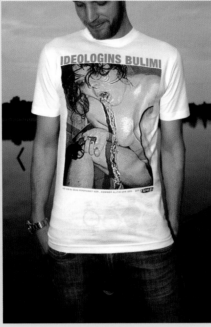 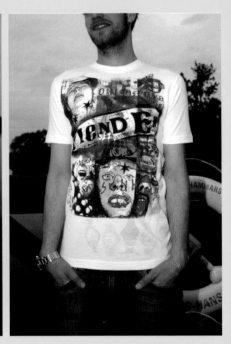

All photographs by Peter Jöback.

28_Fienden

www.fienden.com
www.myspace.com/ffiieennddeenn
Sweden

FIENDEN (or "The Enemy" as the label becomes lost in translation) was once invented, or rather constructed, by some unbegotten children. Since then, in the course of the last 5 or 6 years, it has taken on a variety of forms; it has even collapsed a few times, but its fundamental core, to which all manifestations of the label can be reduced, remains one and the same: Nothing.

In their view there is no other way to relate to expectations than to ignore them. They do not find it interesting to explain their philosophy unfolding; they do not have the desire to paint narcissistic images of themselves; and, surely, they feel no inclination to single out an exact description of their mission. They do not think that a narcissistic game, presented in the guise of a philosophy, would provide anything useful for the understanding of their work, but would only obscure and confuse that which they try to convey: Nothing.

Why T-shirts?
We wanted to find a way to spread our ideas, those that didn't make it to a canvas. T-shirts are also something almost everyone has had some kind of relation with and most people can afford. More traditional objects of art can be both expensive and, for some people, inaccessible.

What was the first T-shirt you designed?
The first T-shirt we did had a gun sticking down on the side, making you appear like you were some kind of idiot cowboy that didn't get laid, not if you're into girls anyway.

What are you wearing right now?
Gucci pants, D&G shirt, Prada shoes, and a pair of silk Mickey Mouse ears.

What famous person would you like to design a T-shirt?
The only one we really, really would like to design a T-shirt for is the Slovenian philosopher and psychoanalysist Slavoj Žižek. His work and eccentricity have influenced us a lot. When Žižek lectures he tends to sweat a lot, but also to pull his T-shirt, so his T-shirts always look amazingly worn out. It would be amazing if he held a lecture, sweating like a maniac and tore one of our shirts apart. Thinking about it though, Slavoj Žižek is way too fat for our shirts.

A message you would like to spread with a T-shirt...
Support the wealthy!

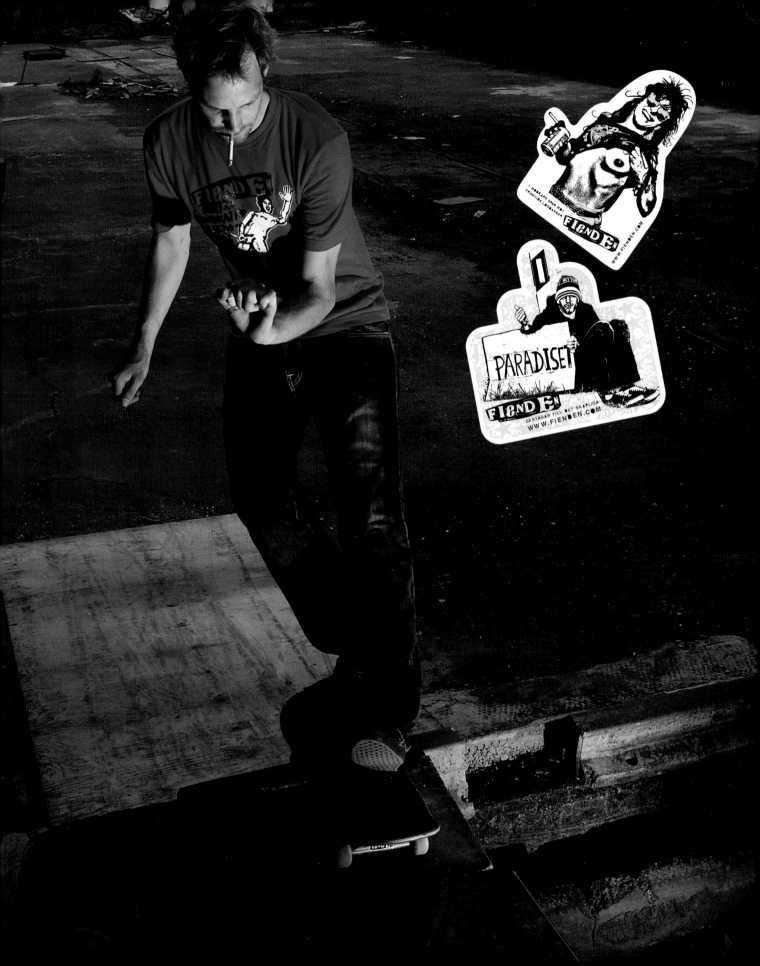

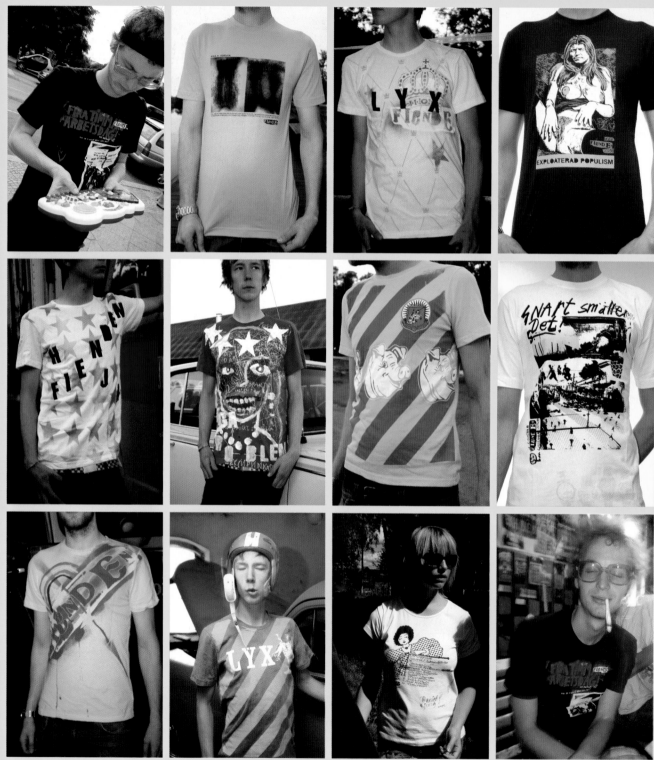

All artwork by Fienden.

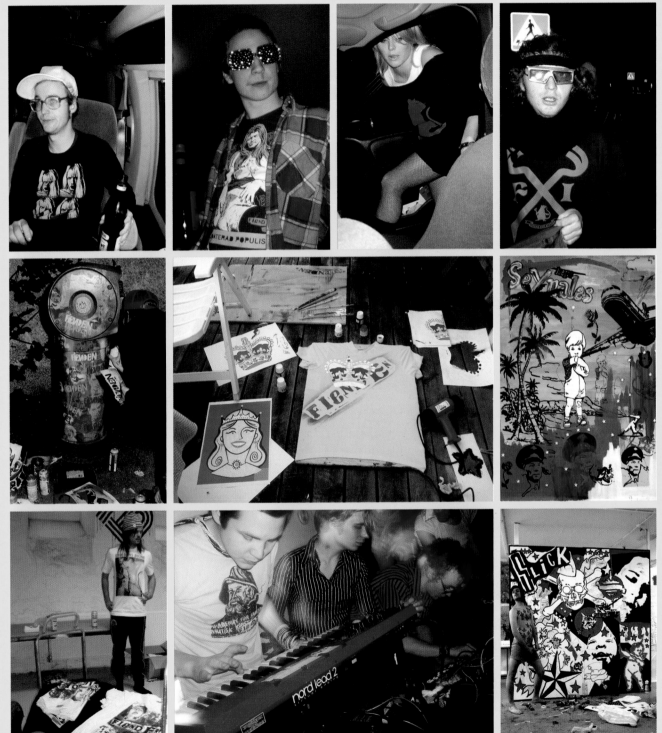

All artwork by Fienden.

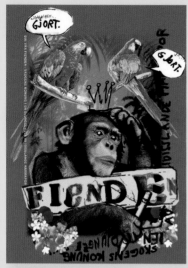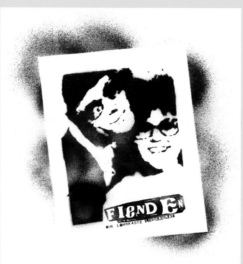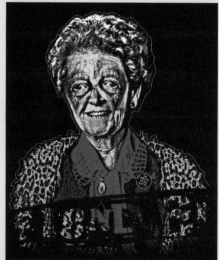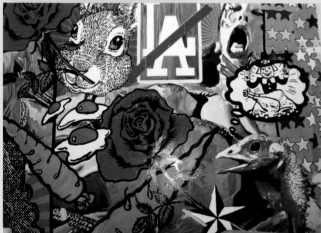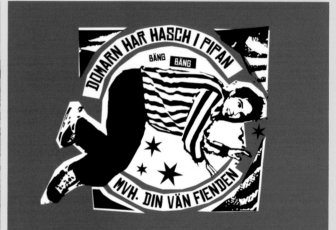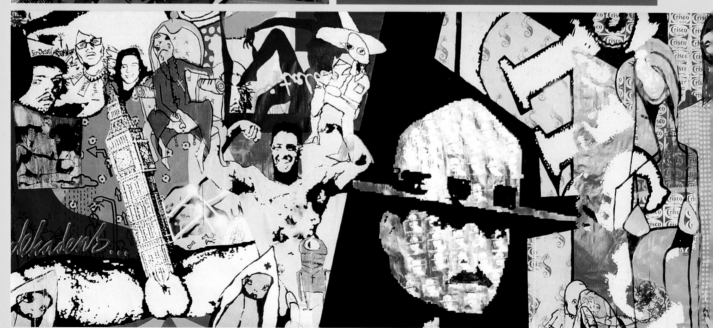

All artwork by Fienden.

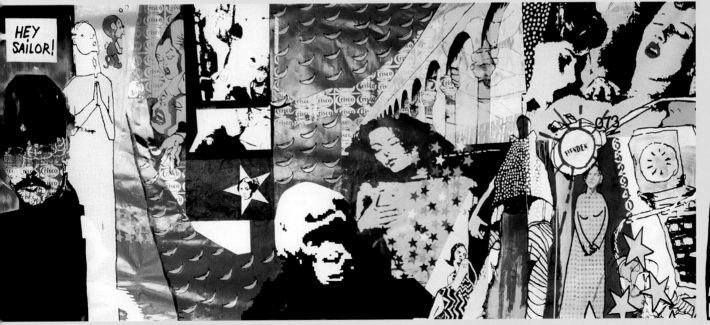

All images courtesy of Fienden.

MAGMO began to illustrate his characters in short stories that focused on a variety of topics that had been affecting his neighborhood: urban sprawl, big business, and traffic nightmares. Magmo's ideas and illustrations evolved into silk screen prints, paintings, T-shirts, handmade toys, and fine art *gicleé* prints. Magmo combines his unique illustration style of both digital and traditional media with original characters and stories to create a collage of artwork that tells cautionary tales about everything from deadly trans fatty monsters and gas-guzzling families, to radioactive octopuses and evil war spirits. Simply, Magmo likes to destroy the bad things in life that try to destroy us: pollution, greed, apathy, the failing healthcare system, unhealthy foods, and war.

Magmo is here to help. Magmo is here to destroy.

Why T-shirts?
The T-shirt is a universal piece of clothing that functions as fashion, art, political protest, and communication. No matter where I have traveled in America, Europe, or Asia, T-shirts are worn by all ages, all classes, all races, all over the world. The idea of the T-shirt is so simple, but when it's used creatively it can have a powerful visual impact for all to see. Magmo wears T-shirts everyday.

What was the first T-shirt you designed?
One of my first T-shirt designs was of the Magmo face and the sentences "I Am Here to Help. I Am Here To Destroy." It was my first printed shirt and also the first time I met my friend MCA of Evil Design, who had screen printed them.

What are you wearing right now?
Monkey Discipline T-shirt, designed by Evoker.

What famous person would you like to design a T-shirt?
Cenghis Khan.

A message you would like to spread with a T-shirt...
Destroy!

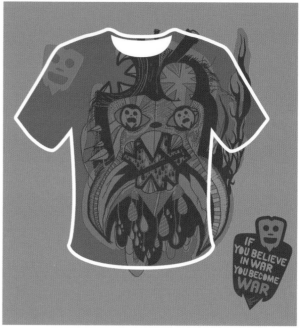

29_ Magmo The Destroyer
www.magmothedestroyer.org
Rhode Island, USA

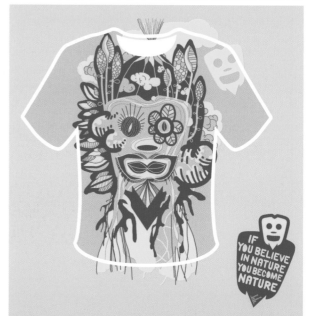

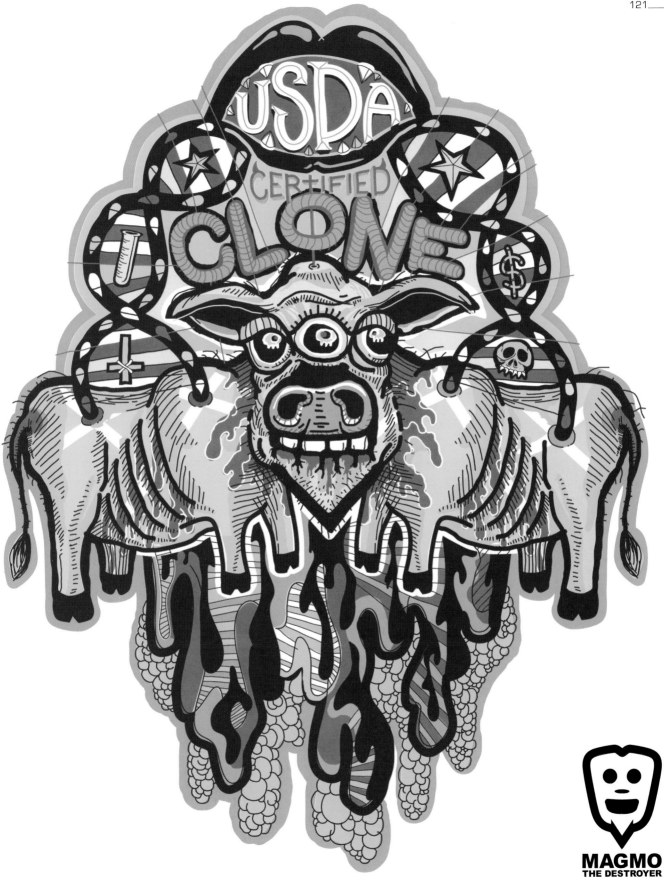

MAGMO
THE DESTROYER

Magmo Peace (www.sabrestyle.de). All images courtesy of Magmo The Destroyer.

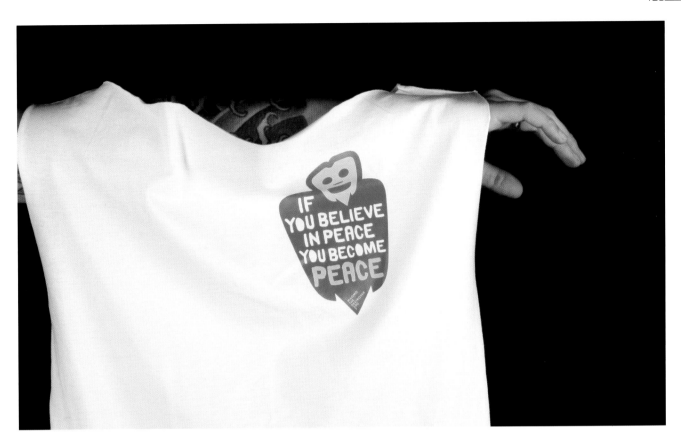

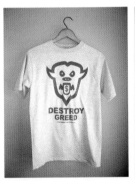

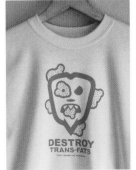

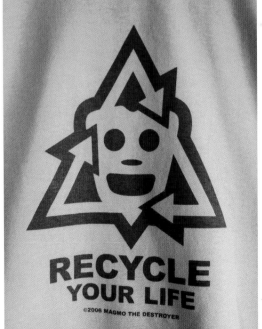
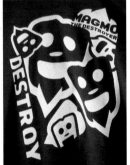

MAGMO
THE DESTROYER

All artwork by Magmo The Destroyer.

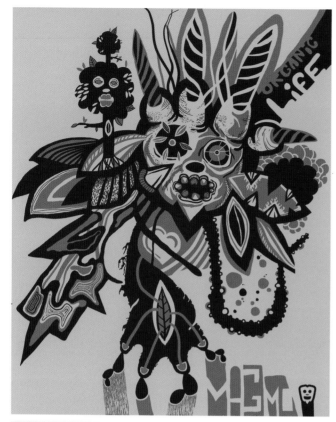
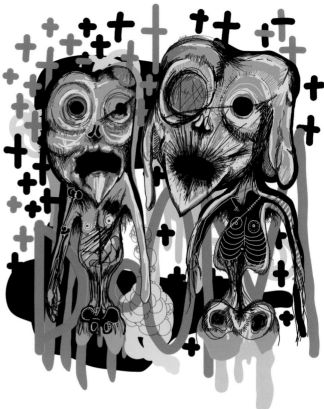
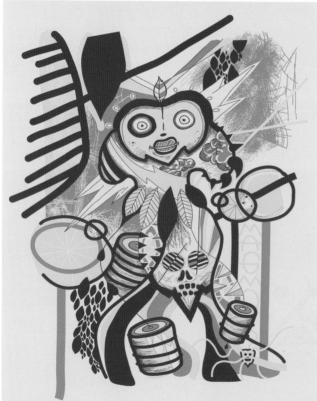
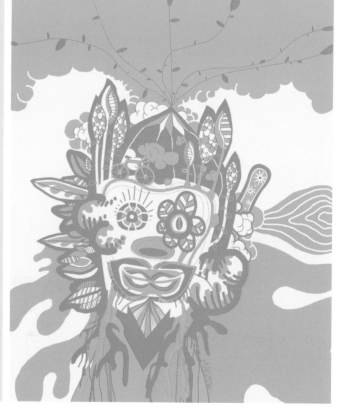

Clockwise from top left: Organic Life, Uninsured in America, Mothermo Nature, and Earthmo Attacks.

SAVE YOUR CULTURE
DESTROY GLOBALIZATION

SAY NO TO GMO's

DESTROY TRANS-FATS

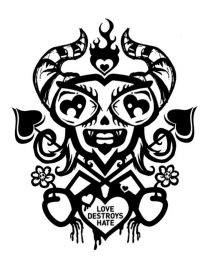

LOVE DESTROYS HATE

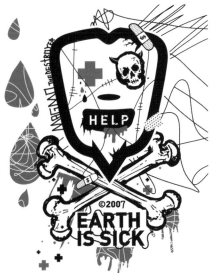

©2007
EARTH IS SICK

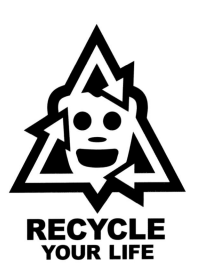

RECYCLE YOUR LIFE

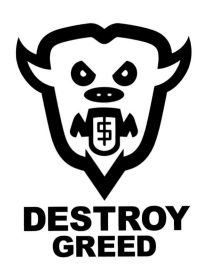

DESTROY GREED

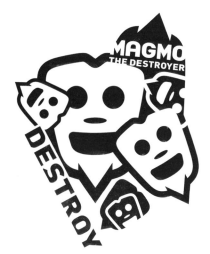

MAGMO THE DESTROYER
DESTROY

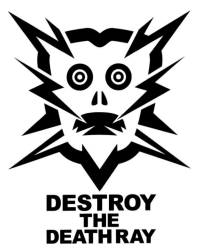

DESTROY THE DEATH RAY

MAGMO THE DESTROYER

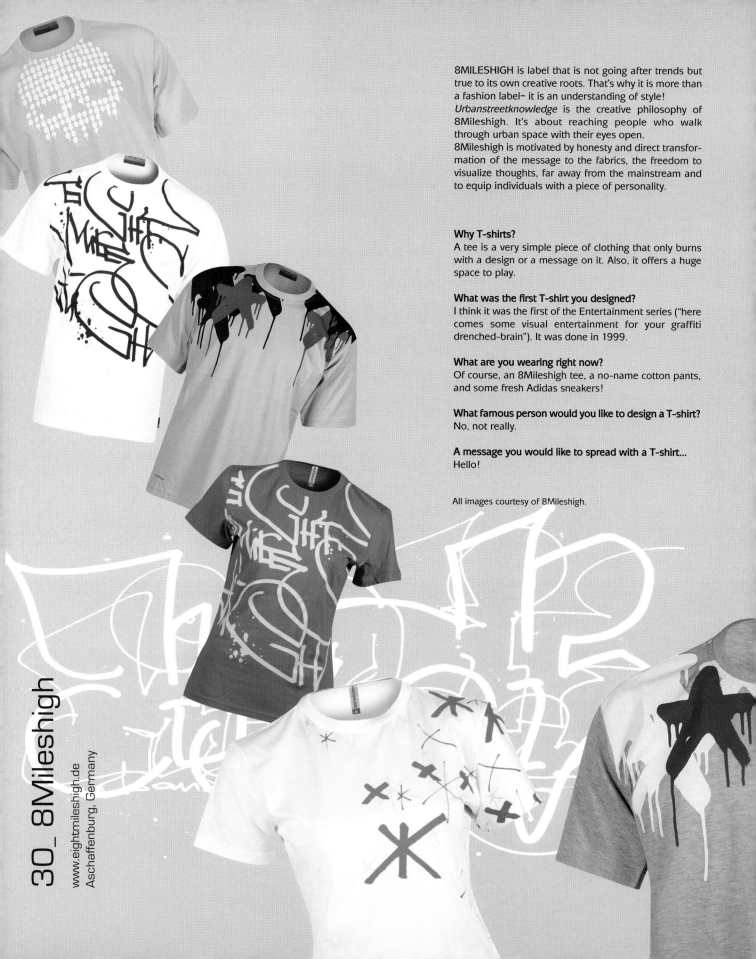

8MILESHIGH is label that is not going after trends but true to its own creative roots. That's why it is more than a fashion label– it is an understanding of style!
Urbanstreetknowledge is the creative philosophy of 8Mileshigh. It's about reaching people who walk through urban space with their eyes open.
8Mileshigh is motivated by honesty and direct transformation of the message to the fabrics, the freedom to visualize thoughts, far away from the mainstream and to equip individuals with a piece of personality.

Why T-shirts?
A tee is a very simple piece of clothing that only burns with a design or a message on it. Also, it offers a huge space to play.

What was the first T-shirt you designed?
I think it was the first of the Entertainment series ("here comes some visual entertainment for your graffiti drenched-brain"). It was done in 1999.

What are you wearing right now?
Of course, an 8Mileshigh tee, a no-name cotton pants, and some fresh Adidas sneakers!

What famous person would you like to design a T-shirt?
No, not really.

A message you would like to spread with a T-shirt...
Hello!

All images courtesy of 8Mileshigh.

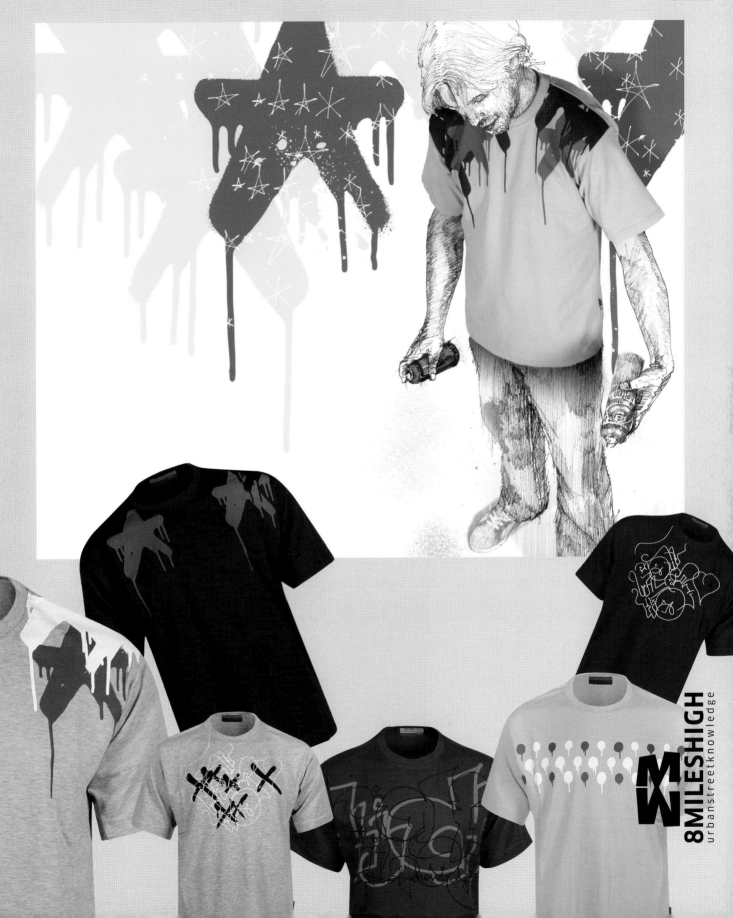

8MILESHIGH
urbanstreetknowledge

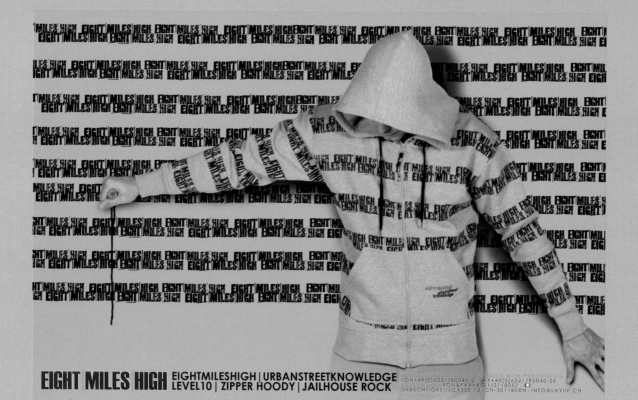

EIGHT MILES HIGH EIGHTMILESHIGH | URBANSTREETKNOWLEDGE
LEVEL10 | ZIPPER HOODY | JAILHOUSE ROCK

WWW.EIGHTMILESHIGH.DE
CONTACT@EIGHTMILESHIGH.DE

FON+49[0]6021/90040-0 FAX+49[0]6021/90040-20
FON&FAX+41/31/3118057
GERECHTIGKEITSGASSE 12 CH-3011BERN INFO@LAYUP.CH

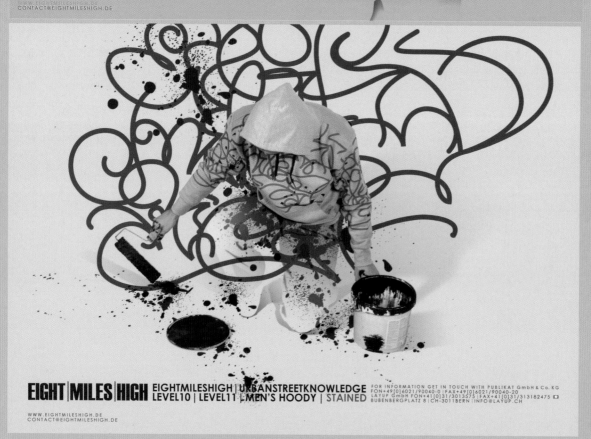

EIGHT | MILES | HIGH EIGHTMILESHIGH | URBANSTREETKNOWLEDGE
LEVEL10 | LEVEL11 | MEN'S HOODY | STAINED

WWW.EIGHTMILESHIGH.DE
CONTACT@EIGHTMILESHIGH.DE

FOR INFORMATION GET IN TOUCH WITH PUBLIKAT GmbH & Co. KG
FON+49[0]6021/90040-0 FAX+49[0]6021/90040-20
LAYUP GmbH FON+41[0]31/3013575 FAX+41[0]31/313182475
BUBENBERGPLATZ 8 CH-3011BERN INFO@LAYUP.CH

This page: 8Mileshigh advertisements by www.atelierschlee.de.

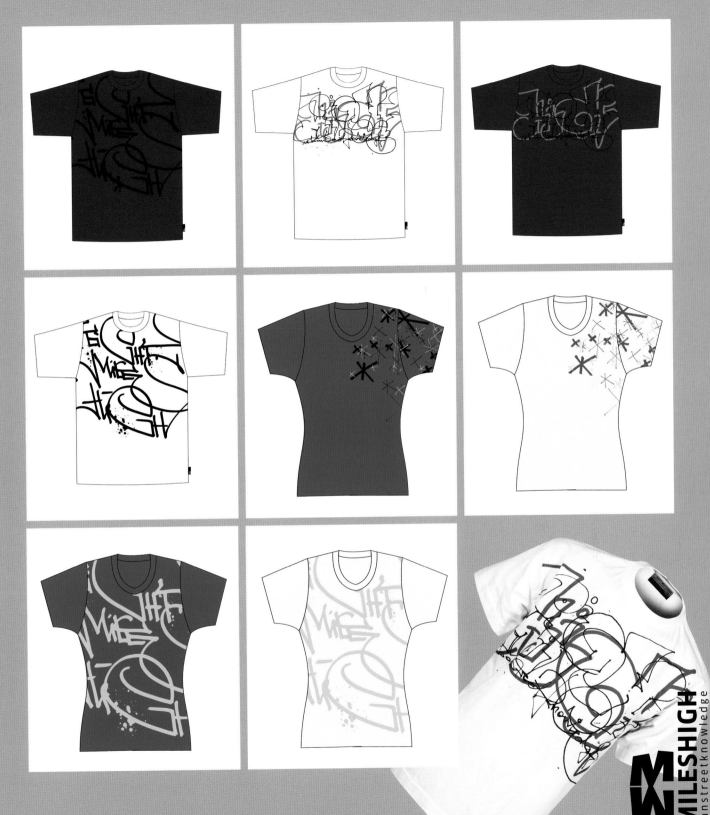

8MILESHIGH
urbanstreetknowledge

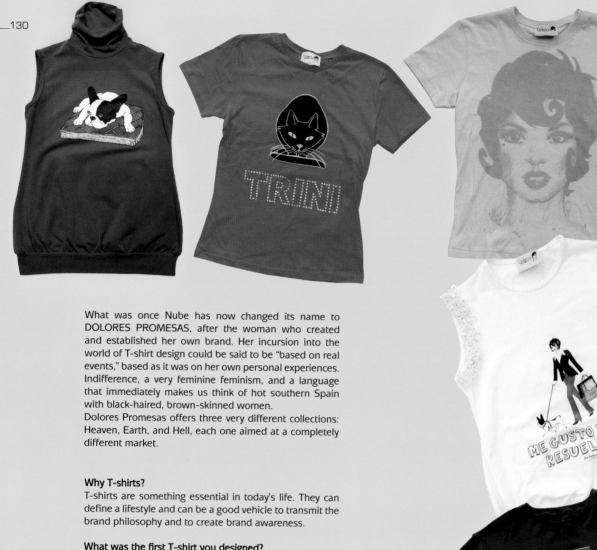

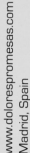

What was once Nube has now changed its name to DOLORES PROMESAS, after the woman who created and established her own brand. Her incursion into the world of T-shirt design could be said to be "based on real events," based as it was on her own personal experiences. Indifference, a very feminine feminism, and a language that immediately makes us think of hot southern Spain with black-haired, brown-skinned women.

Dolores Promesas offers three very different collections: Heaven, Earth, and Hell, each one aimed at a completely different market.

Why T-shirts?
T-shirts are something essential in today's life. They can define a lifestyle and can be a good vehicle to transmit the brand philosophy and to create brand awareness.

What was the first T-shirt you designed?
As you know, all my creations are based on my life experience. As I tell in my biography, when I decided to become a fashion designer the inspiration was not immediate. One day my friend Pepa came to spend the day with me, and when I woke up in the morning and saw myself in the mirror, I had found out my first design, a very very personal design.

What are you wearing right now?
Today is a beautiful spring day in Madrid. I am happy and I have decided to wear a long, springlike dress.

What famous person would you like to design a T-shirt?
I design tees for everyone who feels the Dolores spirit. The important thing is the soul, whether it's famous or not.

A message you would like to spread with a T-shirt...
I always try to transmit positiveness in my messages. I think that the important thing in life is not what happens to you, but what you do with things that happen. It is easy. One can be more or less happy, but you always have to try.

All photographs by Jorge Pintado.

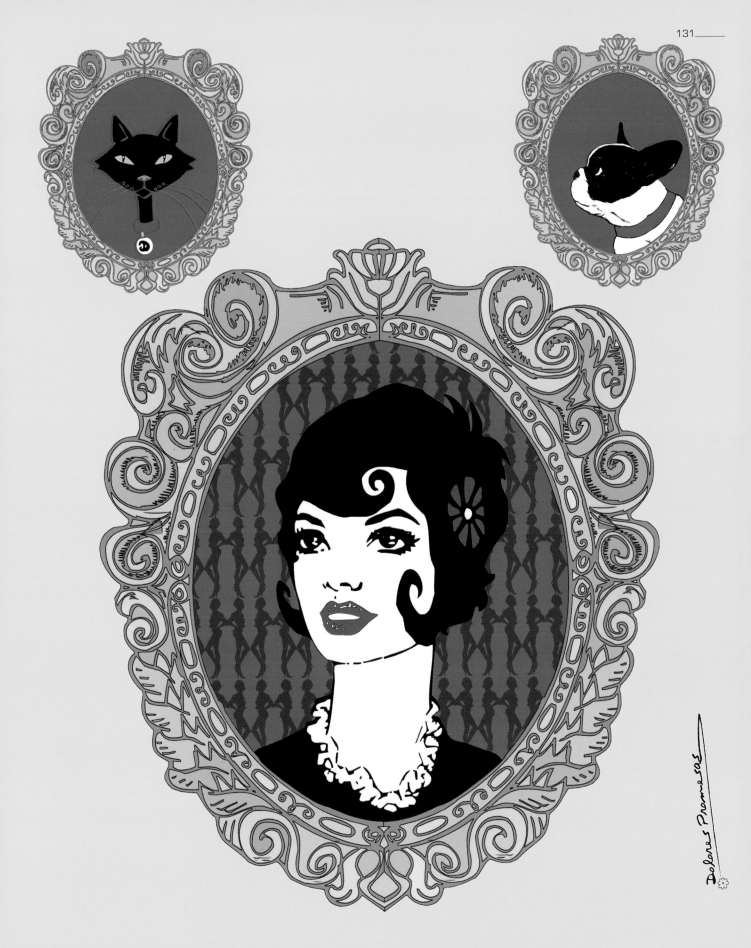

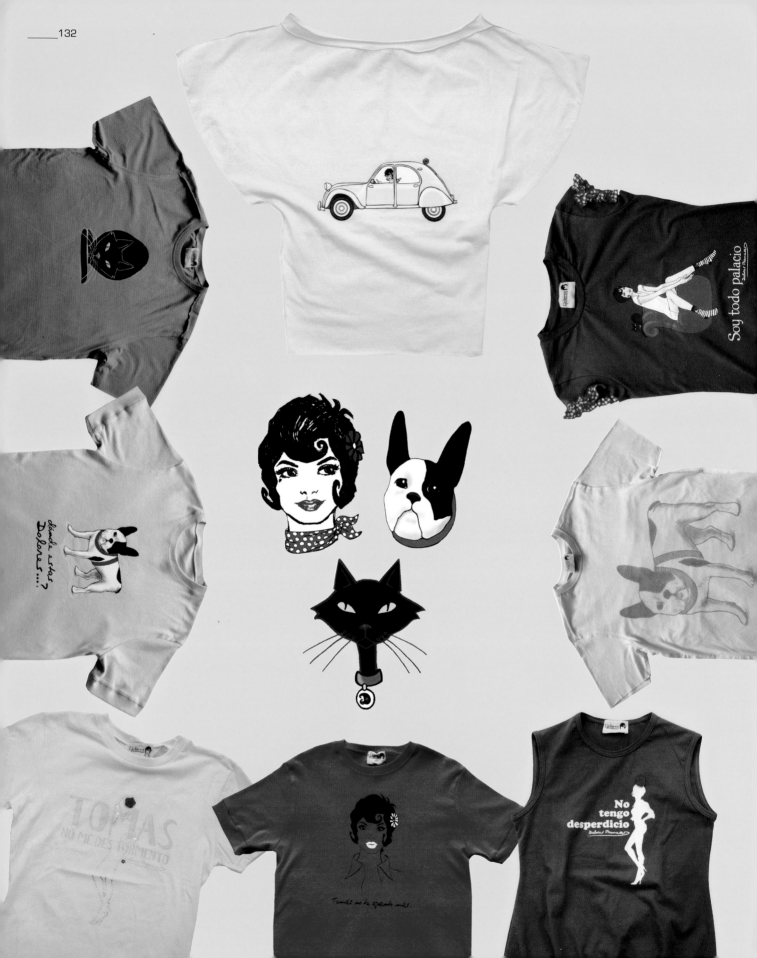

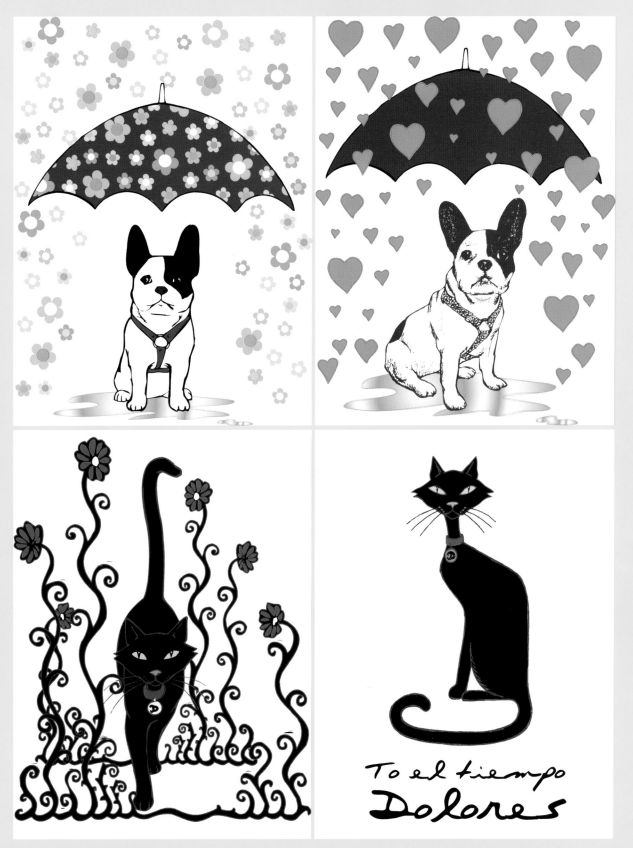

To el tiempo Dolores

Dolores Promesas

Tula the dog and Trini the cat are Dolores's pets.

All images by Delphine Delas.

32_ Delphine Delas

www.delphinedelas.com
www.myspace.com/delphinedelas
Barcelona, Spain, and France

The T-shirts by DELPHINE DELAS, the multidisci-
plinary French artist currently living and working
in Barcelona, are virtually an extension of her
neo-pop and baroque artwork. She expresses her
characters through painting, *art brut*, street art,
illustration, installation, and other techniques.
Screen-printed T-shirts bearing her illustrations
are produced annually. They depict a world in
which masked characters, rare animals, and
vanished monsters are united.

Why T-shirts?

Although it might seem rather contradictory, I wasn't
actually seeking to create a link with fashion by producing
T-shirts. Rather, I was seeking to find another artistic
outlet for my work amongst many others. My artwork has
been very much influenced by the *art brut* movement as
well as street art, expressionism, and other styles, so, one
way or another, as far as art is concerned, everything
goes: wood, recycled material, cardboard, and so on. So
the T-shirts are more than just another object of creation
but another way to permanently go beyond the limits.

What was the first T-shirt you designed?

The first T-shirt I made was adorned with masks, some-
thing with which I am obsessed and which frequently
appears in my work.

What are you wearing right now?

A Mexican fuchsia T-shirt sporting a freestyle wrestling
mask. Ha, ha!

What famous person would you like to design a T-shirt?

I would say about Björk that I adore her work and that
she is extremely multifaceted, and that goes for her
partner too, Matthew Barney.

A message you would like to spread with a T-shirt...

If we take the example of my mask T-shirts, the message
is precisely that we are all hiding our true selves behind
masks that we constantly remove and replace, until
finally, the question "Who is hiding behind this face?"
goes far beyond that of just our appearance.

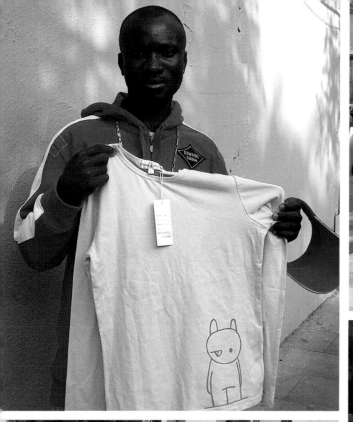
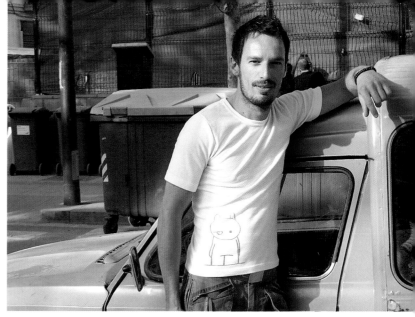
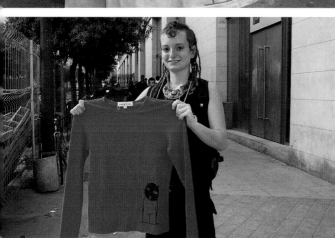
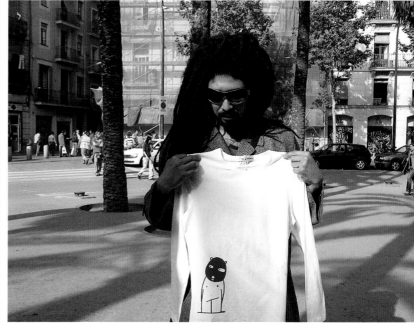
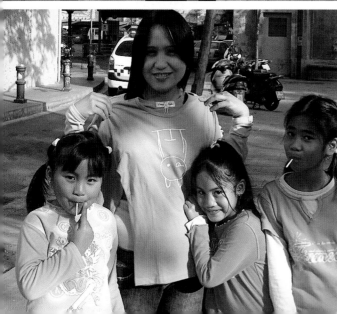
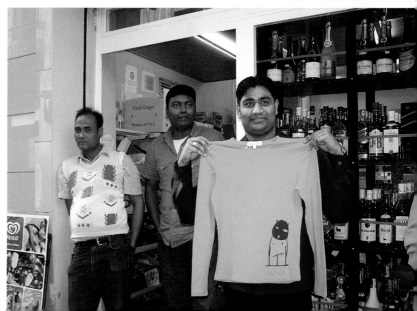

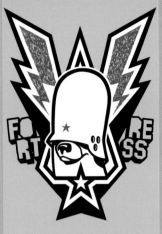
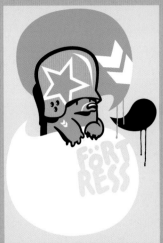
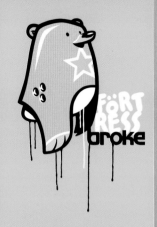
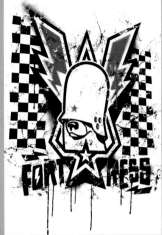
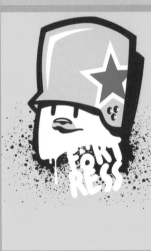
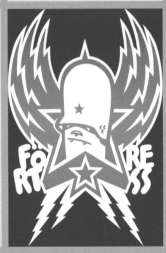

All images courtesy of Flying Fortress.

33_Flying Fortress

www.flying-fortress.de
Munich, Germany

FLYING FORTRESS has been on a mission of classic graffiti since 1989. He stopped graffiti around 1995 because the whole scene had gotten stuck. After studies of graphic design, he got back on the street by sending out a proper army of his iconic teddy troops. He used all kinds of media: stickers, posters, spray paint, and so on. After he had occupied his local territories he started to invade also other cities in other countries: London, Paris, Barcelona, Hamburg, Rome, Zagreb, Berlin, Zurich. Since 2004, the teddy troops have been released as urban vinyl toys by AdFunure.

Why T-shirts?
They are just the best way to make a statement using yourself as a billboard.

What was the first T-shirt you designed?
When I was a teenager I couldn't get any Beastie Boys T-shirts in my city, so i bought a blank one and started to create my own by drawing on it with some markers.

What are you wearing right now?
A T-shirt from my friend Stefan Marx aka Gomes. He is my favorite T-shirt designer.

What famous person would you like to design a T-shirt?
NOFX.

A message you would like to spread with a T-shirt...
Get off *your* shirt, girl!

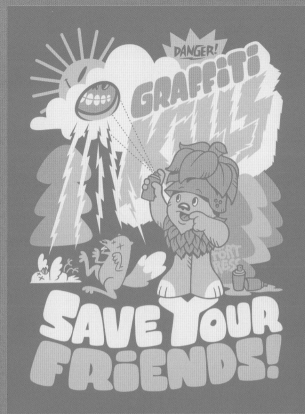

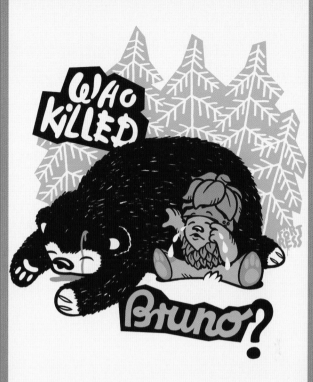

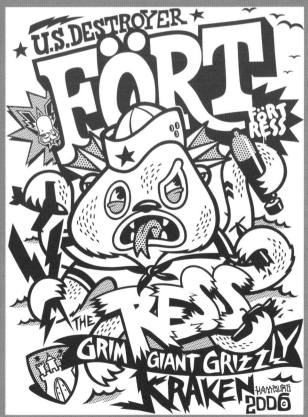

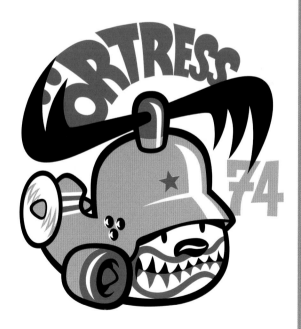

All artwork by Flying Fortress.

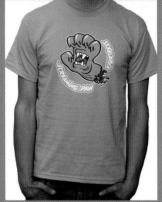

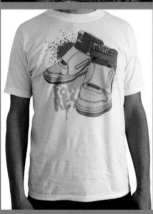

All artwork by Flying Fortress.

make more ♥ ∀ S friends !

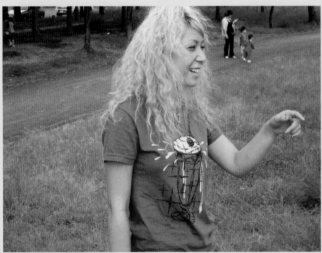
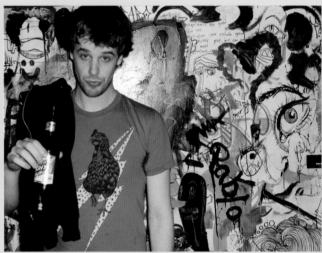

All images courtesy of Yogurt.

34_Yogurt

www.ygrt.net
www.yohnagao.com
Japan

Japanese artist and designer Yoh Nagao launched his brand of T-shirts and clothes by the name of "Yogurt," at a New York fair in 2006. YOGURT uses T-shirts as a medium for his works of art just like paper or canvas, this being a particularly valuable medium for displaying his work to the public at large.

Why T-shirts?
T-shirts are very familiar in daily life. Putting art on a T-shirt brings another style of daily life.

What was the first T-shirt you've designed?
A T-shirt uniform for a sports festival of a friend's high school.

What are you wearing right now?
Yogurt's Rooster T-shirt.

What famous person would you like to design a T-shirt?
Michael Jackson.

A message you would like to spread with a T-shirt...
Now there are so many choices around you, you have to choose something you can really love. I think sharpening that kind of sense is becoming more important.

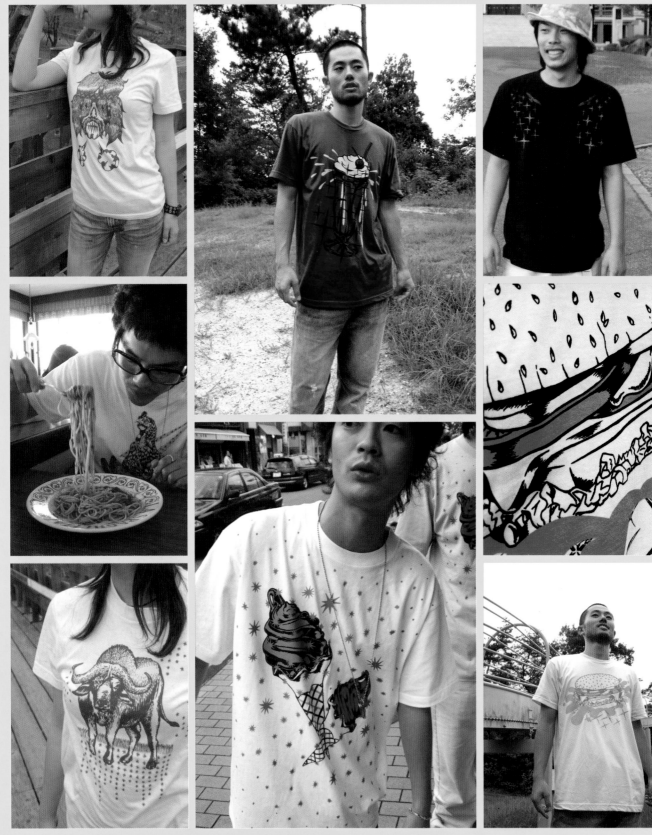

All artwork by Yogurt.

All artwork by Yogurt.

yogurt

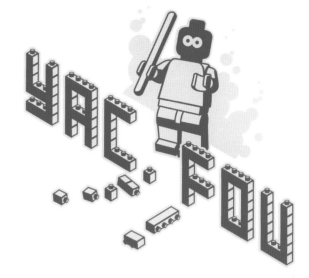

YACKFOU are Martin Krusche and Tobias Herrmann. Two very young designers from Berlin that in 2002, launched their careers in the T-shirt world. They design T-shirts, mesh caps, badges, buttons, posters, hoodies, sweaters, and more. They participate in different exhibitions and organize some by themselves.
Welcome to the Yackfou world!

Why T-shirts?
Martin: It's a simple way to put graphics on humans without tattooing them.

Tobias: T-shirts are a good, basic material on which we can do what we want to do. It is a good opportunity to work independently from the wishes or ideas of clients. T-shirts provide a proper framework for that. In the end there just have to be enough people who like our stuff.

What was the first T-shirt you designed?
Martin: A self-painted ugly one 7 years ago.

Tobias: In the beginning we did this whole silk-screen printing in a DIY manner in the basement of our university. Doing it by yourself is a lot of fun because in the end you hold the final product in your hand made by yourself. Unfortunately, the quality of our prints wasn't satisfying ,so we decided to let the shirts be printed by professionals. But every once in a while we still do stickers and posters by ourselves.

What are you wearing right now?
Martin: A Yackfou shirt, of course.

Tobias: I'm wearing a shirt by Threadless that a friend of mine gave me from his trip to Hawaii.

What famous person would you like to design a T-shirt?
Martin: Marx.

Tobias: Don't know!

A message you would like to spread with a T-shirt...
Martin: You don't need words all the time!

Tobias: Put in above, get out below.

All images courtesy of Yackfou.

35_Yackfou
www.yackfou.com
Berlin, Germany

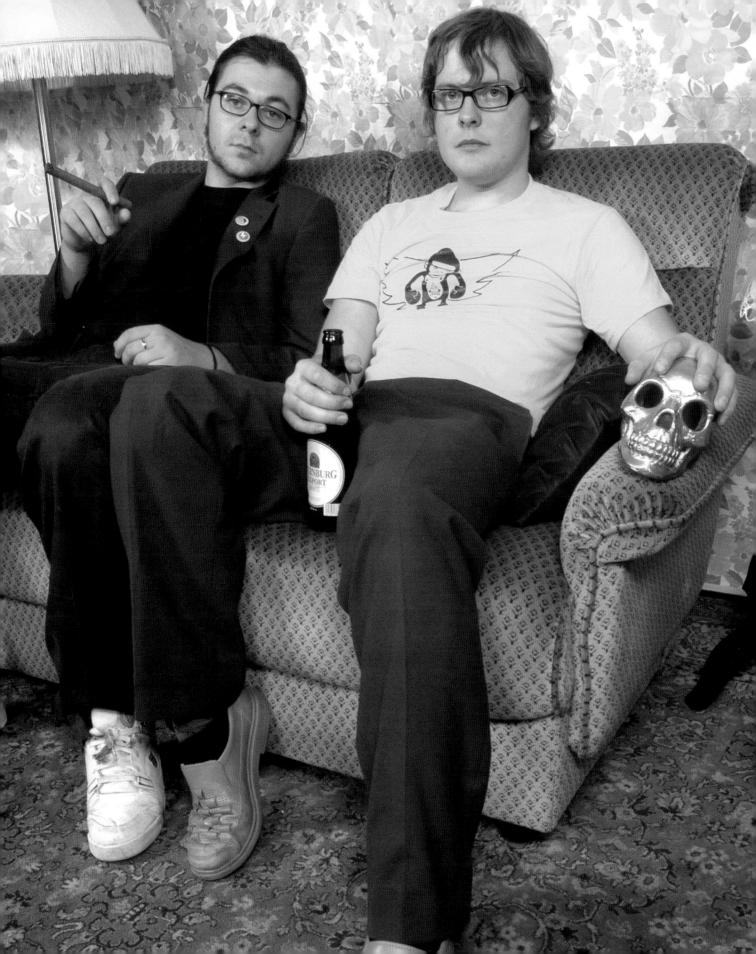

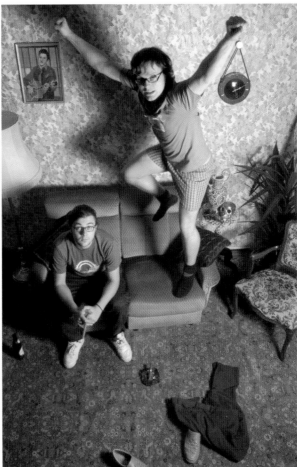

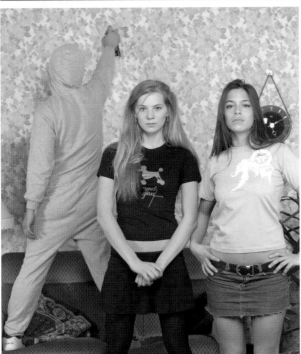

All artwork by Yackfou.

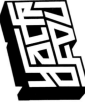

Creative director and New York native Jennifer Garcia launched the T-shirt line STAR ELECTRIC EIGHTY EIGHT in 2003. Her tees have made their way into the *New York Times*, *Complex* magazine, WWD.com, and Josh Rubin's influential Coolhunting.com blog site. Past collaborations include limited-edition tees for Brooklyn-based menswear line Yoko Devereaux, women's wear label H. Fredriksson, and Japanese department store Beams T. Beginning in October, SEEE will be featured in Atlanta's To a Tee exhibit at the Museum of Design.

Why T-shirts?
To decorate people with.

What was the first T-shirt you designed?
An all-over print made up of corporate logos.

What are you wearing right now?
Pajamas.

What famous person would you like to design a T-shirt?
Paul McCartney.

What message would you like to spread with a T-shirt?
Be easy.

36_Star Electric Eighty Eight

www.seee.us
www.myspace.com/starelectriceightyeight
New York, USA

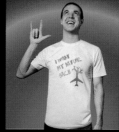
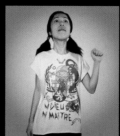
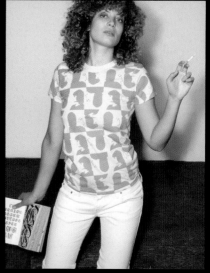
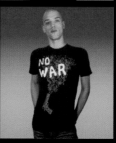

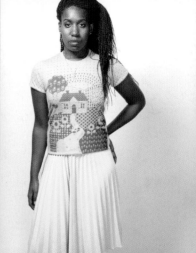
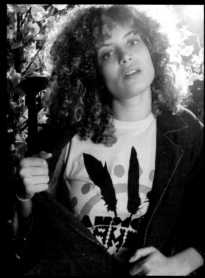

Photos on these pages by Jennifer García, Marc McAndrews, and Bettina.

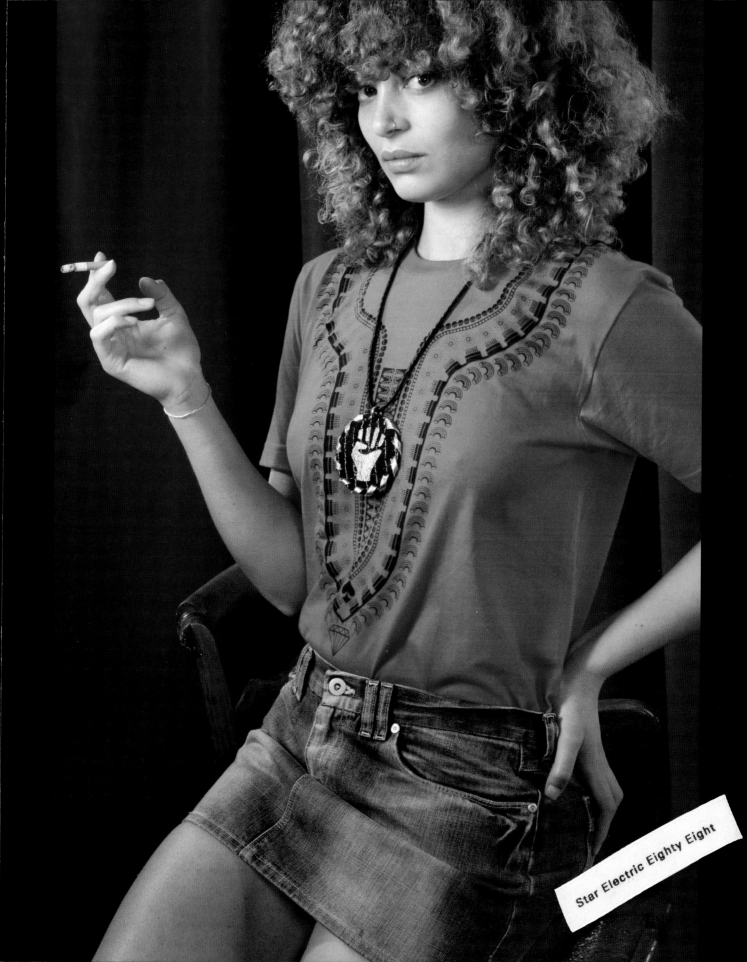

Star Electric Eighty Eight

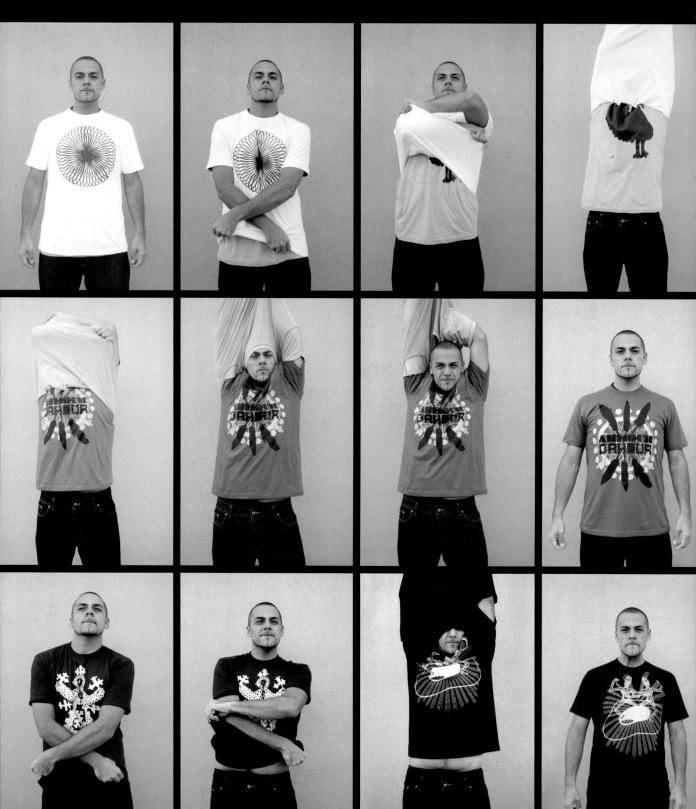

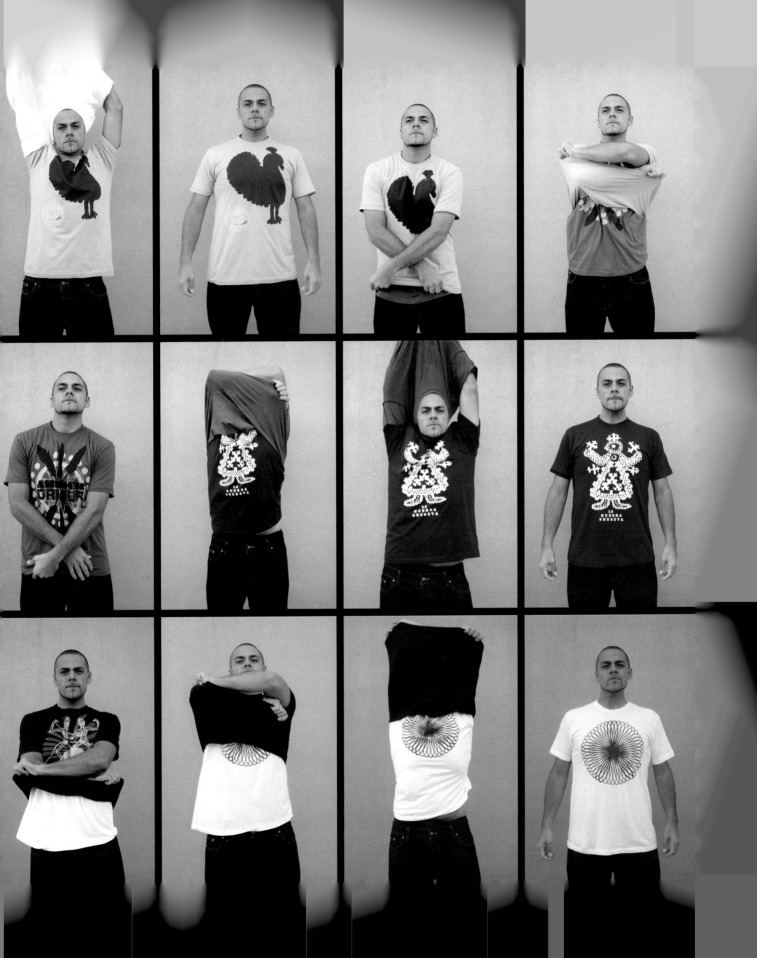

All photographs by Chris Tran Van (christranvan@hotmail.com).

37_ She's a Superfreak

www.superfreak.es
www.myspace.com/superfreakcamisetas
www.youtube.com/superfreakcamisetas
www.fotolog.com/labionda
Madrid, Spain

Mabi Barbas created SHE'S A SUPERFREAK in 2004. Although dedicated to the many fields of graphic design, Mabi's restless character drove her to explore a new means of communication. A friend of protest and an enemy of conformity, the devil's advocate with a feverish mind, for this artist all events serve as a source of inspiration to create a new design. She prints her T-shirts in a rather traditional way, using OBM prints or vinyl ironed onto cotton T-shirts. This limited production line guarantees unique T-shirts. It would be very difficult to come across tow in the same city of the same design and color.

Why T-shirts?
After jeans, T-shirts are the most worn and the most multi generational garment there is. This can also be said to be the most powerful publicity medium after TV (almost).

What was the first T-shirt you designed?
The first of my designs You Got Me Fed Up was created specially in July 2004 to celebrate Gay Pride Day in Madrid with some friends.

What are you wearing right now?
At this moment what I can see is jeans, trainers, my striped T-shirt Take care of the Dog (I'm at work), and a denim jacket.

What famous person would you like to design a T-shirt?
I would love to design a T-shirt for Adrien Brody. I also like Alaska, but she already has one of my T-shirts.

A message you would like to spread with a T-shirt...
I believe the next message I am going to illustrate on a T-shirt will be "The mad are invincible."

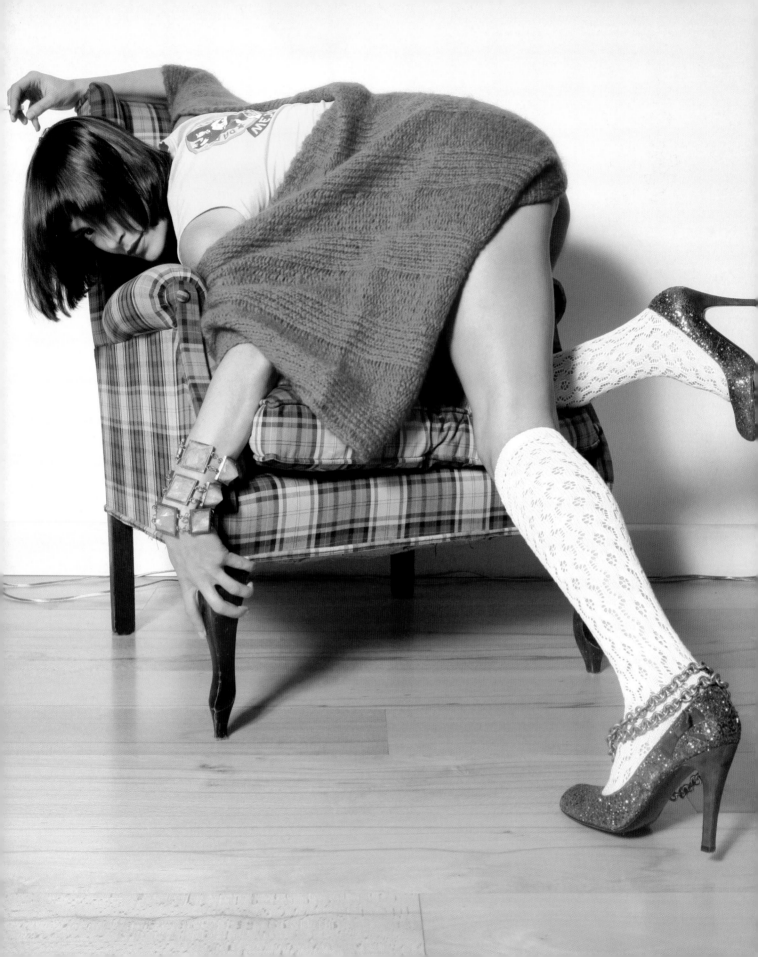

PAPUTA Y NO COBRA
MEJO HONRA

Chula de Mierda

Todas somos la Caif

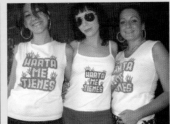

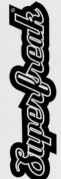

Superfreak

All artwork by She's a Superfreak.

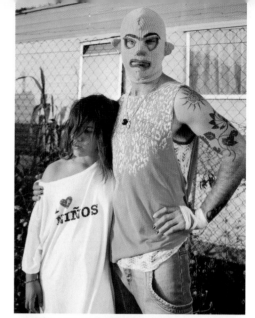

BARRIO SANTO may shock you sometimes, but it will always make you look good. It has three guiding principals: a good fit, quality, and attitude. It purpose is to promote free thinkers who question everything they are told or sold: who, where, why, when, how; what they wear, do, undo; who they fuck; how they live or die. Barrio Santo is also committed to making only clean clothing: fair salaries and working conditions, respect for the environment, fair prices. Dignified clothes.

Why T-shirts?

A few reasons: They are a perfect banner for the designer's graphic work; they allow for a lot of creative freedom, more than other garments (because of your choice of color, prints, patterns and form). They are a great tool for the wearer to express him or herself; it's an item that sells well and, since lately they've become a great reflection of democracy (they are worn by people in all social and economic levels, from a refugee in a raft to a socialite at play on a golf course), your work can reach a wider section of the public.

What was the first T-shirt you designed?

A simple T-shirt: A bit on the large side, open, sexy neck, and big print in red/black/white combination that said: *Mata al Papa. Santo Súbito,* (Kill the Pope, Immediate Sainthood.") John Paul II had just died and the crowd in the Vatican was screaming for him to become a saint right away. Proceedings for sainthood started immediately, despite church laws that require waiting for several years after the person's death. The Catholic Church bends its supposedly sacred laws whenever it pleases, proving that there's much of human and very little of holy in the institution. The church continually attacks people's freedoms (sexuality, family planning, women's rights, and so on) and supports the economic status quo. "Kill the Pope" is a metaphor to express that one should kill all preconceived notions and an appeal to start thinking rationally and on your own. It's a deliberately shocking and cheeky declaration of freedom from harmful social mores or conventions.

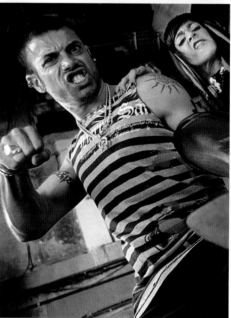

What are you wearing right now?

Gold chain, a sleeveless T-shirt, washed magenta, with a green leopard print and the word *Junkie* across de chest (Barrio Santo), zebra print belt, electric blue pants (also Barrio Santo), bulky light gray running shoes. Nice and discreet.

What famous person would you like to design a T-shirt?

Gore Vidal and Alaska.

A message you would like to spread with a T-shirt...

Free yourself.

Photographs by Thomas Wagner and Sergi Margalef.

38_Barrio Santo

www.barriosanto.com
www.myspace.com/barrio_santo
Barcelona, Spain

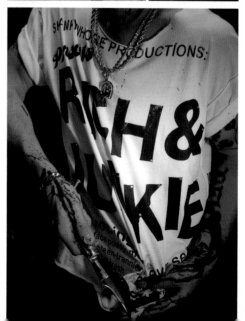

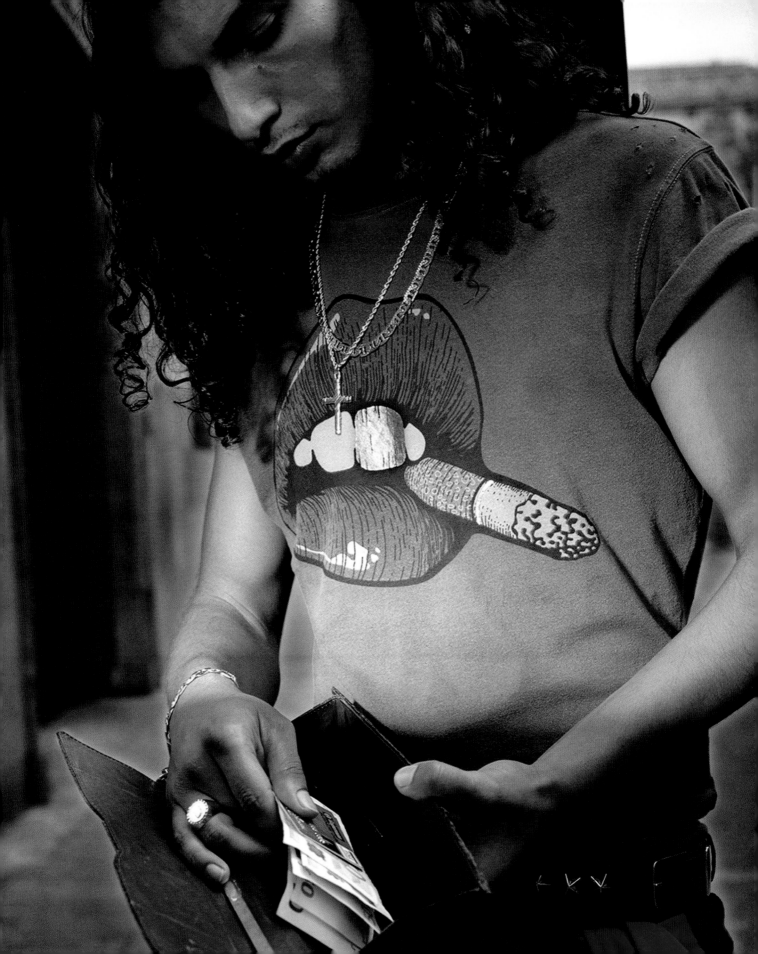

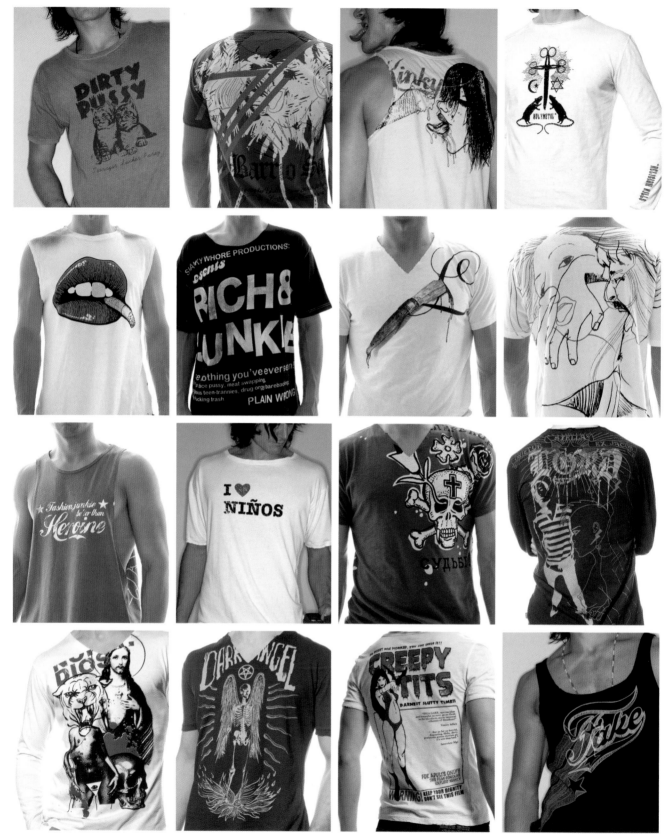

These pages: T-shirts by Barrio Santo.

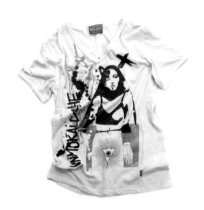
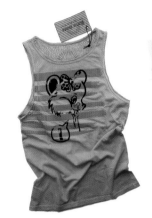
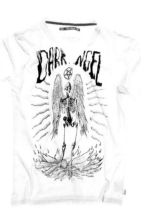
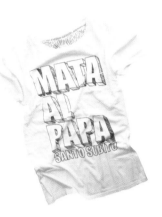
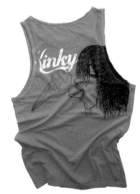
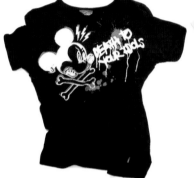

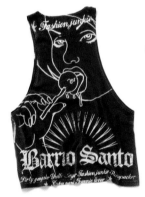
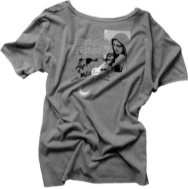
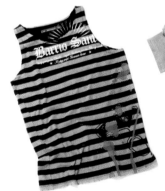
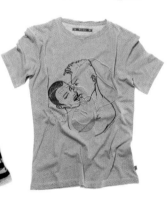
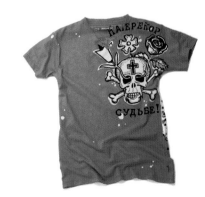

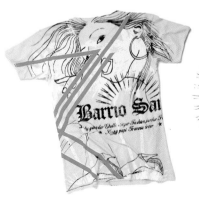
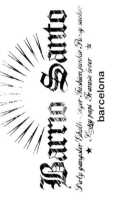

LADY DILEMA makes traditionally crafted garments for young men and women, hand and machine sewn with lots of care using the finest fabrics from around the world, beginning with plain clothes, cotton T-shirts, and vintage garments collected from wherever. Lady Dilema garments have all been given a personal touch that in turn gives them life and personality. Songs, paintings, loves, and dramas all serve as a source of inspiration. Each garment is unique and aspires to be very special and memorable in the eyes of those who see it. For anyone wishing to order something special, with someone or something particular in mind, Lady Dilema is the perfect choice .

Why T-shirts?

This is one of my favorite clothing garments, extremely versatile, expressive, modern and as simple as a blank canvas, as well as being affordable. For a designer such as myself, whose work is based on customization, this is a particularly useful and valuable factor.

What was the first T-shirt you designed?

I sewed a red fabric heart, in big stitches, onto the chest of a plain black T-shirt, which originally I didn't care too much for and which just goes to prove that, at times, it is the simplest of details that make all the difference.

What are you wearing right now?

A T-shirt with a butterfly embroidered by my mother in the '70s and some denim shorts.

What famous person would you like to design a T-shirt?

Any with their own personality and sense of humor (also in the way they dress) I'm thinking of people such as Beck, Bill Murray, or the Lori Meyers group.

A message you would like to spread with a T-shirt...

I love life, music, and love.

39_ Lady Dilema

www.ladydilema.com
www.myspace.com/lady_dilema
www.fotolog.com/ladydilemashop
www.flickr.com/ photos/ladydilema
Murcia, Spain

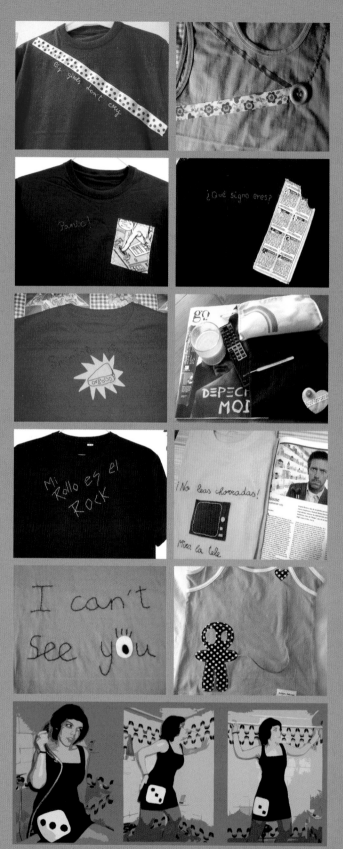

Images courtesy of Lady Dilema.

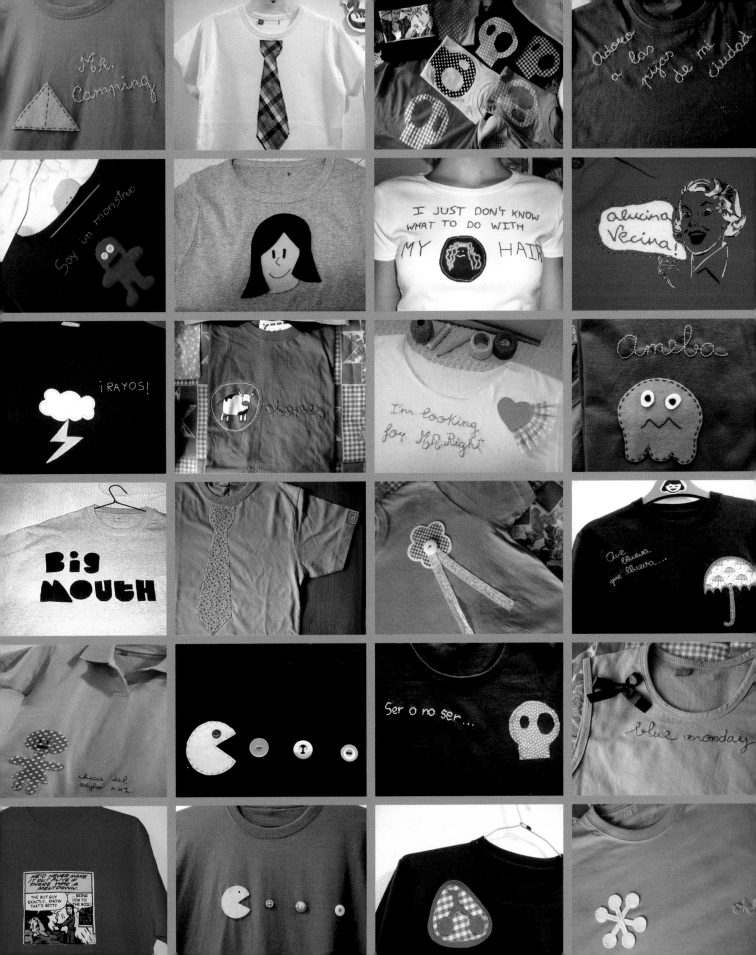

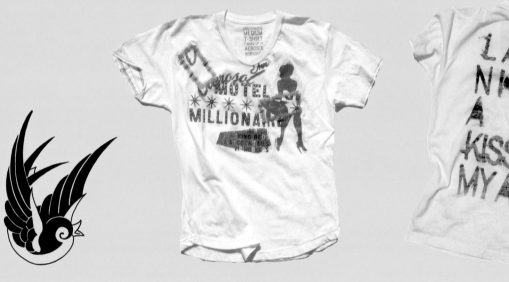

40_Aerosol

www.myspace.com/aerosol_barcelona

Barcelona, and Ibiza, Spain

The AEROSOL "true story" goes way back to 1997 with the opening of the Aerosol shop in Ibiza. Back then Guido Michél, founder of Aerosol, was serving the celebrities of the island with an exclusive streetwear collection customized individually in front of the client. Fascinated by the T-shirt as an utilitarian canvas, Aerosol launched its first T-collection in 2001 with the Wicked World Tour. Today 4 collections are on the shelves of about 100 selected shops throughout Europe. The Aerosol collection is known for its different, sometimes provocative style and unusual use of color.

Wearing Aerosol, you feel special. With its pinch of self-deprecation and humor, Aerosol responds to the labels paraded by others. Cool and glamorous Aerosol T-shirts, hoodies, and polos display graphics that speak about music, culture, and lifestyle. Handcrafted, eye-catching details, high-quality materials fucked up by Aerosol.

Why T-shirts?
Best message board ever!

What was the first T-shirt you designed?
Pink tee with Schwarzenegger stencil and "Killer" in glitter print.

What are you wearing right now?
Aerosol Fresh 'Till Death pink Tee.

What famous person would you like to design a T-shirt?
Let's face the next generation: Rocco Ritchie Ciccone.

A message you would like to spread with a T-shirt...
Buy me!

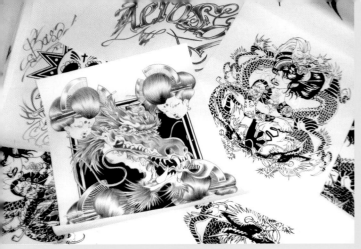

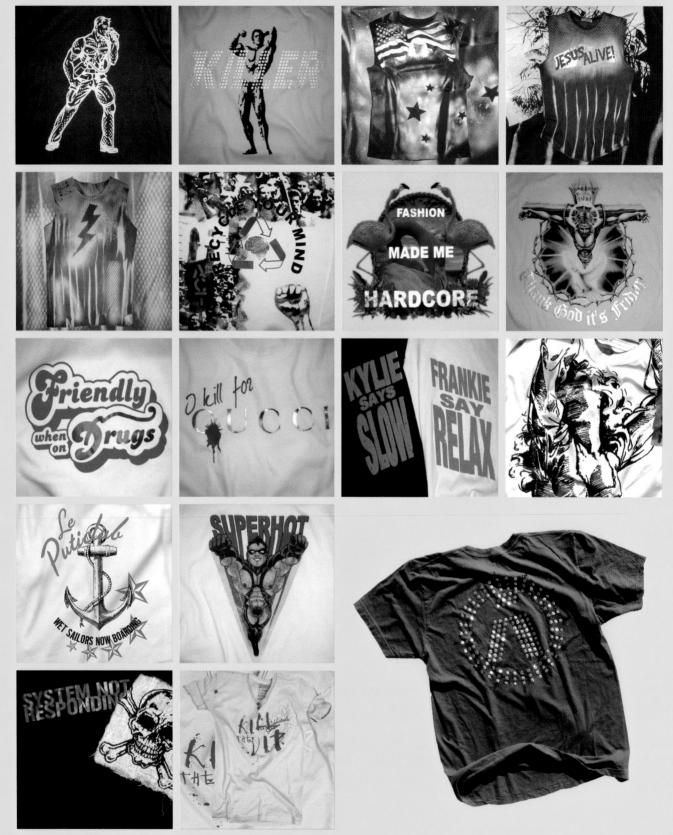

Images courtesy of Aerosol.

Artwork by Bernardo for Aerosol.

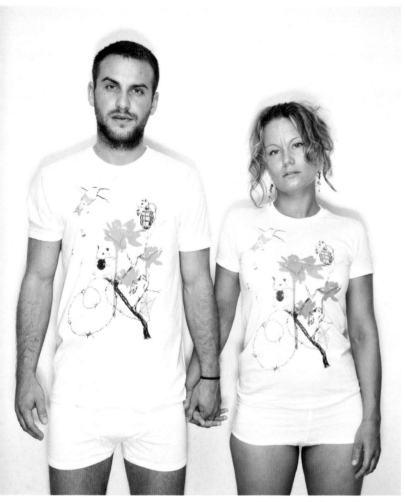

<div align="center">All photographs by www.knotan.com</div>

41_T-post

www.t-post.se
Sweden

Founded in 2004, *T-POST* is the world's first wearable magazine. In the past, a T-shirt was just an article of clothing to wear. Today, *T-post* has made it a mode of conversation; they are yet another way to communicate and awaken the senses. Just as one would subscribe to *W*, *Der Spiegel*, or the *New York Times*, fashionistas and news junkies alike can get current events printed on designer T-shirts. Similar to a magazine subscription, *T-post* subscribers receive a new T-shirt every 6 weeks with an illustration on the front of the tee made by a hand picked designer that echoes the news topic printed on the inside of the T-shirt.

Why T-shirts?
Back in 2004, we started conceiving new ways to engage people about important topics, and T-shirts seemed like an ideal medium for doing so. T-shirts inspire conversation, and when you put an actual story behind them, you get people thinking, forming opinions and discussing various topics with their friends. Nobody asks you about the article you just read in the bathroom. But if you're wearing an issue of T-post, people tend to ask what it's about. The next thing you know, you're talking about the ethical treatment of robots or some bank robbers in Brazil who got away with 45 million bucks. You're forming your own opinion, getting someone else to think about the topic, and it just keeps going from there. That's the magic of this medium, it gives everyone a chance to interpret a news story and communicate it in their own way. By combining a news magazine subscription with a T-shirt, we're able to utilize the attention and commitment associated with the fashion world while communicating interesting and important news topics. It all started out as an experiment, a fun project amongst friends, but by 2006 we had subscribers from all four corners of the world.

What was the first T-shirt you designed?
I haven't designed a single T-shirt myself. To keep *T-post* interesting we work with a new designer each time. But our process of making an issue begins way before that. It all starts with the news editor. He's the guy that scans the globe for the best *T-post* stories out there. He keeps in touch with news blogs all around the world, scans newspapers and connects the dots from stuff that's happening all around the world. After he's collected a couple of good stories, the whole editorial team sits down and decides on which one we're going to run. The editorial team consists of me, the News Editor, the art director and our copywriter. After that we choose the designer that we think could best portray that particular story and we contact them. We keep a library of who we like to think are the most interesting illustrators/designers in the world. The *T-post* designers are the people who translate our stories into visual images. He or she deserves the spot in the limelight –at least until the next issue, when a new designer takes over.

What are you wearing right now?
A T-shirt made by our friend Nick Philip at Imaginary Foundation called Somewhere... and white underwear.

What famous person would you like to design a T-shirt?
I would love to have Terry Gilliam design one of our issues. The stuff he did for Monty Python was brilliant!

A message you would like to spread with a T-shirt...
It's not so much the specific message behind each T-shirt that we're most concerned about. We try to keep the message in our news topics somewhat neutral regarding our opinion. And when we do express our opinion, we try to do so with a sense of humor. We want people to make their own decisions but, of course, some things are just common sense, and when we see that, we laugh at it. For example, the fact that you can now paddle a canoe to the North Pole is not a good thing. We'll gladly point that out, but we don't want to preach to people all the time. We don't think a bunch of T-shirts are going to save the world. We just want to get people talking and see what happens after that.

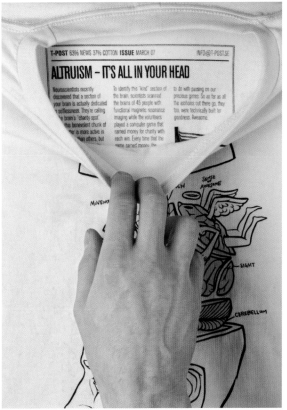

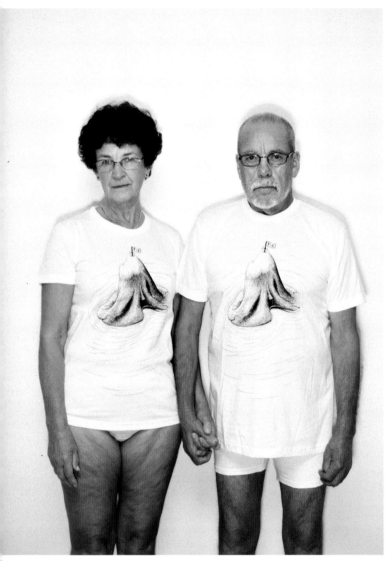
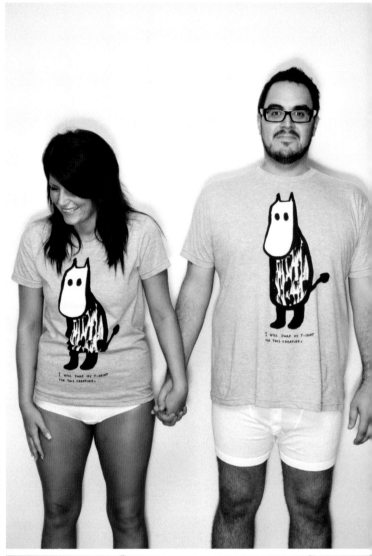
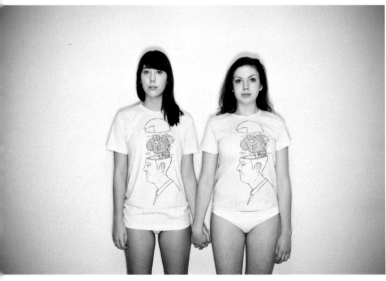
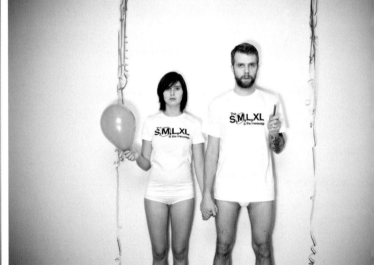

All artwork on these pages by *T-Post*.

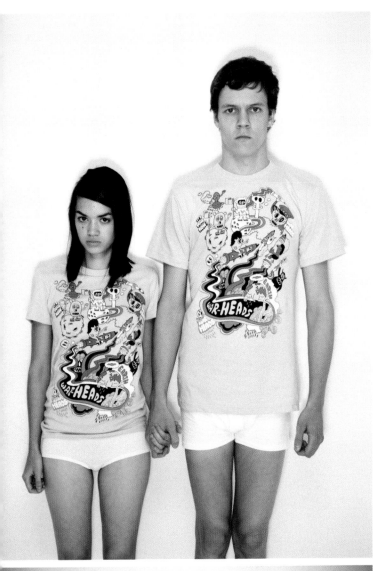
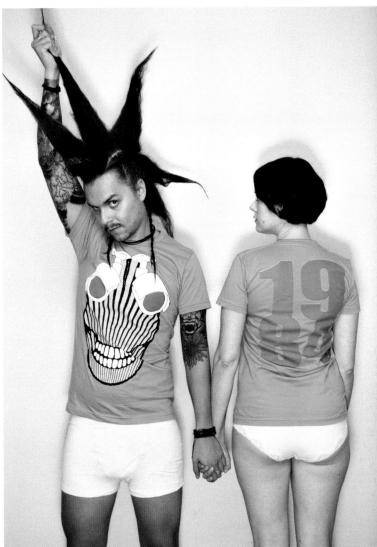
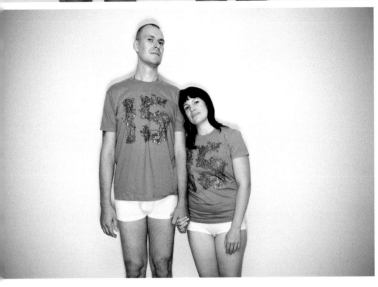
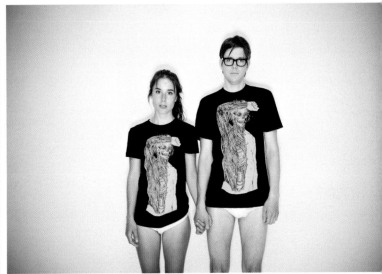

Images courtesy of King Stampede.

KING STAMPEDE clothing is an outward reflection of the experiences, passions and beliefs of four individuals. Their lines are visual scrapbooksm of moments and images that have shaped their lives and built their character. Each season is developed with the intent of providing consumers with something substantially different in both style and concept. They pride themselves in staying one step ahead of the creative curve and hold steadfast to that in our pursuit of greatness.

King Stampede is available in the finest retailers worldwide and has been recognized by many of the worlds leading street-wear publications, online forums and entertainers alike.

Why t-shirts?

I have been a bit T-Shirt obsessed for most of my life. It started with the 3/4 sleeve metal shirts in about the 4th Grade. I used to make my Dad take me to the flee market at-least once a week just so I could look at all the tees and feel the vibe of the big kids who hung around the booth smoking butts and cranking tunes. I remember the first one I ever bought, it was a Blizzard of Oz one. My Mom freaked on my Dad because he took me to CCD class that night and I wore it under a sweatshirt that I took off once I got inside. Thats when the shit hit the fan. They really did not take well to the upside down burning cross in religion class. Anyway for the rest of my life no matter what scene I was into my T-Shirt was the one way I could show the whole world what i was digging without ever having to say a single word. And now I design them all day long.

What was the first T-shirt you designed?

In the 80's there was a great store in the mall by my house called Shirt Shack. It was one of those boardwalk style shops where you picked from dozens of designs posted all over the walls and had it heatpressed onto any style shirt you wanted. Well one special day my friends and I went into the shop and the guy who owned the place told us he had a new machine which would allow us to have any image we gave him printed on a tee. Well holy fuck I must have missed getting hit by a car 5 times as I raced my bike home in anticipation of making my own custom tee. I threw my bike down in the driveway, ran up to my room, blasted *Anthrax's* Fistful of Metal and began to cut up every hit parader, bmx plus, and thrasher magazine I owned. A few hours later I rode my bike back and about 2 weeks later I had the tuffest teeshirt in my school, ohhhh yeah kid. I fucking though I was the shit with that tee on, talk about limited edition my friends.

What are you wearing right now?

An Carhardt sweatshirt, a pair of Levi's corduroys, a pair of New Balance sneakers, and a Woolrich ski hat.

What famous person would you like to design a T-shirt?
Daniele Baldelli.

A message you would like to spread with a T-shirt...
Walk your own Path Kids, you'll learn the right way.

NOTHING

WILL HARM YOU NOTHING WILL STAND IN YOUR WAY

KING STAMPEDE !

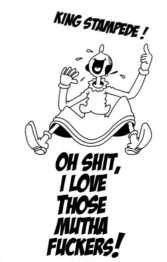

OH SHIT, I LOVE THOSE MUTHA FUCKERS!

DARK NESS!

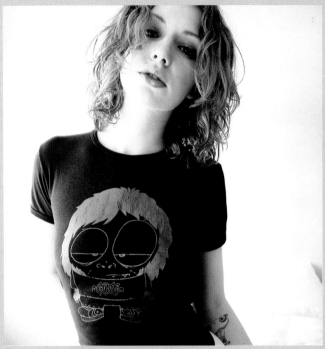

Images courtesy of Evil Design.

43_ Evil Design
www.evildesign.com
New York City

EVIL DESIGN was born in 1991, when one of MCA's favorite entertainers, Pee Wee Herman (Paul Reubens), was arrested in an adult movie theater. Aside from his highly successful collaboration Show Destroy You, NYC – MCA + MAGMO at Orchard Street Gallery in Manhattan, he has also participated in Adicolor x Toy2r (Berlin), Kid Robot's MUNNY Show (NYC), Toy2r x APM Bunny Fiesta (Hong Kong), and "Show C215: Toyz Insolites (Paris), to name just a few. These days, MCA is most excited about his venture into the realm of toy design.

Why T-shirts?
They are the perfect invention. Do people call items of clothing inventions? I dunno, but yeah, T-shirts are the best fashion/clothing invention. I was watching an Ed Roth documentary and in it they said that he was the first guy to draw/paint on the blank white T-shirt. Is this true? It was his california version of the hot rod club jacket. A T-shirt is such an obvious canvas that you can see how it was maybe over looked for a while. T-shirts are a great way to get your art out there. What's better than walking down the street and seeing a cute girl wearing a shirt with a drawing of yours on it.

What was the first T-shirt you've designed?
The first was of my Paul Reubens/Pee Wee Devil head with *evil* written under it. It was designed around Mr. Reubens's mug shot. This shirt also gave me the *Evil* in Evil Design. I used the word sarcastically to show how I felt about the way he was treated after being caught in the movie theater. Crazy moms burning Pee Wee dolls, c'mon!

What are you wearing right now?
I am wearing a T-shirt by the great designer Wrecks, the Athlete's Foot (Bum) design, green shorts, and Harlem Globetrotter socks (best socks ever). I'm on the cutting edge...

What famous person would you like to design a T-shirt?
Design a tee for? A couple famous folks no longer with us that I would have enjoyed designing for are Jerome Lester Horwitz and Maury Amsterdam. A couple of living people it'd be cool seeing in a T-shirt I designed woudl be Nick Sutton and Jacob Reynolds. I also think it'd be fun to collaborate with Amy Sedaris on a line of shirts all themed around juvenile delinquent rabbits.

A message you would like to spread with a T-shirt...
Be Kind to the elderly.

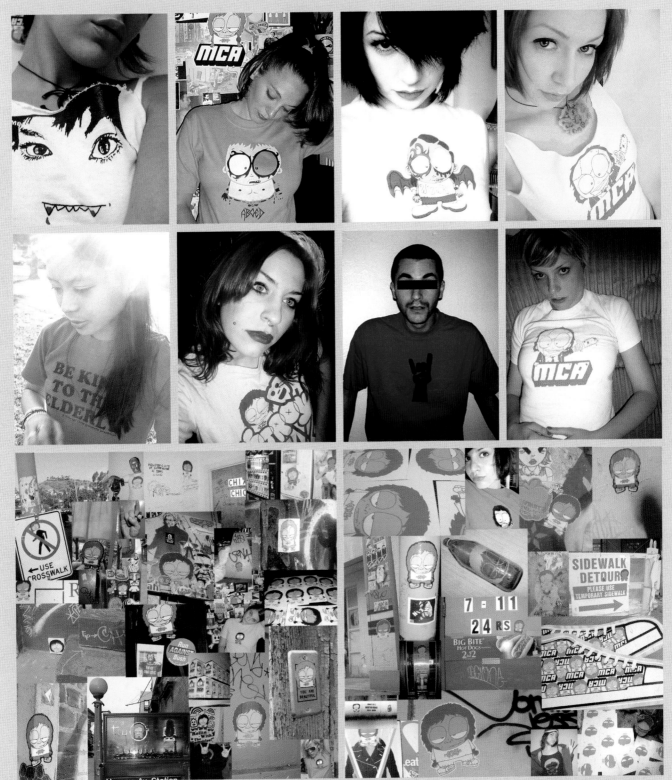

All artwork on these pages Evil Design.

POLLOCK has designed T-shirts for the last 20 years in a completely amateur fashion without pretensions of becoming famous. He secretly makes a collection of T-shirts by hand every year, exclusively for friends. He produces one unique T-shirt for each design and it comes with a special tube packaging. The collection can be viewed in a catalog with the option to choose between 30 exclusive designs.

Why T-shirts?
One day, when I was 15 and at home in a bad mood, I said to myself: I wanna do T-shirts! And so, with a paintbrush and a jar of paint I did three T-shirts; I kept one for myself, and sold the others to my brother. Ten years later, I said to myself again: I wanna do T-shirts! Although I took it more seriously this time, my intention was still the same —to have a good time.

What was the first T-shirt you designed?
When I was still at school, I designed a boring ecological T-shirt.

What are you wearing right now?
Now, for example, a shirt with a new white T-shirt underneath. Just how cool is a white T-shirt when it's new and still white!

What famous person would you like to design a T-shirt?
John Locke (the young one).

A message you would like to spread with a T-shirt...
!!!

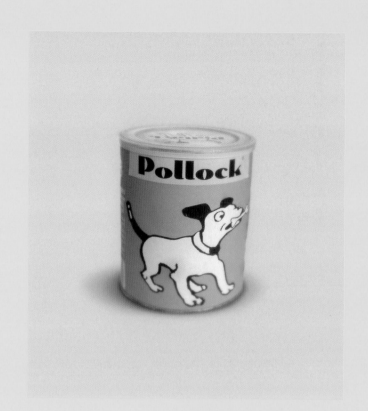

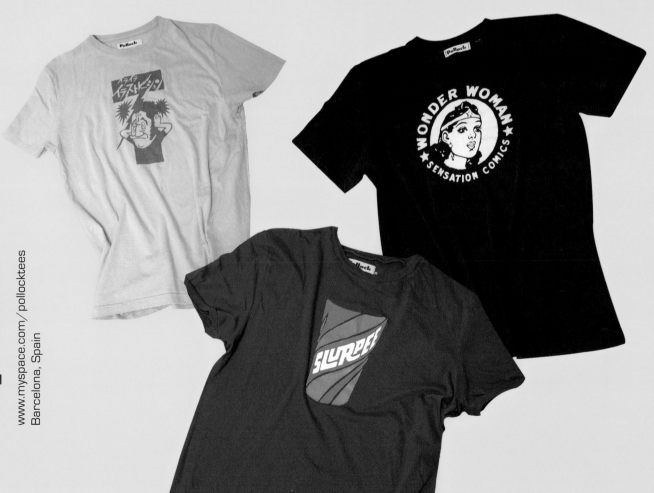

44_ Pollock
www.myspace.com/pollocktees
Barcelona, Spain

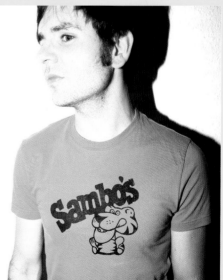

Images courtesy of Pollock.

Pollock®

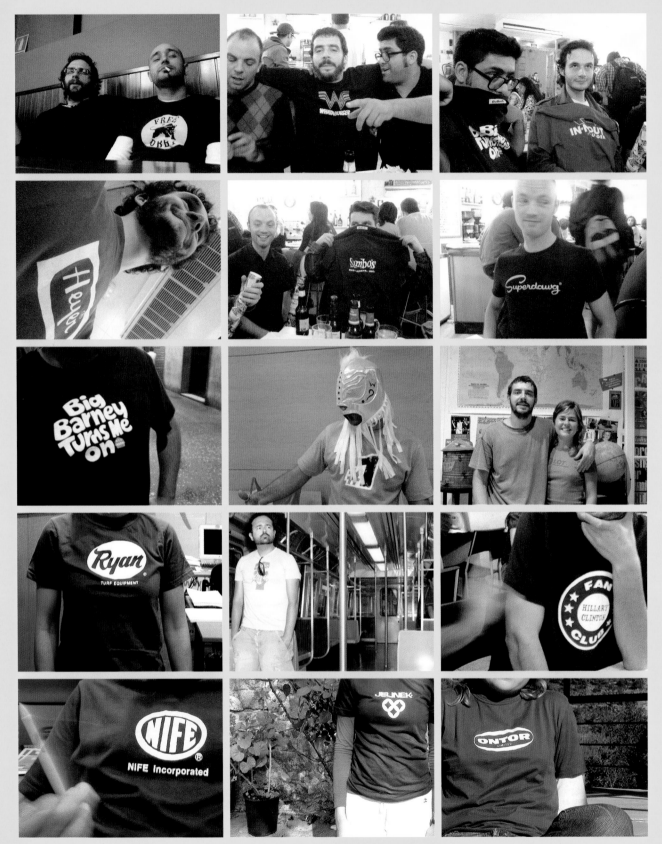

These pages: t-shirts by Pollock

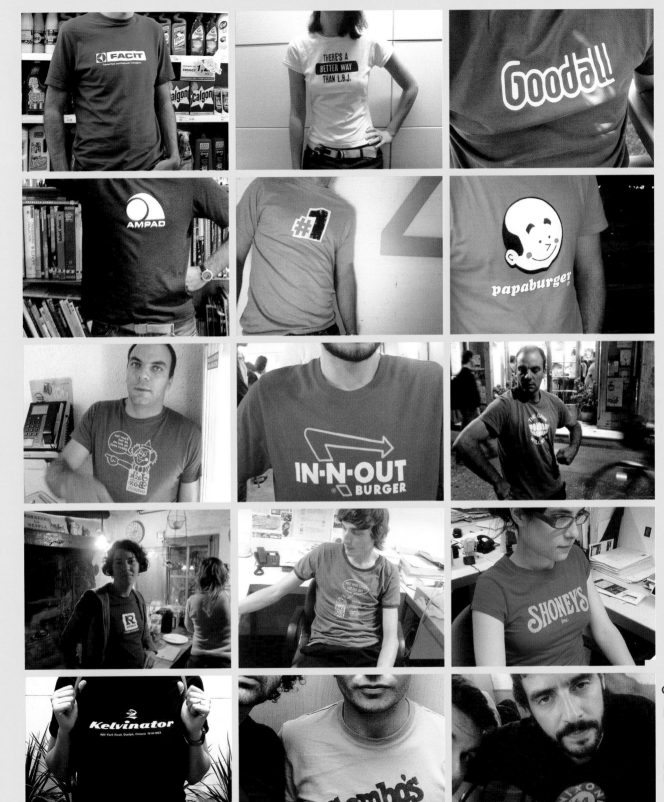

Pollock®

45_ Putos Modernos

www.putosmodernos.com
Barcelona, Spain

PUTOS MODERNOS is a creative venture and a vindicating clothing brand founded a year and a half ago in Barcelona to literally ridicule the most recalcitrant of fashion victims. The Putos Modernos collection includes a full range of apparel with which to confront "the urban battle": T-shirts, caps, jackets, and sweatshirts. The garments come with silhouettes and messages either screen printed or in vinyl. The most successful and in fact the most daring of the T-shirts is plain, decorated with enormous letters: Putos Modernos. Putos Modernos operates via the Internet, their up-to-the minute T-shirts available, exclusively from the web.

Why T-shirts?
And why not? These are nothing more than small ephemeral, washable and biodegradable works of art.

What was the first T-shirt you designed?
My first T-shirt design was in support of a group which even now, years later, continues to protest against the dual carriageway they want to construct in my valley and which for sure will destroy my town: Zabaldika (Navarra). The message is a very simple one: *Autobiderik Ez* ("No dual carriageway").

What are you wearing right now?
Jeans, black jersey, 2 Putos Modernos button pins, and striped socks.

What famous person would you like to design a T-shirt?
I would love to design a Putos Modernos shirt for Pedro Almodóvar.

A message you would like to spread with a T-shirt...
I believe the best slogan would actually be "Puto Mundo" although I would also like to see our "Putos Modernos" displayed throughout the entire world.

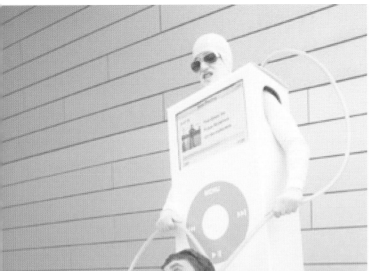
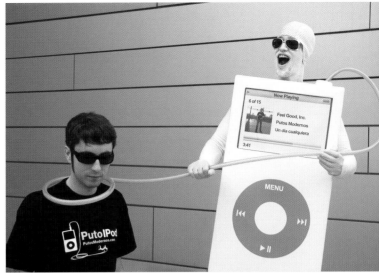
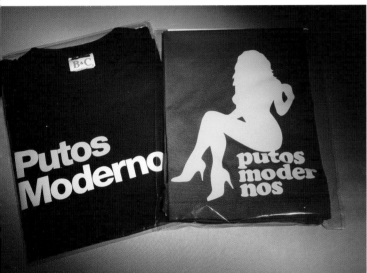

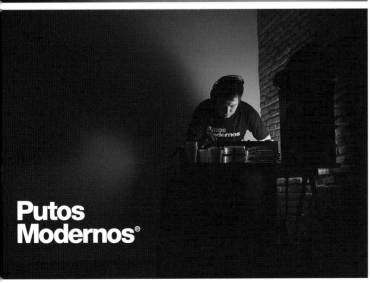
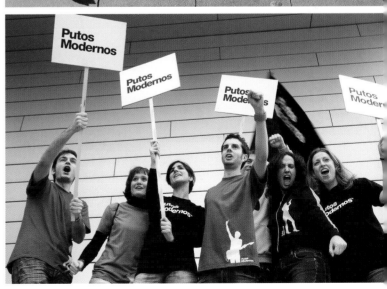

Images courtesy of Putos Modernos.

Tees for peace...

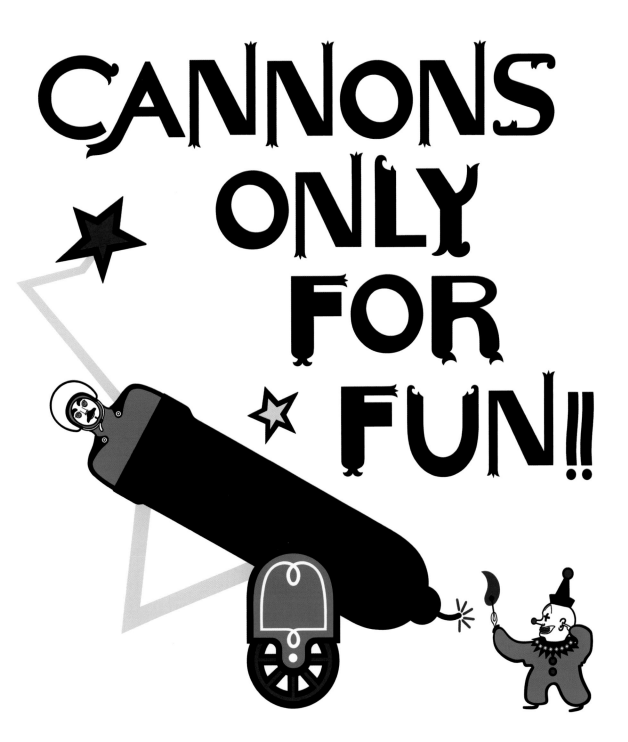

CANNONS ONLY FOR FUN!!

Tees for peace...

cannons just for fun
gonzalo cutrina
spain

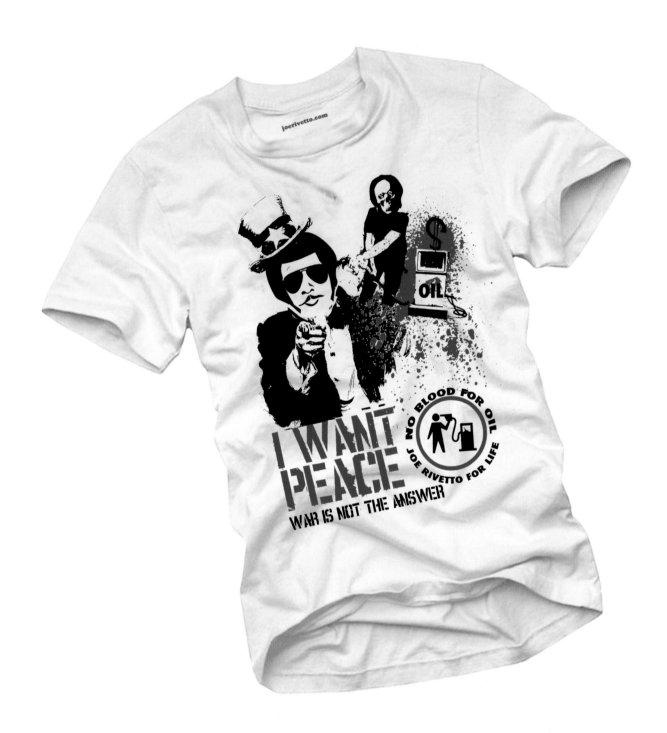

i want peace

joe rivetto

italy

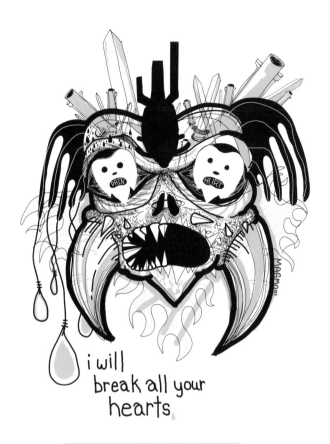

i will break all your hearts
magmo the destroyer
usa

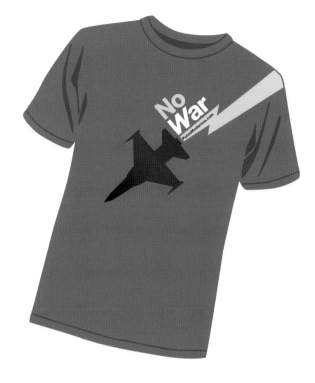

no war
putos modernos
spain

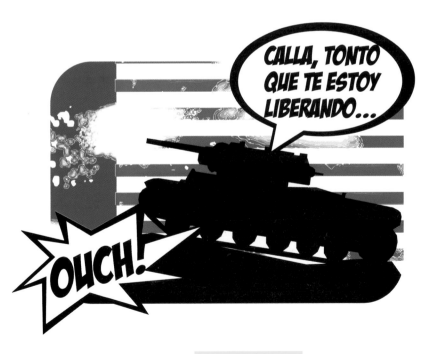

ouch!
she's a superfreak
spain

Tees for peace...

nowhere to fly
yogurt

japan

jane fonda

star electric eighty eight

usa

Tees for peace...

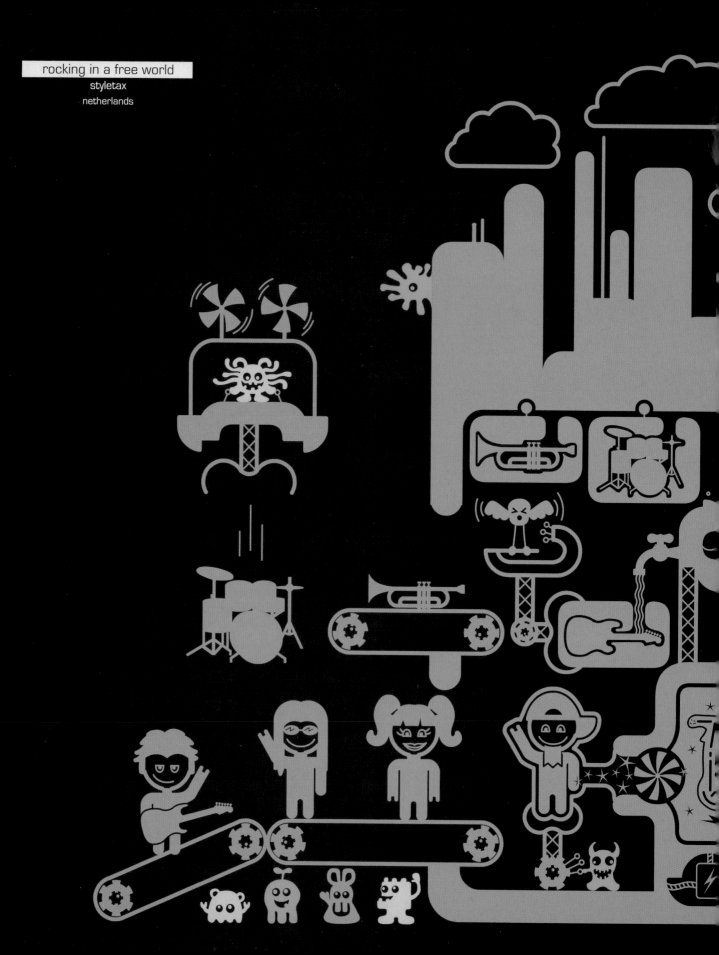

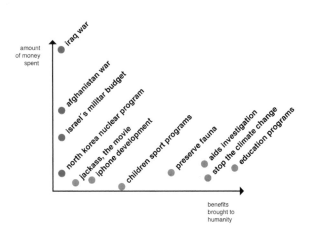

Y=money X=benefit to humanity
max-o-matic
spain

war is death
aerosol
spain

make fellatio, not war
barrio santo
spain

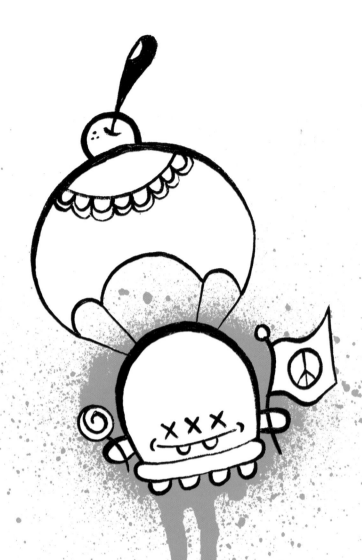

peace trooper
buff monster
usa

Tees for peace...